S0-BBJ-240

THE FEMININE FACE OF THE PEOPLE OF GOD

Gilberte Baril, O.P.

The Feminine Face of
the People of God

Biblical Symbols of the Church
as Bride and Mother

A Liturgical Press Book

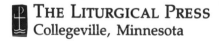
THE LITURGICAL PRESS
Collegeville, Minnesota

Cover design by Ann L. Blattner
Illustration by Ethel Boyle

The Scripture quotations herein are from the Revised Standard Version of the Bible, Catholic edition, copyright 1965 and 1966 by the Division of Christian Education of the national Council of the Churches of Christ in the USA, and are used by permission. All rights reserved.

The author acknowledges the assistance of a grant from the Albert-le-Grand Dominican Foundation in the writing of this book.

Feminine face of the people of God: Biblical symbols of the Church as bride and mother was first published in the United Kingdom by St. Paul Publications, Slough.

Original title: *Féminité du peuple de Dieu*
Copyright © 1990 Les Éditions Paulines, Montreal, Canada

Translated by Florestine Audette, R.J.M.

English translation copyright © St. Paul Publications UK 1991. All rights reserved.

This edition for the United States and Canada published by The Liturgical Press, Collegeville, Minnesota 56321.

1	2	3	4	5	6	7	8	9

Library of Congress Cataloging-in-Publication Data

Baril, Gilberte.
 [Féminité du peuple de Dieu. English]
 The feminine face of the people of God : biblical symbols of the church as bride and mother / Gilberte Baril.
 p. cm.
 Translation of: Féminité du peuple de Dieu.
 Includes bibliographical references.
 ISBN 0-8146-2130-9
 1. Church. 2. Motherhood—Religious aspects—Christianity. 3. Feminist theology. I. Title.
BX1746.B34313 1992
262'.7—dc20
 92-15163
 CIP

To Mother Julienne du Rosaire, foundress of my religious community, the Dominican Missionaries of the Adoration.

Without her support, I could not have written this book or experienced the joy of contemplating the work of salvation accomplished through Christ and his Church, at the heart of humanity.

Contents

Abbreviations

AC	–	*Ami (L') du Clergé* (Langres)
CBQ	–	*Catholic Biblical Quarterly* (Washington, Cath. Biblical Association of America)
Com	–	*Communio* (Paris, French ed.)
Conc	–	*Concilium* (Paris, Beauchesne)
DC	–	*Documentation Catholique (La)* (Paris, Bayard-Presse)
EC	–	*Église Canadienne* (Québec)
ED	–	*Euntes Docete* (Rome)
EE	–	*Estudios Eclesiasticos* (Madrid)
EgT	–	*Église et Théologie* (Ottawa, St Paul University)
ETL	–	*Ephemerides Theologicae Lovanienses* (Louvain, Catholic University of Louvain)
EtM	–	*Études Mariales* (Paris, Societé Française d'Études mariales)
EU	–	*Encyclopaedia Universalis* (Paris, 1974-1975)
EV	–	*Ésprit et Vie (Anc. L'Ami du clergé*, Langres)
Irén	–	*Irénikon* (Chevetogne)
LEV	–	*Lumière et vie* (Lyon)
Mar	–	*Marianum* (Rome, 'Marianum')
MS	–	*Marian Studies* (Washington, Mariology Society of America)
NRT	–	*Nouvelle Revue Théologique* (Namur, Casterman)
NTS	–	*New Testament Studies* (Cambridge, Cambridge University Press)
RB	–	*Revue Biblique* (Paris, Gabalda)
RHP	–	*Revue d'Histoire et de Philosophie Religieuse* (Strasbourg, Kraus reprint)
RSPT	–	*Revue des Sciences Philosophiques et Théologiques* (Paris, Vrin)
RSR	–	*Recherches de Sciences Religieuses* (Paris)
RTho	–	*Revue Thomiste* (Paris, Desclée de Brouwer)
SVS	–	*Supplément, Vie Spirituelle* (Paris, Cerf)
TOB	–	*Traduction Oecuménique de la Bible* (Paris, Cerf, 1975)
TS	–	*Theological Studies* (Washington, Georgetown University)
VT	–	*Vetus Testament* (Leiden, E. J. Brill)
VTB	–	*Vocabulaire de Théologie Biblique* (Paris, Cerf, 2nd ed., 1971)
ZAW	–	*Zeitschrift für die Alttestamentliche Wissenschaft* (Berlin, Walter de Gruyter & Co.)

Introduction

Christ has entered history and remains in it as the bride-
groom who 'has given himself'. 'To give' means 'to
become a genuine gift' in the most complete and radical
way: 'Greater love has no man than this' (Jn 15:13).
According to this truth, all human beings – both men and
women – are called, through the Church, to be the 'bride'
of Christ, the redeemer of the world. In this way 'being the
bride', the 'feminine' element, becomes a symbol of all
that is 'human', according to the words of Paul: 'There is
neither male nor female, for you are all one in Christ' (Gal
3:28).

In the Church every human being – male and female – is
the 'bride', by accepting the gift of the love of Christ the
redeemer, and by responding with the gift of self.[1]

With these words, John Paul II brings to light the symbolic
dimension of the 'great mystery' of the nuptial union of
Christ and the Church mentioned in Paul's Letter to the
Ephesians, chapter 5, verses 21-33. Here the pope echoes an
idea found in the reflections of certain theologians such as
Louis Bouyer:[2] 'Before God, before Christ, the whole Church
is "feminine."

But can one legitimately speak of a certain 'femininity' of
the Church? At first, the expression may come as a surprise.
And, in fact, serious objections are raised. Is there not an
element of danger in speaking of a 'feminine' aspect of the
people of God? Does not this expression immediately arouse

11

suspicions in the minds of many of our contemporary men and women who often see in it a dangerous exaltation of a so-called 'essence of woman' or of an 'abstract femininity'? For them, such an exaltation would be all the more dangerous as it might seek to dehumanize women and prevent their proper and effective integration in a world dominated by men.[3]

Besides, the idea of 'femininity' may appear even more disquieting when mentioned in connection with the mystery of the Church, and more particularly within the context of Catholic ecclesiology. Would there not be the danger of perpetuating what has been termed 'the traditional exclusion of women' from ecclesial life? Would not these symbolic ways of interpreting the mystery of the covenant contribute to the preservation of a certain 'mystification' of women?[4]

And yet, Scripture itself directs our attention to this symbolism, as is shown in the quotation from John Paul II. God's chosen one in the firstborn Son is indeed the Church. St Paul, in the wake of the writers of the Old Testament speaking of Israel, calls the Church 'the bride', this bride whom Christ presented to himself by giving himself up for her so that she may be 'in splendour, without a spot or wrinkle or anything of the kind – yes, so that she may be holy and without blemish' (Eph 5:27). The new Jerusalem, 'the Jerusalem above' (Gal 4:26), is truly the mother of all human beings.

Moreover, Scripture leads us to believe that human beings, called to the adoptive filiation in Jesus, are destined to collaborate, each man and woman his or her share, in the maternal mission of this New Jerusalem. Thus, the Church, bride and mother, is actualized concretely in the community of the faithful; every member is expected to live the nuptial mystery and the maternal fecundity each in his or her own way.

The 'feminine'[5] element thus becomes, for Scripture, a symbol both of the Church and of each of her members. So how can one determine adequately the meaning of this expression vis-à-vis a sane anthropological outlook without being confronted by the difficulties mentioned above?

The first objective of this research[6] is to examine in depth

the mystery and the mission of the Church and her members deriving from the two symbols of the bridal union and the salvific motherhood used by the Old and the New Testaments, to describe the covenant relationship of God with humanity. We will thus be in a position to determine better both what this 'feminine qualification' of the people of God consists in and the limitations we must detect in such an expression.

This study will be conducted in two stages. The first, 'Listening to the word of God', is an essay in biblical theology. The second stage, 'Contemplating the "facets" of the "Mystery"', is devoted to a dogmatic synthesis.

A few comments must be made on both the scope of this study and the method used. In the first place, I do not claim to offer here a complete treatise on ecclesiology, which would have demanded a full exploration of the various images and symbols used by the Scriptures to express the ecclesial mystery.[7] The aim is more restricted: to help readers discover more deeply the abundance of 'light' and 'life' contained in the bridal and maternal symbols in which Scripture expresses the mystery of this covenant of love.

Two additional remarks must be made about the method used. To be complete, this study, especially the second part, should have included a research on the use of the bridal and maternal symbols by the Fathers of the Church as well as in the history of theology. Such an investigation, however, would have extended well beyond the scope of this work. Subsequent studies would benefit from pursuing investigations along this line.[8]

Secondly, the contribution made by the experimental sciences, the humanities and philosophy is equally important for a thorough investigation of the questions raised. If I have occasionally referred to studies of this type, it is because I believe that a serious confrontation between the fundamental ideas of these respective sciences and the major elements of the present research is still needed. This study is, therefore, only one step on the long road towards a more profound clarification; nevertheless, I hope that the ideas presented

here and especially the overall view may be of some use.

I mentioned earlier the difficulties that may be encountered in a research of this kind, particularly when the presentation is fundamentally dogmatic in nature. Since many movements of thought and action in our world of today have been profoundly influenced by the functional, pragmatic and Stakhanovite mentality predominant in our Western culture, we often mistrust all discourses of the so-called 'essentialist'[9] type which seek to apprehend reality 'in itself'. And yet, despite of the limitations of our perception and our contingent human situation, revelation invites us to a true 'penetration' of the mystery itself. We are urged to probe more deeply into the heart of the mystery of God, of Christ and of the Church. At the same time, the mystery of the human person and the transformation of humankind itself into the image of Christ through the Spirit may be revealed to us.

This revelation is borne by the Church. No doubt, the Church, being incorporated in the history of humanity, shares the burdens, prejudices and injustices of the world. But she bears the Word of revelation and remains forever the 'light of the nations'.[10] We are, therefore, invited as Church to listen to this revelation in order that we may draw our nourishment from it, and open ourselves more and more to the mystery of God's plan for us. Our conviction that such a listening in depth to the word of God is urgent for the life and the mission of the people of God underlies this research. This work aims to be essentially a theological initiative of a faith in quest of understanding: *fides quaerens intellectum*. May this study make its modest contribution to the renewal of the Church in these crucial times.

NOTES

1. John Paul II, Apostolic Letter *Mulieris Dignitatem* on the occasion of the Marian Year (1988), no 25. In this quotation, John Paul II uses the inclusive language.
2. Louis Bouyer, for instance, in *Mystère et ministères de la femme*, Paris, Aubier Montaigne, 1976, 39ff.

3. Almost all the works of feminist authors hark back to these themes which do not fail to conjure up a true historical problem, that of treating women as inferiors, the complex social and religious causes of which are many.

4. Already in 1949, Simone de Beauvoir, in her study, *Le deuxème sexe*, 2 vols., Paris, Gallimard, points out the danger of such a mystification. See also Betty Friedan, *The feminine mystique*, New York, Dell Publications Co., 1967, p.384.

5. The meaning we give to the word 'femininity' stems directly from the symbolisms mentioned here. It is, therefore, something other than what we could call 'feminine qualities' although we do not deny these. Likewise, we are not referring here in any explicit way to what certain authors have termed 'the polarity of the feminine'. The expression 'femininity', according to the point of view of our work, is linked directly to the scriptural content; consequently, its full meaning will emerge only at the end of this study.

6. This study is the fruit of a long research undertaken within the framework of a doctoral thesis I defended in the Faculty of Theology at Laval University in June 1984. This book contains the major part of the central section of my thesis, although it is presented in a lighter and revised form. This work is also the fruit of my subsequent research, experience and reflection since 1984 in connection with my lecturing in Mariology and ecclesiology, as well as my other activities in the service of my community and of the Church.

7. According to exegetes, there are approximately eighty images of the Church in the New Testament, the main ones being those of the body, the people, the vine, the flock and the building.

8. For a study dealing precisely with the theme of the Church as spouse throughout history see Claude Chavasse, *The bride of Christ, An enquiry into the nuptial element in Early Christianity*, London, Faber and Faber Ltd., 1940.

9. This fear is very present in the book by Bérère, Dufour and Singles, *Et si on ordonnait des femmes?*

10. *Lumen Gentium*, no 1.

Listening to the word
of God

'On that day, says the Lord, you will call me "my husband"...
And I will take you for my wife forever... I will take you for
my wife in faithfulness; and you shall know the Lord' (Hos
2:16, 19, 20). And so, the prophet Hosea was the first to
interpret in nuptial terms the covenant God had established
between himself and his people, Israel. A few centuries later,
the Deutero-Isaiah would take up again the same analogy:
'Sing, O barren one who did not bear... For the children of the
desolate woman will be more than the children of her that is
married, says the Lord' (Is 54:1).

In and through Christ the people of Israel becomes a
Church, bride and mother. This is the people, a select portion
of humanity, the elect, chosen by the creator in view of a
covenant communion, in which every human being would
ultimately be called to take part. In order to understand the
profound meaning implied by a fruitful conjugal relation-
ship between God and humanity, we must listen attentively to
the Scriptures. For it is there that the mystery of the election[1]
of humankind is revealed. This election is initiated by God's
choice of Israel and perfectly fulfilled in Jesus Christ and
destined to reach full fruition at the end of history. Scripture
reveals the mystery of this covenant[2] which bound Israel to
Yahweh and welded together the community of the disciples
of Christ into one body with him through the Spirit. Scripture
again shows us how the espoused people are always the
chosen community, as is each member in this profound and
unique mystery. This communal and personal character de-

termines the life and mission of Israel, and of the Church of Christ.[3]

Our first step will be to dispose ourselves in the next five chapters to listen to word of God in order to grasp its testimony on this fruitful nuptial covenant that God willingly made with humanity. First, we shall examine the figure of the bride and mother as portrayed in the ideal of the couple in the Old and New Testaments (Chapter 1). Then we shall see how the bridal and the maternal symbolisms were developed in the Old Testament (Chapters 2, 3 and 4), and finally study how the New Testament reveals the full development of the same symbols (Chapters 5 and 6).

In this section of biblical theology we will listen attentively to the word of God in order to understand the profound meaning of these symbols. For only such attention to the word can bring us to grasp fully what specific light can spring forth from the expression, *Church, bride and mother*. From a complementary point of view, we will be able to discover the implications of referring to the 'femininity' of the Church.

NOTES

1. The theme of election is fundamental in Scripture, and the history of the chosen people must always be read in this light. On the unique character of the experience of Israel, see among others, Harold Henry Rowley, *The biblical doctrine of election*, London, Lutterworth Press, 1950, pp. 16-19. For a synthesis of the different aspects of the theme of election, see also Paul van Imschoot, *Theology of the Old Testament, I, God*. translated by Katheryn Sullivan RSCJ and Fidelis Buck SJ, Tournai, Desclée, 1954, pp. 245-255; Edmond Jacob, *Theology of the Old Testament*, London, Hodder & Stoughton, 1958, pp. 201-209.

2. On this theme of the covenant, van Imschoot has this to say: 'The idea of the choice of Israel is intimately linked to the one of the divine covenant' (*op. cit.*, p. 245). See also Rowley, *op. cit.*, pp. 46-52; Jacob, *op. cit.*, pp. 209-210.

3. In his small book *L'homme selon la Bible*, Paris, Ligel, 1968, p. 72, Albert Gelin explains the central place of this bond 'community-person'.

Chapter 1

The ideal of the couple in Scripture

Scripture speaks of the people of the covenant by comparing it to a bride and a mother; it does so in the light of Israel's and the early Church's perception of the human couple. We must therefore try to understand first what this ideal was in the life of Israel and in the first Christian communities.

1. The couple in the life of Israel

Israel's view of the human couple[1] and the full religious significance of the conjugal pact is a complex question, for two main reasons. First, this perception had evolved throughout the long history of the people. Secondly, there was an inevitable discrepancy between the ideal and the way it was lived in the various periods of that history.[2]

a. Desacralization related to pagan religions

The institution of matrimony in Israel brings about a radical break from the perception of marriage among neighbouring peoples. For them, sexuality was invested with a sacral character, that of sharing the forces of the divinities of nature. This break from the pagan ideologies and rites, however, is not a late development of minor importance in the religion of Israel. On the contrary, as Pierre Grelot points out, it is

... a direct consequence of its most fundamental dogma. Yahweh, the God of the fathers who revealed his name to Moses (Ex 3:13-15), who led Israel out of Egypt to make this people his own, who demands to be worshipped exclusively by Israel (Ex 20:1-3), Yahweh is the one God (Deut 6:4): he has no goddess by his side, no other god may be associated with him, none of the forces at work in the world may be considered divine, for if all things derive their existence from him, they do so from their condition as creatures.[3]

Thus Yahweh's pure religion banned the myths related to sexuality, as well as the rites of fertility, sacred prostitution, hierogamy and everything related to it.[4]

b. The sacred character of the union of man and woman according to Genesis 1 and 2

This radical desacralization of sexuality, nevertheless, implied a 'consecration' of the stable and fully human union of man and woman and, consequently, of the love relationship between the two within the religion of the covenant. This covenant also consecrated sexuality as a gift from God to man and woman in order to enable them to cooperate freely with him in communicating life to other human beings. This stands out clearly in the first three chapters of the Book of Genesis, a passage which contains the quintessence of the ideal of the human couple in the Bible.

First, the human couple is presented in the two accounts of creation, in Genesis 1 and 2, as the concrete and typical realization of humanity as willed by the creator. Of course, there is no question here of a pre-existent androgyne being subjected to a subsequent branching out. The narratives present the creator's plan of the two fundamental modes of human existence which be the feminine and the masculine modes, each fully human and, at the same time, correlative to the other.

According to Vogels, it seems that the decision of the compilers of Genesis, to place the Yahwist narrative after the priestly narrative, shows a will to make the more synthetic affirmation of Genesis 1:27 more explicit by using the detailed mythical narrative of verses 18-24 of chapter 2.[5]

The human couple, understood as the 'encounter' of two persons, one of masculine sex and the other of feminine sex, appears when the Yahwist narrator begins to speak of *îsh*, that is, of the masculine person receiving from Yahweh a similar helper, *îshâh*, the woman (cf Gen 2:18-24). Previously, there was only *hâ'âdâm*. Three points of prime importance must be made here. First, *hâ'âdâm*, mentioned before the creation of the woman and who is, so to speak, the generic human being, finds himself in a situation of communion with the Yahweh-God who created him in a first and fundamental covenant. The basic communion of the human being with God must come prior to any relationship between individual persons.

Secondly, the duality of human subjects is introduced with the gift of a similar helper (*ézèr kenègdô*). This expression in the Bible denotes something other than an assistance provided by a subordinate subject since at times the word *ézerî* (helper) refers to the help that God brings to men, for instance in Psalm 121:2. André Feuillet explains: 'The Hebrew term which expresses this idea is suggestive: it evokes the support that, by virtue of the covenant, God himself provides to the chosen people and to each of its members (Ex 18:4; Deut 33:7, 29; Ps 70:6; 115:9, etc.).'[6] The 'similar helper' is, therefore, an *alter ego* whose similarity of nature corresponds exactly to its partner.[7]

Thirdly, it is only at the moment he finds himself before *îshâh* that *îsh* becomes aware that he is a masculine human person; up to this moment, *hâ'âdâm* had been unable to find in any of the animals a mirror of the same nature who would reveal him his own identity. Hence his exclamation full of emotion, already foreshadowing the one expressed later by the young man to the young maid of the Song of Songs: 'This at last is bone of my bones and flesh of my flesh' (Gen 2:23a).[8]

Man certainly stands in wonder when he becomes aware of the close connaturality that exists between himself and the woman. However, this exultation is more than a statement of enthusiasm, as several exegetes have noted: 'Man proposes a pact to the one Yahweh presents to him, a pact in which he apparently commits himself more than in any other agreement between humans. And this pact involves his whole visible and tangible being'.[9] For the expression 'my bone and my flesh' (and here, the simple formula is amplified) is the classical wording used in the Bible to express an agreement among individuals (or with a group).[10]

The following remark made by the Yahwist author in verse 24: 'That is why a man (îsh) leaves his father and mother[11] and clings to his wife (îshâh), and the two of them become one flesh', confirms the fact that the conjugal bond of the couple is a commitment, a voluntary option. Moreover, the unity thus formed – 'one body' – in itself conveys much more than a carnal meaning. It is rather 'the conjugal union in all its fullness, that is, the commitment based on the fidelity and love of the man and the woman, a commitment that draws them closer than any other contract made among humans; it binds them to one another in every sinew of their being...'.[12]

This fidelity and this love, the basis of the commitment made by the man and the woman, aptly reproduce the point of view the Yahwist author has of the covenant in the whole of chapters 2 and 3. This is especially evident when he describes the tragedy of the fall. The breach introduced by sin between Yahweh and the first two human beings is a covenant breach and the cause of the curse cast upon the world; its repercussions are symbolized first and foremost by the conflict which erupts within the couple themselves. This state of things is the exact counterpart of the covenant unity that existed between Yahweh and humanity and within the couple before the fall. According to the Yahwist author, there is thus a continuity between the fidelity and love of the people for Yahweh, who brought them into being, and the ideal of a similar loving fidelity within the conjugal covenant of a man and a woman. And the covenant breach between the human person and

Yahweh is similar to the disharmony between man and woman.

This narrative thus brings out the communal and covenantal character of the human being typified in the couple where husband and wife help each other. This reciprocity springs from the covenant as well as from man's common destiny on earth. For in the narrative, the pair Adam (the collective *hâ'âdâm*) earth (*hâ'âdâmàh*) comes before the second pair: *îshîshâh*, Adam foreshadowing them in their relationship to the earth. In the view of the Yahwist author, the marriage pact is the symbol of a global human project similar to the one suggested in Genesis 1:27 which speaks of the couple as an image of God in the midst of his creation. Fecundity is an essential component of this pact but not the only one.

c. An overall view of the life of the people in relation to this ideal

We have seen that, in the creation narratives, the human experience of the couple in the midst of the people of the covenant is presented as a highly valued global one. In their turn, the historical writings usually present the couple as the solid nucleus in the collective enterprise of the family and the clan.

Of course, many fluctuations and deviations, which often had an impact on the matrimonial institution throughout the history of Israel, will have to be taken into account. This history, in fact, will always remain somewhat imprisoned within the socio-cultural framework of the times characterized by a lesser esteem for women often showing up in a form of double morality, one for men and another for women. There will also be problems raised by divorce and polygamy.

In spite of these shortcomings, however, one can say that the conjugal adventure of man and woman in the midst of the chosen people, is an integral part of the structure of the people and of their religious experience. In this way the conjugal unity of the couple will provide an allegory for Yahweh's relationship with his chosen people.[13]

d. Two key concepts: fidelity and love

A final observation must be made on the ideal view of the Israelite couple. We have pointed out that the unity of the couple was based on a commitment of fidelity and love. Brueggemann has stressed the prime importance of the idea of fidelity in Genesis 2:23a. And he explains what the relationship established by the matrimonial pact between man and woman consists in:

> First, the relation is grounded in shared concerns, loyalties, and commitments which are taken with seriousness. It is not a light, casual relation springing from a mood or a feeling. It is rooted in an oath of solidarity. Secondly, the real meaning of the relationship is found not in mutual enjoyment though that is not precluded, but in the stewardship of the earth. Human relations are set in a context where solidarity with and responsibility for the larger world are directly affirmed.[14]

But then what place is given to love in this relationship? The old patriarchal narratives give us some indication of the theme of love stealthily but surely insinuating itself in relationships as in Jacob's affection for Rachel. To be sure, at this time, the question of fecundity always predominates and is the reason why bigamy and polygamy are often practised. In the other historical books, the love of husband and wife for each other is occasionally mentioned. Nevertheless, it always takes a second place to that of a fruitful union.

However, at the time of the prophets, when nuptial symbolism applied to the relationship of Yahweh with Israel appears, the matrimonial pact (*bèrît*) is presented more often as 'closely linked with elements of the affective order: love, fidelity, fondness of the heart (*hèsèd*)'.[15] Besides, at this same time, the Sinai covenant (*bèrît*) itself was often expressed in terms of love by the prophets, a fact that surely helped to enhance the importance of the affective aspect of the matrimonial bond.[16]

In any case, it is certain that the affective substratum of the conjugal pact must already have been an established fact, as the experience of Hosea and, later, the allusion to Ezechiel's wife as the delight of the prophet's eyes, suggest. In these expressions, the 'heart' of each of these men appears to be deeply committed to the woman of his choice. It is from their affective experience that these prophets will gain an analogical understanding of the loving 'heart' of Yahweh. Because the value of the human love between man and woman could be enhanced in this way, as the Song of Songs also proclaims, such a love could very well become a favoured symbol of the *hèsèd* of Yahweh for his people. Thus the value of human love in marriage is not of secondary importance even if it is essentially linked with the basic idea of fecundity from the point of view of the Old Testament. For, ultimately, only a truly faithful, stable, fruitful love – barrenness being a symbol of the people's infidelity to the covenant – appears to be in conformity with the biblical ideal of marriage since such a love alone can be approximated to that of the God of the covenant.

2. Marriage and family in the early Church

The ideal of the human couple in the midst of the people of the covenant is, to a considerable extent, still the same among the Jews at the time of Jesus. The Hebrew concept of marriage will also shed considerable light on the Christian attitude to human fecundity. This is of some importance in understanding the theme of salvific motherhood. However, one must be aware of the radical innovation in the teaching of Jesus and the apostles, especially St Paul.

a. The attitude and teaching of Jesus

In the first place, what is striking about the teaching of Jesus is his radical opposition to the current discussions in

Judaism about the grounds justifying a divorce, of which man alone could be the initiator.[17] Jesus absolutely forbids man as much as woman to divorce and, as Jeremia notes, he fearlessly criticizes the Torah because it allows divorce on account of the hardness of the human heart (cf Mk 10:5). The same author adds that for Jesus marriage is so indissoluble that he considers the remarriage of divorcees, man or woman, as cases of adultery.[18]

When he proclaims the indissolubility of marriage (cf Mt 19:3; Mk 10:2ff), Jesus expressly refers to the text of Genesis 2:24, which we have already analysed. By doing this, he demonstrates that only such an ideal is in conformity with the will of God. The unity thus formed between a man and a woman excludes all ideas of polygamy.[19] At the same time, Jesus destroys at its roots the principle of a double morality, one applicable to the man and another to the woman. In other words, Jesus makes a stand against anything preventing the biblical ideal of marriage from being realized in all its purity.

But it is especially the new attitude of the Lord with regard to women[20] that could best promote the ideal of the couple. In the socio-cultural framework of the period, this attitude appears profoundly revolutionary. Indeed, the Lord's behaviour towards women is surprising. He welcomes them in his company and among his disciples,[21] he speaks freely to them, instructs them (as in the case of Martha and Mary – cf Lk 10:38-42; Jn 11:20-40). He lets them touch him,[22] heals them, calls them 'daughters of Abraham' (cf Lk 13:10-17).[23] He treats them in a natural and assured manner. And yet, his attitude could not but surprise. Certainly Jesus was not seeking to shock but he did want to say something essential. He was affirming a truth that would lead humankind to have a better understanding of the mystery of every person before God.

In fact, this message, as Le Guillou suggests, implies a complete change of perspective. In the community that Jesus regroups around him, 'there is a rediscovery of communion between man and woman, a communion that is essential to the apostolic proclamation of the Gospel.'[24] This rediscovered communion is the result of the new attitude Jesus has

adopted towards the class of abased persons that women are. This attitude challenges the monopolization of values by male hierarchies. Le Guillou demonstrates how 'Jesus, by looking on woman, freed her from the covetousness and the domination of man',[25] both within her marriage and in her human and Christian vocation.

Rudolf Schnackenburg emphasizes the respect that Jesus displays towards children in the scene where, in response to the request that he bless them,[26] he presents them to the disciples as models to imitate (cf Lk 9:47; Mt 10:40; Lk 10:16). Here we meet again the proclamation of the value of human life first encountered in the Old Testament.

On the other hand, we could believe that Jesus does not give much importance to fecundity or to motherhood since he hardly speaks of this vocation except to compare the hour of his death to the hour of child birth (cf Jn 16:21). Jesus even diverts attention away from the natural motherhood of his mother, without minimizing its value, in order to stress the importance of Mary's faith (cf Lk 11:27-28). These facts do not amount to a devaluation of human fecundity and of the family. The attention Jesus gives to children proves the contrary, as do his frequent references in his teaching to some aspect of family life. Rather, in the perspective of the kingdom, he places emphasis on the personal worth of the child, fruit of this fecundity, and on the prime importance of faith in life, in whatever vocation, including parenthood.

These last remarks lead us directly to another aspect of the teaching of Jesus: the subordination of the matrimonial state and of natural bonds to the fact of belonging to the new world. In a discussion with the Sadducees about the resurrection of the dead and the case of a woman who had had seven husbands (cf Mt 22:23-33), Jesus answers by showing that marriage and procreation belong to the order of the present world only. In the world to come, human beings, because they are immortal, will no longer need to procreate. Thus the human institution of marriage will be transcended.[27]

Three observations result from this point of view. First, far from devaluing marriage and family, this reference to the

kingdom adds a yet more serious touch to the present, as we have seen from the ethical demands made by the teaching of Christ concerning the indissolubility of marriage.

Secondly, Jesus gives an important place to virginity as a state of life 'because of the kingdom' (cf Mt 19:12).[28] This kingdom is the world to come, but 'with his coming (the coming of Jesus), the eschatological world, the world to come, has become present, though it remains unfulfilled.'[29] Like many other values emphasized by Jesus, virginity for the kingdom is destined to be a sign of his presence in the world to come as it is totally beyond the natural order of things now.

As a third consequence of his teaching, Jesus proclaims the importance of an attitude of radical liberty with respect to natural relationships. Every believer must be disposed to transcend the ties of blood when fidelity to Christ and to the will of the Father demands it. Besides, such was the case of the disciples, those 'converted Jews whose faith in Jesus had cruelly torn them away from their first environment and especially from their own families.'[30] Such is also the case of those who, in order to remain faithful to Christ, must suffer persecution (cf Mk 13:12).

> The break of natural ties is henceforth imposed upon Christians because of the lack of understanding and of the persecution existing even within families. This option we take on behalf of the 'kingdom of God', at the cost of the dearest of our affections, whenever our fidelity to Christ hangs upon such a decision.[31]

b. St Paul's teaching on marriage and the couple

St Paul's basic teaching about the institution of marriage echoes that of Christ, particularly on matters touching divorce, formally prohibited (cf 1 Cor 7:10-11) except when one of the spouses, a non-believer, refuses to live with the Christian partner.

For Paul, marriage essentially includes the exercise of sexuality as an integral part of the conjugal pact with the rights and duties which stem from it (cf 1 Cor 7:1-9). However, both partners undertake to be chaste (cf 1 Cor 7:3-4), to purify themselves continually by means of asceticism. Sexual disorders, for the Christian, are radically opposed to his belonging to Christ and to his body as a temple of the Holy Spirit, which such disorders would desecrate (cf 1 Cor 6:19-29). What is meant here is the taint of sin understood as an infidelity to God. For the New Testament, like the Old, does not speak of matter and flesh as being intrinsically evil. Briefly then, for Paul, the legitimate use of sexuality in marriage must be intrinsically related to fidelity to Christ and to the journey towards holiness.

In order to have a clear understanding of Paul's thought on marriage, it is essential to analyse the text of Ephesians 5:21-33, one of the highest points of his thinking on this question. However lofty the theological meaning of this passage might be, it nevertheless explicitly affirms that woman is subordinate to man, echoing other New Testament texts which express the same view.[32] We may ask ourselves if, from these texts, it is still possible to maintain that Paul held the same attitude towards women as Jesus did.

We must dwell rather at length on this passage of Ephesians 5:21-33 in order to clarify the problem we have just raised. This is necessary because this text is one of the choice instances where the conjugal symbolism is applied to the union of Christ with his Church. By analysing the Apostle's teaching on Christian marriage, beyond the difficulty in this text, we shall have a better perception of its full symbolic significance when we come to the fifth chapter of this book.[33]

Our section (Eph 4:1) introduces a more particular development; it borrows a traditional form to present a domestic code of ethics called *Haustafel Form* (domestic form) by the Germans. This form, probably pre-Christian, draws its inspiration from Jewish traditions and Stoic writings.[34] We can find other complete or partial examples of these forms in the New Testament, of which those of Colossians, Ephesians and the

First Letter of Peter are the most complete. These texts, in which the sacred writers quite freely use the basic scheme or some of its elements, offer precise exhortations to the Christians urging them to live according to certain standards so as to maintain order and harmony in the domestic society. A life lived in love, unity and peace welcomes the will of God into the relationships between spouses, between children and parents, and between slaves and their masters.

In comparison with the parallel text of Colossians 3:18ff, the *Haustafel* of Ephesians expands the part devoted to the spouses to a remarkable degree. Here Paul develops once again the doctrinal theme that lies at the heart of the letter: 'the saving action of Christ who has intimately united his Church to himself',[35] according to the mystery of his Father's will. Hence the possibility of detecting, in this passage, two overlapping levels of meaning.

A fact of prime importance must be established here. The ideal proposed converges on the unity at the heart of the whole section. It simply applies to concrete life the ideas presented in the first three chapters of the letter focused on the theme of unity in Christ and on a harmonious communion among the members of the Church.[36] The Apostle expresses this ideal of unity at the very beginning of his *Haustafel* in these words: 'Be "subject" to one another out of reverence for Christ' (v. 21). By having all the members of the community and of the domestic society practise such a reciprocal submission to one another, implying demands of detachment, meekness, humility, availability, the Christians translate into concrete terms the vertical dimension of Christian life mentioned in the previous verses: 'Give thanks to God the Father at all times and for everything in the name of our Lord Jesus Christ' (Eph 5:20).

From this overall view, Paul goes on to apply specifically to the wife the idea of submission expressed in a form of reciprocity in verse 21: 'Wives, be subject to your husbands as you are to the Lord. For the husband is the head of the wife just as Christ is head of the Church, the body of which he is the saviour. Just as the Church is subject to Christ, so

also wives ought to be, in everything, to their husbands' (5:22-24).

As Cambier notes, it seems that it is the word *kephalè* (the head) which forms the basis of the comparison between the submission of the wife to her husband and that of the Church to her head, Christ. In 1 Corinthians 11:3, Paul had argued in the same way in order to settle the question of order and harmony in the assemblies by prescribing, in conformity with the tradition, that women wear a veil when praying in the assembled community: 'But I want you to understand that Christ is the head (*kephalè*) of every man, and the husband is the head of his wife, and God is the head of Christ.' And further on he adds: 'Man ... is the image and the reflection of God; but woman is the reflection of man. Indeed, man was not made from woman, but woman from man. Neither was man created for the sake of woman, but woman for the sake of man' (1 Cor 11:3, 7-9).[37] According to certain exegetes, we can detect, underlying these lines, a reference to a sapiential reading of Genesis 3:16 recalling the idea of lordship of man over woman.[38] This reading also suggests a reference to Genesis 2:21-22 which, according to a Jewish and rabbinical interpretation, affirms the existence of a hierarchical order, willed by God, in creation. In other words, for an honest Jew, as Paul is, the first recommendation of the *Haustafel* asking the wife to be subject to her husband clearly corresponds to the divine plan of creation as revealed in the Yahwist text of Genesis.

Nevertheless, it must be noted how in this text, as in the text of 1 Corinthians 11:12, Paul, at grips with disciplinary problems and traditional behaviour, appears to be somewhat awkward in the development of his argument. That is understandable in view of the singular place women held in the Christian community with respect to the customs of the times and especially to the Jewish practices. But we see that Paul is thinking in somewhat more precise terms in 1 Corinthians 11 when he writes: 'Nevertheless, in the Lord woman is not independent of man or man independent of woman. For just as woman came from man, so man comes through woman;

but all things come from God' (1 Cor 11:11-12). His uneasiness reappears towards the end when he adds: 'But if anyone is disposed to be contentious – we have no such custom, nor do the churches of God' (11:16). It is this same need of precision that leads Paul, in the text from Ephesians, to make clear that submission of women must be exercised as an 'obedience offered to the Lord'.

We may then conclude that this text of Paul, like others elsewhere, bears the stamp of the socio-cultural framework of the period when harmony in the family was founded on the authority of the man and the subordination of the woman, with the ethical implications entailed in this structure. Thus, the conventions of the social structure of the times, corroborated by the Hebrew (and even the rabbinical) reading of Genesis 2-3, make Paul's exhortation for unity in the family sound normal. A similar convention will justify Paul when he urges slaves to obey their masters without questioning the objective value of this social institution, as we see in his Letter to Philemon.

But we may add that this conditioning brought about by the customs of the times must be transcended. Heinz Schurmann says: 'When the New Testament writers see the wife as subject to the husband..., we feel that the Holy Spirit has led Christians today, along with the contemporary environment, into a deeper understanding of the moral obligations of personal relationships.'[39]

Ephesians 5:25ff also offers another facet of Paul's thought on the subject: 'husbands, love your wives, just as Christ loved the Church and gave himself up for her... In the same way, husbands should love their wives as they do their own bodies. He who loves his wife loves himself.'

For Sampley, the verb 'to love' (*agapate*), the same as in the parallel text of Colossians 3:19, could also be part of the traditionally basic form of exhortation addressed to husbands as is the case for the submission of woman.[40] Moreover, the same author suggests that, as the exhortation to submission addressed to women is based on a reading of Genesis 2-3 (and especially of 3:6), the exhortation to love could also be based

on a text of the Old Testament, in this case, on Leviticus 19:18 translated as follows by the Septuagint: 'You shall love your neighbour as yourself'.[41] For to love one's wife and to love one's own body or one's own flesh – especially in the conjugal context in which the two have become one flesh – is somewhat identified with the precept of loving one's neighbour as oneself (the husband's nearest neighbour being his wife).

Moreover, by proposing the attitude of Christ, head and spouse of the Church in the very act of giving his life for her, as a model for the husband to imitate, Paul shows that the authority of the husband over his wife is one of service and sacrifice. This is all the more obvious for, in Paul's view, the husband is certainly not the 'saviour of woman'. The New Testament always lays much enphasis on these qualities of being humble, obliging, loving, which should be those of all authority claiming to exercise itself according to the will and example of Christ. Thus, the ideal suggested to the husband introduces into the view of the world order that Paul had inherited a transforming ferment similar to the one that was to be at work in the Church and society based on the counsels of Paul to Philemon concerning his slave Onesimus, now a 'brother'.

However, there is more to this. Just as verse 21 extended the attitude of submission expected from the wife in verse 22 to all interpersonal relationships, so Paul had already suggested that love in self-surrender expected from the husband in verse 25 was to be a fundamental attitude for all Christians: 'Therefore be imitators of God, as beloved children, and live in love, as Christ loved us and gave himself up for us, a fragrant offering and sacrifice to God' (Eph 5:1-2). Consequently, as in any ecclesial community, order and harmony in the conjugal association demands as much a submission of the husband to his wife as it does of the woman to her husband in their common search for the will of God, as a mutual love-gift even if, in the text of Ephesians 5:22-33, because of the customs of the times, submission was demanded more from the woman and the love-gift more from the husband.

We can then say that the ideal of unity in reciprocal submission, in mutual love, in humility and meekness, suggested by Paul to the Christians living in a domestic society, holds priority over his conception of a world order where a functional hierarchy of subordination of women with respect to men would be established as a fixed divine order of creation.[42] At the same time, it must be affirmed that the heart of Paul's message to spouses, when shorn of the characteristics of the times, is intrinsically marked by Ephesians 5:1-2 and 21, texts of prime importance to which this teaching on the couple is linked. By the very same fact, Paul asks married Christians (as he asks children and slaves) to realize fully among themselves the ideal of communion.

Such an ideal of communion supposes a diversity of gifts and functions (cf Eph 4:11-16) as much within the domestic society as in the whole Church. This variety in equality is the opposite of all egalitarian levelling. Within the Christian couple, man and woman are expected to fulfil their personal vocation of husband and wife, of father and mother according to the gifts received from the Spirit. Like any other sacred writer, Paul too does not find fault with the traits of this diversity. As in the case of any personal gift, it is a matter of using particular abilities given for the good of all.

Briefly, Ephesians 5:22-23 opens onto a global view of the Christian marriage and of the communion implied. This is one of the loftiest ideals for which the transforming presence of the grace of Christ within the couple is necessary. Modern interpretation allows us to find in this passage, beyond the letter of the word, an invitation extended to the spouses urging them to express towards each other something of the attitude Christ has for his bride, the Church, as he invites them to reproduce the faithful response of the Church to her bridegroom. Indeed, such an ideal not only helps to make this conjugal society a privileged setting for an authentic Christian life in the midst of the people of God, but it becomes the symbol, in the union of the spouses, of the very mystery of the union of Christ with humankind in the 'person' of his bride, the Church.[43]

A final word is necessary to show that, in Paul's writings, the perspective of the synoptics, linking the importance of conjugal life to the eschatological world towards which the community of disciples is directed, is again found in its full integrity. Paul also takes up, without depending directly on the gospel tradition (cf 1 Cor 7), the theme of virginity for the kingdom. The imminence of the eschatological end is the predominant theological preoccupation in these reflections. Some Christians may be called to live now according to the world to come, proclaiming the theological (not the historical) nearness of the parousia. Surely, Paul does not expect everyone to choose this vocation which, like marriage itself, is a call and a gift from God (cf 1 Cor 7:7). In fact, in virginity is proclaimed and already mysteriously inaugurated the integral surrender of the baptized person to Christ, the bridegroom of the Church (cf 1 Cor 7:34).

The concept of marriage and family, which is the same in the early Church and the Old Testament, this ideal reaches its total fulfillment in Christ. This is conveyed especially by proclaiming the unity and indissolubility of marriage and by affirming the basic equality of man and woman bound to each other by the same fundamental moral obligations. It is on these grounds that marriage is the sign of the nuptials of Christ with the Church.

NOTES

1. We base ourselves especially on the conclusions drawn by Pierre Grelot in his study, *Le couple humain dans l'Écriture*, new ed. with additional studies in appendix, Paris, Cerf, 1964, especially pp. 15-69.
2. The Gospel alone develops all the ethical demands derived from the sound principles established by the religion of the covenant in matters pertaining to marriage and human sexuality. It is especially in Matthew 19 and in the parallel texts that Christ 'completes' the implications of divine Revelation concerning the reality of marriage.
3. Grelot, *op. cit.*, pp. 26-27.
4. Cf. *ibid.*, pp. 27-28. The author points out that this process of desacralization was gradual and was often interrupted by setbacks, especially among the masses. It is precisely against such relapses that the prophets fought.

5. Cf Walter Vogels, 'It is not good that the "Mensch" should be alone; I will make him/her a helper for him/her (Gen 2:18', in *EgT*, 9 (1978), pp. 25-26. In this analysis, we follow first the study made by Vogels and also two other studies which converge on the first: Walter Brueggemann, 'Of the same flesh and bone (Gen 2:23a)', in *CBQ*, 32 (1970), pp. 532-542; Maurice Gilbert, '"Une seule chair" (Gen 2:24)', in *NRT*, 110 (1978), pp. 68-89.

6. In 'Le triomphe de la femme d'après le Protévangile', in *Com*, 3 (1978), p. 9.

7. Cf John Paul II, *Original unity of man and woman: Catechesis on the 'Book of Genesis'*, Boston, St Paul Editions, 1981, p. 68, note 5.

8. This link between Genesis 2:23a and the enthusiasm expressed in the Song of Songs has been pointed out by the Pope: 'The concise text of Genesis 2:23, which contains the words of the first man at the sight of the woman created, "taken out of him", can be considered as the biblical prototype of the Canticle of Canticles' (*ibid.*, p. 71).

9. Gilbert, *op. cit.*, p. 71.

10. See, for instance, Gen 37:27.

11. According to Gilbert, this shift in situation would not be, as certain writers claim, the sign of 'a reminiscence of a primitive matriarchate', since 'clinging oneself to' does not mean to change one's dwelling. This would apply to the passage into adult life and to the establishment of a new relationship (*ibid.*, p. 73).

12. Gilbert, *ibid.*, p. 88.

13. This is what Albert Gelin affirms in *Hommes et femmes de la Bible*, Paris, Ligel, 1962, pp. 212-213.

14. Brueggemann, *op. cit.*, p. 542.

15. Grelot, *op. cit.*, p. 48.

16. Cf *ibid.*, pp. 48-49. See also Albert Gelin, 'Le rôle de la famille dans la sanctifiction de l'humanité d'après la Bible', in *AC*, 63 (1953), p. 548.

17. We might recall the discussion between the disciples of Rabbi Shammai and Rabbi Hillel concerning the grounds for divorce (cf. Joachim Jeremias, *Jerusalem in the time of Jesus: An investigation into economic and social conditions during the New Testament period*, translated by F. H. and C. H. Cave, London, SCM Press Ltd., 1969, pp. 359-376.

18. Cf *ibid.*, p. 376.

19. Polygamy still existed in Jerusalem at the time of Jesus (cf Jeremias, *op. cit.*, p. 369, note 54).

20. On this question, see Karl Hermann Schelkle, *The Spirit and the bride: woman in the Bible*, translated from the German by M. O'Connell, Collegeville, Minn., Liturgical Press, 1979, especially pp. 143-160, which appears to be a good presentation of the essential facts; also Jean-Thierry Maertens, *The advancing dignity of woman in the Bible*, translated by Sandra Dibbs, De Pere, Wisconsin, St Norbert Abbey Press, 1969, especially chapter 4, 'woman in the New covenant', pp. 133-155.

21. There appears to be an evolution from Mark to Matthew and especially from Matthew to Luke in the allusions made to the presence of women. This presence of women in the company of Jesus is especially pointed out by Luke. About these parallels, see also Maertens, *op. cit.*, p. 145.

22. The evangelists point out the fact that he lets the haemorrhagic woman

touch him in spite of the ritual impurity that such a contact entailed according to the prescriptions of the law (cf Lk 8:43-48). But above all, he allows a woman of loose morals to touch him, hence Simon's indignation (cf Lk 7:36-50).

23. Schelkle notes, when speaking of the title of 'daughter of Abraham', that this was 'a very unusual way to speak of a woman. Israelite men liked to be called "sons of Abraham", but rabbis applied the title "daughter of Abraham" only to the Israelite people as a whole. According to this statement of Jesus, women were members of the people with the same rights as men' (*op. cit.*, pp. 145-146). As for Maertens, he considers this cure and these words of Jesus as a true call to become a full-fledged member of the (synagogal) assembly (*op. cit.*, p. 147). Luke thus notes the full participation of women in the new Qâhal (assembly) convened by Jesus.

24. Joseph Le Guillou: 'The Novelty of the evangelical outlook on woman', *The Church and the International woman's Year*, Pontifical Council for laity, Rome, 1976, p. 90.

25. *Ibid.*, p. 91.

26. Rudolf Schnackenburg, *The moral teaching of the New Testament*, translated by J. Holland-Smith and W.J. O'Hara, Montreal, Palm Publishers, 1965, p. 140; also Schelkle, *op. cit.*, pp. 75-76.

27. An excellent theological study concerning the implications of this pericope is presented by Pope John Paul II in his Wednesday audiences from November 1981 to June 1982, in *The theology of marriage and celibacy Catechesis on marriage and celibacy: in the light of the resurrection of the body*, Boston, St Paul Editions, 1986, pp. 1-138.

28. On this pericope, see Jacques Dupont, *Mariage et divorce dans l'Évangile*, Bruges, Desclée de Brouwer, 1959, pp. 161-222.

29. Lucien Legrand, *The biblical doctrine of virginity*, London, Geoffrey Chapman, 1963, p. 41.

30. Simon Légasse, *L'appel du riche, contribution à l'étude des fondements scripturaires de l'état religieux*, Paris, Beauchesne, 1965, p. 210.

31. *Ibid.*, p. 91.

32. Cf Col 3:18ff; 1 Cor 11:3-16; 1 Cor 14:34-38 (to which may be added 1 Tim 2:8-14, as well as certain other writing of the New Testament where there is question of domestic morality: 1 Pet 3:1-7; Tit 2:5).

33. For our analysis of this text from Ephesians 5:21-33, we refer especially to two studies. The first is by Jules Cambier, 'Le grand mystére concernant le Christ et son Église. Éphésiens 5:22-33', in *Bib*, 47 (1966), pp. 43-90 and 223-242. The second reference is the book by John Paul Sampley, *And the two shall become one flesh*, London, Cambridge University Press, 1971, p. 177. Other references will be mentioned as we proceed.

34. Cf Sampley, *ibid.*, pp. 17-30 and Cambier, *ibid.*, p. 61.

35. Cambier, *ibid.*, p. 48.

36. Cf Pierre Benoît, 'L'Unité de l'Église selon l'épître aux Éphésiens', in *Exégèse et théologie*, III, Paris, Cerf, 1968, pp. 335-357.

37. See the interpretation by André Feuillet, for whom the expression 'reflect' used here contains a very positive meaning; its sense is akin to the idea of honour, in 'L'Homme "gloire de Dieu" et la femme "gloire de l'homme"', (1 Cor., XI, 7b)', *RB*, 81 (1974), pp. 161-182.

37

38. Cf Cambier, *op. cit.*, pp. 49-50.
39. Heinz Schürmann, 'How normative are the values and precepts of the New Testament? A sketch', in *Principles of Christian Morality*, San Francisco, Ignatius Press, 1986, p. 40.
40. Cf Sampley, *op. cit.*, pp. 28-29.
41. *Ibid.*, pp. 30-34.
42. Cf Maximilian Zerwick, *The epistle to the Ephesians*, London, Burns and Oates, 1969, pp. 153-154.
43. It is from there that the understanding of the sacramental meaning of Christian marriage is developed.

Chapter 2

The bridal symbolism
in the Old Testament

Among all the nations of the earth, God gave himself a people destined to be his own in a unique way. This is the mystery of the covenant. In order to describe the closeness that this covenant brings about between Israel and its God, the prophets made use of an analogy particularly rich in meaning: the nuptial analogy.

1. Origin and development of the nuptial symbolism in the Old Testament

a. Origin and first developments with Hosea

Israel was chosen by Yahweh to serve in the realization of his salvific design for all nations. The people received this vocation from God alone. God, Yahweh, is the one who took the initiative of choosing, guiding, liberating, educating, purifying his people. He alone established the basic coordinates of the covenant relationship between Israel and himself. Moreover, he alone made himself responsible for the ultimate realization of salvation, the people itself forever undergoing the painful experience of its inability to understand and follow faithfully the path of this God who first loved Israel.

It is in this context that, in the eighth century with the prophet Hosea, the nuptial allegory 'suggesting the love of God and of the chosen people in an original and profoundly

lyrical form'[1] appeared for the first time. The prophet, in obedience to God,[2] took for his wife a young girl (Gomer) who had probably been involved in sacred prostitution. It is through the painful relationship with his wife, forever tempted to prostitution and infidelity, that the prophet is led to experience what the wounded love of Yahweh for his chosen people might mean. For this people is also constantly at grips with the temptation of infidelity and the failure to recognize the true nature of its belonging to its God.

It is important to bear in mind this deep-rootedness of the marriage symbolism in the prophet's experience in order to understand why its use is so significant. With the settling in Canaan, with the evolution of the society in an agrarian context,[3] especially from the outset of the royal period, the danger of the neighbouring polytheistic cults weighed heavily on Yahwism. The prophets were continually confronted not only with the necessity of extirpating the worship of false gods from Israel, but also with the urgency of 'debaalizing' Yahwism by severely condemning all forms of syncretism.[4] In greater depths, as Évode Beaucamp shows, the problem for the prophets was to instil in the people a true notion of its relationship with God in a world where orgiastic rites to placate Baal were quite common.

> Was Yahweh to be considered as a *baal*, that is, as the owner of the land, the fertilizer of the soil, the provider of food for man and beast, or as a 'loving will', summoning his people to let itself be guided by what he desired? In the first case, the chosen people would have done enough, under the cover of the name of their God, to ensure salvation by observing the ritual and ceremonies designed to obtain a renewal of the forces of nature. In the second, there could be no other religion for Israel but a response through obedience and fidelity to the will of the God who loved them.[5]

In denouncing the contamination of the religion of Israel by its adoption of the cults and customs of the neighbouring

pagan nations, Hosea, and the other prophets in his wake, insistently affirmed the unique originality of the religious experience of the chosen people with the demands of absolute faith it supposed. Without that, the people would reduce Yahweh to be no more than a force of nature or a national king[6] whose favours must be won for assuring their prosperity and happiness.

Having recourse to conjugal symbolism to denounce this wayward path would better transpose the language of the covenant to the register of a love contract. If this covenant is a social pact dependent upon the will of Yahweh, the only one able to make the descendants of the 'wandering Aramaean' his very own people, this pact takes on at the same time the traits of a betrothal, a marriage. Yahweh has created a people for himself so that it may be his bride. As happens in Hosea's personal experience, the infidelity of the espoused people cuts the bridegroom's loving heart to the quick; he is hurt, so to speak, by the adultery (the sacred prostitutions, the idolatries) of the one 'who forgets everything she has received'.[7]

Hosea's subsequent development of the allegory will map out the stages in this history of love, always culminating in the triumph of the merciful, salvific tenderness of the bridegroom. These stages, always more or less explicitly present in the ultimate use of this symbolism, are the following: 'apostasy of Israel (in terms of prostitution, adultery), punishment by Yahweh, repentance of Israel, forgiveness by Yahweh (in Ezekiel the actors succeed each other; instead of an alternate rhyme, there is a crossed rhyme, forgiveness immediately following punishment and preceding repentance).'[8]

b. The development of this symbolism after Hosea

Later, the prophet Jeremiah will take up the nuptial symbolism once more 'in order to oppose the betrayal and the corruption of Israel to the eternal love of God for his people'.[9] However harsh the accusation made against the people may be, the message that Jeremiah, like Hosea, wants to convey

clearly is that at the heart of the present and future upheavals, Yahweh, the one, the holy, remains the loving bridegroom, close to his people through kindness, loving tenderness. But there is something obscure in this nearness. Indeed, the prophet recalls the symbolism, first to remind the people of the past wonder of the betrothal in the desert and of the loving response Israel then gave to God, her bridegroom (Jer 2:2). But, later on, the obduracy of the people (Jer 13:27), in spite of the appeals made by Yahweh to his rebellious bride (cf Jer 3), provokes the prophet to use harsher and harsher words: Israel is called 'a virgin' (Jer 18:13), an expression which, in the context, is synonymous with barrenness, sterility. Finally, the hopeless situation of Israel and Judah makes the two kingdoms appear as widows (Jer 51:5). If, in Hosea, the message of forgiveness and the renewal of relationships complete his allegory of the conjugal love of Yahweh for Israel, it is not so for Jeremiah. Even if he does proclaim the eternal character of God's love for the chosen people (31:3) and foretells the ultimate forgiveness, the new covenant through the transformation of the heart (32:4 ff), yet he never expresses this change in terms of a renewed conjugal bliss, as the Deutero-Isaiah will do later. It is as if, in Jeremiah, the jealous love of Yahweh does not allow the unfaithful bride to make light of the required conversion through the transformation of the people's heart by God.

Besides, something of this paradox is part of the very life of the prophet who is forbidden by the jealous Yahweh to take a wife (Jer 16:2). This mysterious 'celibacy', absolutely unprecedented in the Old Testament, was to be as eloquent a sign for Israel as had been the conjugal misfortunes of Hosea. Jeremiah's solitude was to predict the desolation of Israel and the impending ruin of Sion, a necessary journey towards an ultimate conversion. Moreover, as Lucien Legrand points out: '...it was his tragic destiny to anticipate in his existence and signify by his own life the terrible fate of the "Virgin of Israel". "The Virgin of Israel" was soon to undergo the fate of Jephthe's daughter, to die childless, to disappear without hope.'[10] Jeremiah's tragic experience evidently shows that

the nuptial relationship between Yahweh and his people was no idyllic venture.[11]

Chapter 16 of the Book of Ezekiel[12] is entirely constructed around the use of the conjugal symbolism. The story of Israel is told by recalling the mystery of the love of Yahweh wooing his bride, Jerusalem (symbol of the chosen people). The prophet thus describes the various stages of this love relationship: birth and choice of Jerusalem (vv. 3-6), puberty (v. 7), betrothal (v. 8), marriage (vv. 8-14), infidelity and prostitution (vv. 15-35), chastisement (vv. 35-44), and mysterious restoration (vv. 53-63).[13]

In this allegory, the gratuity of God's love stands out all the more forcefully because such harsh words are used: 'Israel was nothing but an abortion, an abandoned fruit of bastardy, when God met it and took a fancy to it. Its infidelities were only a consequence of such sullied origins.'[14]

We must also note that chapter 23 of Ezekiel lays more stress on the abominable infidelity of the people mentioned in chapter 16 and on the violence of the chastisement inflicted by Yahweh. In spite of the fact that nuptial symbolism is not referred to directly in chapter 23, it is implied since Oholah (Samaria) and Oholibah (Jerusalem), these 'two women, daughters of the same mother' (v. 2), recall the two historically divided kingdoms which are, nevertheless, united since they both belonged to Yahweh. Their infidelity – and especially that of the Kingdom of Judah, still more abominable than the infidelity of Samaria – attracts a chastisement which is a radical purification, not necessarily a restoration.

On the other hand, in chapter 16, because everything depends on divine gratuity, the symbolic narration shows how 'the love of God, in spite of everything, will ultimately prevail. God will forgive everything, and the new covenant, the fruit of his forgiveness, will be eternal.'[15]

Indeed, in this triumph of God's forgiveness for the sake of his holy name (36:22), and also to the shame of the unfaithful wife (16:62) and especially of Jerusalem, the people will see a remarkable extension of its vocation as a consequence of its marriage to God. However, this will not come about

because of its situation as a people, but because of the absolute fidelity of the one who chose and renewed it: '... the bride will become a mother, in the sense that the other nations, her sisters, like the younger Samaria or the older Sodom (who also had been unfaithful but who, until then, never had the light of hope) will become her daughters in the faith'[16] (Ezek 16:53ff).

It is the same destiny of rehabilitation and fecundity sung in tones of overwhelming tenderness that the Deutero-Isaiah takes up again in the Book of Consolation of Israel (especially chapter 54) and also in the two passages of the Trito-Isaiah (chapters 60 and 62).

For the Deutero-Isaiah,[17] the ordeal of the exile has brought about a radical transformation in the religious experience of the people. This transformation has confused the understanding that Israel had until then of God's sovereignty over history and more specifically over the destiny of his people which he crushes, kneads and remoulds as the need may be. Because he is the 'creator', he alone can direct history to its conclusion. Israel, through the voice of the anonymous prophet, now knows that 'the creature can do nothing but abandon itself completely in the hand of the creator who made it, all other guarantees having proved to be futile.'[18] In this new context and with these unprecedented overtones, the reference to the love of Yahweh, the bridegroom, for Israel, assumes new intensity and openness. The great pardon granted after the phase of chastisement entails the resurgence of life precisely where there was only death. Such is, therefore, the message of salvation addressed to Jerusalem in chapter 54, as it is summed up in a note from the *TOB*:

a. barren, she will be the mother of innumerable descendants (vv. 1-3);

b. widow, she will be wedded again by the Lord (vv. 4-6);

c. abandoned, she will be restored in the covenant which, from God's point of view, is indefectible (vv. 7-10);

d. dismantled, she will be rebuilt in magnificence (vv. 11-12);

e. oppressed, she will henceforth be protected from all attacks and will be able to live in peace, attentive to the voice of her Lord (vv. 13-17).[19]

This 'resurrection' of the bride performed by her husband-creator[20] (Is 54:5), her Redeemer, is the fruit of this indefectible love of God, also sung by Jeremiah, for which the chastisements themselves were but a necessary transition, a return to the desert, as Hosea had already expressed (Hos 2:16): 'For a brief moment I abandoned you, but with great compassion I will gather you. In overflowing wrath for a moment I hid my face from you, but with everlasting love I will have compassion on you, says the Lord, your Redeemer' (Is 54:7-9).

The description of this metamorphosis of the bride effected by the 'gratuitous and faithful, immeasurable and eternal'[21] love of the husband foretold by the Deutero-Isaiah, is taken up again in terms akin to those of the Trito-Isaiah (chapters 60-62). Resplendent in the glory of Yahweh, Jerusalem is presented as a complete fulfilment of this vocation of being a light for the nations, a vocation to which she was destined by her election, in a kind of expanded and unforeseeable maternity, as was already suggested in chapter 54 verses 1-3. At the same time, the tenderness, the mutual joy of the period of first love, of which Jeremiah and Ezekiel spoke, are revived in all their first fervour: 'For the Lord delights in you, and your land shall be married. For as a young man marries a young woman, so shall your builder marry you, and as the bridegroom rejoices over the bride, so shall your God rejoice over you' (Is 62:4-5).

This conclusion is proclaimed through the emphasis placed on one aspect of the nuptial symbolism, the theme of the Messianic espousals. The purification of the bride, her transformation, the days of delight promised to the lovers, are like a renewal of the first commitment in the desert. Or more precisely, the days of the first love in the desert were like the betrothal, the eschatological Messianic era being indeed the time of the espousals. The period of the eschatological

Messianic nuptials is therefore clearly outlined by the prophecy of the total union of the bridegroom with the bride.[22]

c. Two controversial texts: the Song of Songs and Psalm 45

In calling to mind the theme of the nuptial symbolism one must point out two Old Testament texts in which the presence of this symbolism is recognized: the Song of Songs and Psalm 45. Is the book of the Song of Songs in itself an application of the nuptial love symbolism to the relationship of Yahweh with his people? Such an interpretation has existed ever since the beginning of the Christian era. Moreover, the testimony of Rabbi Aqiba, at the end of the first century after Christ, shows that at that time an allegorical interpretation of the Song of Songs was current since[23] Judaism saw in it a song celebrating the loving relationship of Yahweh with his chosen people. Writers of the Christian tradition, especially since Origen, quite unanimously identify the allegorical interpretation to be its first literal meaning.[24] The symbolic interpretation has, nevertheless, been questioned by some early authors, by Theodore of Mopsuestia among others. Today, a good majority of the exegetes, even among Catholics, also challenge this first allegorical interpretation of the Song.[25] A fact to be noted is that three recent editions of the Bible *TOB: Ancien Testament, La Bible Osty*, and *The New Jerusalem Bible* unanimously affirm that this book is, in its first literal sense, a collection of songs celebrating 'the loyal and mutual love that leads to marriage. The Song of Songs proclaims the lawfulness and exalts the value of human love; and the subject is not merely profane, since God has blessed marriage, which is here understood not so much as a means of procreation but as the affectionate and stable association of man and woman'.[26]

It is on the grounds of a natural reality integrated into the project of the covenant by the will of God that such a human love between spouses may become a sign of this same covenant between God and the world. It is to such an allegorical

interpretation that tradition, both Judaic and Christian, has given serious attention. Besides, there is nothing to tell us in an absolute way that this allegorical interpretation has not influenced the last compilers of the Old Testament who incorporated this book into the canon of scriptural writings. Several exegetes hold the view that this symbolic spiritual interpretation could be its full literal sense. For others, the first literal meaning could have a typological value with regard to the union of Yahweh/(of Christ) and of his people/ the Church. That is why, in the parts concerning the conjugal symbolism in the Old Testament, one must take into account the symbolic interpretation of this book.

As for Psalm 45 which sings of the wedding of a king and a princess, probably a foreigner, its first allegorical meaning is not more evident. According to Beaucamp, there are very strong indications that this psalm is about the wedding of Ahaz with the princess of Tyre, Jezebel.[27] In time, the first recipients of the *epithalamium* were forgotten but the lofty ideal outlined for the king, Yahweh's vassal, remained, even after the fall of monarchy. That is why the psalm will eventually be reread in the perspective of the nuptials of the kingdom: 'nuptials of Yahweh with Israel for the synagogue, nuptials of Christ and his Church for the early Christians... Finally, we will see, in the foreign bride, the sinful humanity that the victorious Christ will wed by converting and purifying her in his blood.'[28] One simple fact must be kept in mind: a psalm celebrating a royal wedding and disclosing the programme outlined for the king and the queen in a lyrical mode of expression could have come to signify the nuptials of Yahweh with Israel, as was the case for the Song of Songs.

Even if the royal Messianism was important in the perspective of Israel's expectations, this people does not seem to have anticipated the coming of a future ideal king in the prophetic context of nuptial symbolism. In the Old Testament, the Messiah is never identified as the bridegroom of Israel, for the latter is always Yahweh. Besides, the prophets generally compare Yahweh himself to a bridegroom without ever naming him as such except in the later text of Isaiah 54. Thus,

47

the identification of this royal nuptial psalm as a typically Messianic psalm must be put on hold until the New Testament era.

2. The theological significance of this symbolism

a. A symbolism among others and in harmony with them

We may now attempt to determine the theological significance of this symbolism in the Old Testament. Appearing at a very precise moment and context, this symbolism is only one means among others used to illustrate the relationship of the God of the covenant with his people. Other symbolic pairs will fulfil the same function as, for instance, the pairs 'father-child', 'master-servant', 'king-subject', etc. By taking into account the motives that led the prophets to resort to this mystical imagery, we can better understand what this symbolism has in common with the others and what its distinctive aspects are.[29]

In all the images used to depict the covenant relationship, the element of distance between the two terms, God and the people, always remains the same. The first term takes on an absolute value, an ineffable character through the transcendence of the one to whom it is applied.[30] Consequently, even if that aspect does not stand out as obviously in the second term, the radical dependence of the subject in its relation with God is always implied: the wife, the child, the servant, the subject, the creature exist only through Yahweh, the spouse, the father, the master, the king, the creator. For he alone draws Israel into existence, guides it, saves it; the people can have no hold on its God. As a result, the designation used by the sacred writers for each of these pairs always implies the infinite gap that separates the creator of Israel (and of all humankind) from the creature (Israel, each person, and ultimately all creatures). But, at the same time, all these writers want to emphasize the gratuitous nature of Yahweh's choice of the people; his *hèsèd we èmèt* (tenderness

and fidelity)[31] are manifested in precisely wondrous ways through his creating and saving presence *in* the life and *in* the history of his people. This is even the heart of the particular experience of Israel for whom God is not a hostile power but the personal Living Being who is love and who intervenes with kindness in the history of the very ones he has created.

Correlatively, these ways of speaking about Yahweh demonstrate – as a progressively established fact and always insofar as the people has remained loyal to strict Yahwism – that Israel understands the radical difference between its own perception of God and that of the neighbouring polytheistic nations. In most concrete terms, especially in the preaching by the prophets, not only is there a rejection of all forms of idolatry, but Yahwism also refuses to imagine Yahweh as one of the many gods of the neighbouring peoples, often of one particular sex – male gods, goddesses – having relationships which imitate those of humans and display similar 'passions'. Even if the prophets use anthropomorphisms, they constantly introduce corrective details which allow us to have an increasingly clearer idea of the transcendence of a God who is forever beyond our 'grasp'.

If all the pairs mentioned above always fundamentally suggest such a perception of Yahweh in relation to his people, what particular teaching may be derived from the use of the spousal symbolism?

b. The theological peak of nuptial symbolism

The revelation of the 'heart' of Yahweh: what characterizes the biblical use of the nuptial theme is what we could metaphorically call the feelings of the heart of God, for his bride, Israel, in his 'spousal' commitment. In the same way that the conjugal pact between man and woman is founded on fidelity and love, so is Yahweh's *hèsèd we èmèt* constantly bursting forth through his creating and saving presence in the life and history of this humble nation he has given himself to

make it his associate in his plan of salvation. And if this wedded people is time and again confronted with its own infidelity and betrayal of the one who has chosen it, Yahweh's unshakable loyalty shines all the more brilliantly.

— *The emphasis placed on the rapprochement implied by the covenant.* From what has been said already, we see how the nuptial symbolism, more than the other symbols relating to the choice of Israel and the mutual relationships established by the covenant, emphasizes in quality and intensity the assertion made about the rapprochement between the two contracting parties. For this symbolism essentially refers to the union between man and woman leading to a full mutual 'knowledge', and of which carnal union is the type par excellence. In this perspective, the prophets seem to wish to lay emphasis on the objective pursued by God through the covenant, that is, the restoration of the original communion, destroyed by sin, between himself and humanity. No image could illustrate so forcefully this purpose of the history of salvation since the Yahwist author himself in Genesis 2, as we have already seen, establishes such an intrinsic bond between, on the one hand, the first communion between Yahweh and humankind and, on the other hand, the harmonious and complementary union of *îsh* and *îshâh* emerging from the hands of the creator.

An important clarification must be made here: this symbolism, illustrating the rapprochement between God and the people, considers the latter as a collectivity, or better still, as an organic whole forming one moral personality. Therefore, as Néher points out, the biblical use of the nuptial symbol must not be understood within the perspective of the Hellenistic mysticism whose main concern was the intimate union of the individual soul with the divine.[32] Nevertheless, this does not rule out the responsibility of each member of the people expected to live in the love of its God and in fidelity to the conditions laid down by the covenant. For the infidelity of the bride, Israel, is none other than the infidelity of its members and, above all, of its leaders.

If conjugal symbolism brings out in a significant way the

rapprochement with humanity pursued by Yahweh, it does not do so by suppressing the distance between the two, no more than the rapprochement between man and woman suppresses the radical distinction between the two subjects. In fact, in the case of the communion between two human individuals, the distinction remains, and must even be safeguarded, in order that there may be an encounter and a commitment between the persons – the symbol of the conjugal love operating by its very nature, between partners who are equal, according to Néher's expression.[33]

When applied to the relationship between God and creature, this difference can be identified with the infinite gap between the two 'subjects'. The fact that, in this case, the bridegroom is transcendent with respect to his bride, that he is the one who takes the initiative in all things, is not derived from the spousal symbolism as such, since its peak is the initiative of love in view of the rapprochement and of the communion which gives the bride her true dignity. This essential inequality stems from the faith of Israel who knows that Yahweh transcends all things and that human beings exist and grow only through him.

Nor is the idea of rapprochement unrelated to the idea of fecundity. Nevertheless, this last idea is always used metaphorically. The union between Yahweh and Israel is the one that sets up the covenant and pursues the goal of a fundamentally ethical transformation of the people. The resulting fecundity is this realization of the will of God made possible by the full participation of the members of the people in the holiness of its bridegroom. Consequently, there are no traces here of any hierogamic myth.

Symbolics illustrating the dialectics of history; its movement: the conjugal symbolism, which reveals the 'heart' of God in his love for humanity, describes the mystery of salvation especially from the angle of historical dialectics centred on the call to fidelity and love. Hence a third theological meaning, that of 'expressing history', of interpreting its movement.[34]

For, as Néher explains:

The conjugal symbolism does not imply only a covenant, that is, a communication between two beings, but a true dialectics of the covenant, since the latter binds two beings who remain necessarily different, as sexual individualities, and who are perpetually alike through the identity of the love they experience for each other. This movement or, if we prefer, the dramatic character of the conjugal symbolism appears to me as the decisive factor in the prophets' adoption of the symbol.[35]

We see that the nuptial imagery always looks back, as a starting point for the relationships between spouses, upon the same origin in time, the conjugal pact concluded in the desert. Moreover, the allegory projects these relationships towards a common future, the one committing the people to remain faithful to Yahweh's design, but especially towards the eschatological future where, beyond infidelities and purifying chastisements, God's faithful love will bring about the perfect transformation of the bride. Thus, the nuptial symbolism goes back to the linear concept of time, a typical Hebrew view of history,[36] and even places greater emphasis on it.

But this linear movement possesses a yet more typical characteristic. By using this image, in which the question of the fidelity and the infidelity of the bride (hence the dialectics of the four stages mentioned above[37]) predominates, the prophets show that, according to the historical experience of the people, history is rather a sort of oscillation, or better, a somewhat spiral-like forward movement. In our opinion, this describes most adequately, in a theological perspective, the central core of the historical experience of the chosen people.

Much more is at stake in this oscillatory movement than the image of the countless variations which a love story between humans supposes. The dialectics is set straightaway on a religious level in order to challenge, through this imagery, the enticements of the neighbouring hierogamic and vitalistic cults, the main source of the people's infidelity. By using this symbolic to unmask the infidelity of Israel, who abandons

Yahweh in order to chase after the baals and put its trust in others rather than in God, the prophets wish to bring their contemporaries face to face with the sin of adultery which is theirs. They are in a state of sin, guilty of a breach with God, that manifests itself in the enticements luring the whole of humanity into every possible form of idolatry and immorality.

Correlatively speaking, the nuptial imagery allows the prophets to shed a stronger light on the important and serious nature of the divine spouse's creating and redeeming project for humanity and on the intensity of love which permeates his action in this history, apparently so tortuous. Besides, this is what reaffirms the dignity of this humanity to whom Yahweh directs his call, a dignity which is not totally lost in spite of the ups and downs of history. In fact, by giving Israel to himself as a bride, Yahweh had given himself a similar helper to collaborate with him in his salvific work for humanity. He, therefore, wants to deal with the people as with a subject capable of acting responsibly. He wants to rely on its faith, on its fidelity and its love, on its commitment to its mission. Paradoxically, in spite of Israel's historical irresponsibility, the dignity of the *responsible* bride still shows through in the fact that the latter must accept to bear the consequences of her infidelities. And in that too, Yahweh pursues a purpose of love: to bring his bride to repentance in order that, through his transforming forgiveness, she may accede to full maturity and, therefore, to this salvific motherhood of which the eschatological oracles of the Deutero- and Trito-Isaiah speak.

Thus, by means of this symbolic description of history, two essential affirmations come together. The first is that the bride, Israel, in the midst of this wounded humanity of which she is a part and in the service of which she has been mysteriously chosen, cannot claim she is responding faithfully to her God if she does not allow herself to be constantly purified, forgiven, converted, transformed by the bridegroom. But – and this is the second affirmation – that is precisely what the merciful love of Yahweh wants to realize, and will

effectively do so throughout the tragic history of his people in a mysterious future to which he alone has the key. For the history of salvation is the history of the absolute fidelity of God; it is the history of the triumph of God's blessing, which has burst forth in time with the promise made to Abraham, over the curse, fruit of the disobedience and revolt of the human race.

As the nuptial imagery goes through the stages subsequent to the apostasy of the people – chastisement by Yahweh, repentance, eschatological forgiveness – one feels that a selection is being made in the midst of Israel. The bride, transformed by the purifying action of the bridegroom's love, is no longer quite the same as she was, quantitatively as well as qualitatively. The idea of the 'remnant', already mentioned by Amos, is acquiring more and more scope and depth in the wake of Isaiah,[38] Jeremiah and Ezekiel, and reaches a summit in the post-exilic period.[39] This vision of a qualitative Israel, purified in fire (cf Is 1:25; 10:17; 31:9; etc.), circumcised at heart (cf Jer 4:4-14; 24:5-7; etc.), cleansed, raised from the dead in a renewed purity (cf Ezek 36:25; 20:40-41; 37:7-14), clothed in the glory of Yahweh and made fruitful by him (Is 54:1-3; 60:1-5; 62:2-5), is an eschatological expectation resulting from Yahweh's fidelity to the earlier choice he made of this people, from the fidelity to his promise, to his justice. This 'remnant' is what Zephaniah will describe in about 640-630 and which, in a cry of joy, he names 'daughter of Sion', 'daughter of Jerusalem':

On that day, you shall not be put to shame because of all the deeds by which you have rebelled against me; for then I will remove from your midst your proudly exultant ones, and you shall no longer be haughty in my holy mountain. For I will leave in the midst of you a people humble and lowly. They shall seek refuge in the name of the Lord – the remnant of Israel; they shall do no wrong and utter no lies, nor shall a deceitful tongue be found in their mouths.

Sing aloud, O daughter of Sion; shout, O Israel! Rejoice and exult with all your heart, O daughter of Jerusa-

lem! The Lord has taken away the judgments against you... The Lord, your God, is in your midst, a warrior who gives victory; he will rejoice over you with gladness, and he will renew you in his love... (Zeph 3:11-15a,17).

Thus, it is no longer Israel in its entirety who appears here as the bride, but the remnant singled out in its midst and who, in the post-exilic period, will be identified with the *anâwim*, with the devout poor.[40] This remnant will 'inherit the role devolved upon Abraham and his posterity (Gen 12:3)',[41] that of being the source of blessing or of ruin for the pagans (cf Mic 5:6ff).

The point that emerges from a clearer view of a qualitative Israel, even if it is reduced in numbers, is that, by means of the election and the covenant (the idea of a rapprochement), God seeks the absolute moral transformation of his people or, in other words, the fidelity of the bride to the bridegroom and the moral fruitfulness which flows from this fidelity.[42]

Thus the spiral-like forward movement of history appears to be, as it were, a movement of reduction bringing about the purification of the people and its members. It is the very idea of an election as a choice, a setting aside for a vocation to holiness, which is growing in depth.

In order to give a better illustration of this movement, we could use Bouyer's analysis of the mystery of election in the midst of the history of salvation which begins within the experience of Israel. If, from the start, the election of Abraham implies both the acts of selecting and of setting him aside from the multitude of men, this setting aside singles out, so to speak, those on whom God has a special design. For, according to this author:

The human multitude appears evil; it is the *massa perditionis* of St Augustine, which verifies Origen's formula: *Ubi peccatum, ibi multitudo*. The elect must therefore be set apart, separated from this mass. Hence the secession of Abraham and the exodus of Israel from Egypt.[43]

It is the setting aside of a portion of humanity destined to become holy like Yahweh, according to an expression dear to the Deuteronomists.

Bouyer uses an idea drawn from Oscar Cullmann, who speaks of an immense *systole* 'of the multitude towards the One', to characterize this reduction from the mass. This systolic movement, in the wake of the experience of Israel, appears more like a purifying reduction. From the time they settled in Palestine, in the promised land, the experience reveals that not all Israel is Israel. The prophets will interpret the trials to come as the necessary path to follow to bring about an inner segregation, the only true one. Eventually, it is not the mass of the people but a 'faithful remnant' which, alone, will be saved. And already the last prophets foresee that this 'remnant' could be reduced, in a final analysis, to one unique 'faithful servant'.[45]

It is precisely this view of the dialectical movement of history as a purifying reduction that constitutes the most profound core of this third theological meaning of the conjugal symbolism. We can even say that, in a sense, this last theological meaning is a synthesis of the first two. For, in describing history as an immense systolic movement of purification, the conjugal symbolism illustrates in depth the efficacy of the *hèsèd* of the faithful God who promises to triumph over evil at the heart of humanity with the fire of his salvific action. Correlatively speaking, this whole movement reveals the intimacy of the transforming and fruitful union that God wants to restore between humanity and himself.

Obviously, the perspective evoked by this symbolism is eschatological. The Judaism of the last centuries will interpret this promise in many contradictory ways. It is only the definitive revelation of the *hèsèd* of Yahweh for his bride, manifested in Jesus Christ, dead and risen (cf Eph 5:25), that will bring the final word to this dialectics of love and to the perspectives it opens out for all humanity.

NOTES

1. For an overall view of Hosea's message, see Évode Beaucamp, *Prophetic intervention in the history of man*, Staten Island, New York, Alba House, 1970, pp. 19-42.
2. Hosea's obedience is underlined by Hans Urs von Balthasar in his *La gloire et la croix III, Théologie, Ancien Testament*, Aubier, 1974, pp. 210-213.
3. André Néher, *The prophetic existence*, pp. 127-130.
4. Cf Marco Adinolfi, 'Appunto sul Simbolismo sponsale in Osea e Geremia', in ED, 25 (1972), p. 137; also Néher, 'Le symbolisme conjugal', p. 40.
5. Évode Beaucamp, *op. cit.*, p. 27.
6. *Ibid.*, p. 27.
7. Marie-François Lacan, 'Époux/Épouse', in *VTB*, col. 367.
8. Adinolfi, *op. cit.*, p. 138.
9. Lacan, *op. cit.*, col. 367. For an overall view on Jeremiah, see Beaucamp, *op. cit.*, pp. 97-139.
10. Lucien Legrand, *The biblical doctrine of virginity*, p. 27.
11. Something similar happens to Ezekiel too (24:15-27). God announces the imminent death of his wife, but he is forbidden to mourn her so that the people might realize the severity of the punishment that would fall upon them, giving them no time to weep. The destruction of the temple would thus be to the people what the death of his wife was to the prophet.
12. For an overall vision of the Book of Ezekiel see Beaucamp, *op. cit.*, pp. 186-222.
13. See André Néher, *Le symbolisme conjugal: expression de l' histoire dans l' Ancien Testament* in *RHPR*, 1 (1954).
14. Bouyer, *L' Église de Dieu, corps du Christ et temple de l' Esprit*, Paris, Cerf, 1970, p. 253.
15. *Ibid.*
16. *Ibid.*
17. For an overall view of the Deutero-Isaiah, see Beaucamp, *op. cit.*, pp. 176-221.
18. Von Balthasar, *La gloire et la croix*, III, p. 250.
19. *TOB*, p. 860.
20. This is the only instance in the Old Testament where Yahweh is directly referred to as the 'husband' of Jerusalem (Israel).
21. Lacan, *op. cit.*, col. 367-368.
22. Let us note that in the case of the spousal symbolism, there is no direct mention of the wedding feast – the eschatological feast – as in Isaiah 25:6, although this feast is an essential element of the manner used to describe the Messianic era. The fusion of the theme of the Messianic nuptials with the theme of the eschatological feast will come about in the New Testament.
23. *Mishna, Yadaïm III, 5; Taanith IV, 8*. See in Strack-Billerbeck, *Kommentar zum N.T. aus Talmud und Midrasch*, IV, pp. 432-433/
24. Cf Origen, *The Song of Songs, Commentary and homilies*, translated and annotated by R.P. Lawson, New York, N.Y./Ramsey, N.J., Newman Press, 1956, pp. 267-268.
25. For example, André-Marie Dubarle, 'L'amour humain dans le Cantique des Cantiques', *RB*, 61 (1954), pp. 67-86. The great defenders of the

allegorical interpretation on the Catholic side are A. Robert and Raymond Tournai, *La Cantique des Cantiques: traduction et commentaire*, Paris, Gabalda, 1963, p. 463, and André Feuillet, *Le Cantique des Cantiques*, Paris, Cerf, 1952, p. 258.

26. *The New Jerusalem Bible*, New York, Doubleday, 1985, p. 1028.
27. Évode Beaucamp, *Le Psautier*, I, Paris, Gabalda, 1976, pp. 197-200.
28. *Ibid.*, p. 200.
29. Néher, *Le symbolisme conjugal*, p. 33.
30. On this question, see van Imschoot, *Theology of the Old Testament*, vol. I, *God*, pp. 7-28.
31. On this theme, see Jacques Guillet, 'Grâce', in *VTB*, col. 512-515; id. *Themes of the Bible*, translated by Albert J. La Mothe, Jr., Notre Dame, Indiana, Fides Publishers, 1960, pp. 20-46.
32. Cf Néher, *op. cit.*, pp. 46-49.
33. Cf *ibid.*, p. 37. This equality of the subjects is not contradicted by biblical theology even if, in the social structure and the mentality of the times, equality between man and woman was not yet perceived very clearly.
34. *Ibid.*, p. 34.
35. *Ibid.*
36. *Ibid.*, pp. 34 and 43.
37. Cf *supra*, p. 40; 'Apostasy... punishment... repentance... forgiveness...'
38. On the idea of the remnant in Isaiah, see François Dreyfus, 'La doctrine du reste d'Israël chez le prophète Isaïe', in *RSPT*, 39 (1955), pp. 360-386.
39. See Albert Gelin, *The poor of Yahweh*, translated by Katheryn Sullivan, RSCJ, Collegeville, Minnesota, The Liturgical Press, 1964, pp. 27-42; François Dreyfus, 'Reste', in *VTB*, col. 1097-1099; idem, 'Le thème de l'héritage dans l'Ancien Testament', in *RSPT*, 42 (1958), pp. 40-42.
40. Cf Gelin, *op. cit.*, pp. 31-42.
42. Dreyfus, 'Reste', col. 1098.
42. Cf Dreyfus, *La doctrine du reste d'Israël chez le prophète Isaïe*, p. 385.
43. Bouyer, *The Church of God...*, p. 242.
44. We shall see, when speaking of the conjugal symbolism in the New Testament, how this systolic movement is followed by a diastolic movement of extension of the One toward the multitude. This extension is nevertheless foretold in the Old Testament, and especially in the eschatological descriptions of the Deutero- and the Trito-Isaiah concerning the salvific motherhood of Sion. We shall come back to this shortly.
45. See Bouyer, *op. cit.*, p. 242.

Chapter 3

Symbolism of salvific motherhood in the Old Testament

The reference to a certain eschatological fecundity of the wedded people has emerged at the heart of the nuptial symbolization of the covenant according to the Old Testament. This theme ties in with another, very old, theme of the salvific motherhood in the perspective of the promise made to Abraham and his descendants.

1. Human fecundity as a sign of Yahweh's blessing

In the Bible, every maternity is a sign of God's blessing and can, therefore, in a very broad sense, be said to be salvific. As Gelin shows, 'the term *berakah* (blessing) in Hebrew as in Arabic, immediately suggests the idea of fecundity.'[1] More precisely, this term calls to mind the idea of fecundation, an idea 'more in keeping with the active character of the God of the Old Testament.'[2] Thus when a woman conceives and gives birth, God is the one who manifests his operating presence as Eve's exclamation proves: 'I have produced a man with the help of the Lord' (Gen 4:1) or that of Hannah, Samuel's mother: 'The Lord kills and brings to life...' (1 Sam 2:6). Consequently, natural maternity, the result of the joint action of man and woman (Gen 1:27-28), appears as a sign of this permanent, bountiful action of God for his creation. God, who has both a maternal and a paternal heart,[3] gives to the human couple's mission of procreation and to the particular mission of the mother, the favour of being manifestations of his beneficence, of his creating and protecting presence.

2. The salvific motherhood in the perspective of election

a. The salvific motherhood and the promise

According to the Yahwist theologians, our theme takes on a particular significance from the gratuitous intervention of Yahweh in the election of Israel. For the Yahwist, the history of salvation goes through a first stage with the choice of Abraham and the introduction of the divine blessing into the world through the promise made to the patriarch (cf Gen 12:1-2). This blessing is the response of Yahweh's merciful love to the curse that the sin of the first human couple had drawn upon the history of humankind, a curse whose progress we see in the first eleven chapters of the Book of Genesis. Abraham's posterity will bring this blessing of God to all nations, as Yahweh's promise explains in Genesis 12:1.

All through the Book of Genesis, the Yahwist – at times the Elohist as well – will place a strong emphasis on the role played by the mother of the children of the promise (Sarah and Rebecca especially), noting the unusual nature of these maternities – advanced age, barrenness (cf Gen 18:1-15; 25:21). The Yahwist will provide a profusion of details to show the efforts made by both women to guarantee that the person chosen by Yahweh will receive the legacy and the blessing. Similarly, he will emphasize the fecundity of Rachel, Jacob's favourite wife, although barren (Gen 29:31-35; 31:14ff), whose elder son Joseph will play the role of a 'saviour' for his father's tribe. This same theme of fecundity granted to barren women recurs in the account of the birth of Samson (cf Judg 13:1ff), as well as in that of the birth of Samuel (1 Sam 1:1ff). What these authors want to show, in the first place, is that the choice made by God is not to be measured against the laws and usual customs covering matters of inheritance and precedence. The children of the promise are the fruit of a gratuitous intervention on the part of Yahweh as he provides for the future of his people.

Moreover, keeping in mind the unusual nature of these maternities, what the sacred writers also want to bring to light

is the personal commitment of these women chosen to play a special role in the beginnings of the history of salvation. Like the patriarchs, they are personally chosen: the change of Sarai's name to Sarah is a sign of that choice. Moreover, they actively accept Yahweh's free intervention in their lives and are deeply committed to their new role. By assuming the responsibility of their mission of motherhood, these women collaborate in a particular way with God, in communion with their husbands, to the advent of salvation. Their call to motherhood, inasmuch as it is an act of faith in the God of the promise, thus bears salvation in a special way and manifests the triumph of the salvific presence of Yahweh in the midst of humanity. By this very fact, their vocation is a sign and instrument of the introduction of the blessing into the world.

b. The salvific motherhood and the oracle of Genesis 3:15

According to several exegetes, it is this global view of the Yahwist author that best clarifies the meaning of the oracle of Genesis 3:15, traditionally called the Protoevangelium: 'I will put enmity between you and the woman, and between your offspring and hers; he will strike your head, and you will strike his heel.'[4]

The oracle predicts a battle of universal scope to be waged throughout history as a consequence of the fall. However, thanks to Yahweh's blessing linked with the posterity of the woman, a favourable outcome for humankind can already be foreseen. It seems that the promise made to Abraham and his posterity is discreetly suggested here, and that the salvation borne by this promise, even if it comes in an unspecified future, is predicted therein. This oracle is therefore decidedly soteriological and mysteriously directed towards a future that will prove to be decisive for all humanity.[5]

One must note that here also the emphasis is placed on the descendants of the mother, the father not being mentioned. Certainly, a first explanation of this importance given to the woman can be found in the very structure of the text. Indeed,

'the hagiographer is keen to show that Providence saw to it that the seducers be punished by the hands of their victims. The woman seduced by the serpent inflicts its punishment on him, as man, seduced by woman, becomes the instrument of the chastisement of his seducer.'[6] However, there is more to this. For even in the case of this structure, there is a radical difference between the punishment inflicted upon the serpent and the chastisements that the man and the woman will bear; a curse lies heavy on the serpent, symbol of the forces of evil, while neither the man nor the woman will be cursed.[7] The fact that the woman is mentioned is not solely due to the literary structure. Its meaning would be rather essentially linked with the soteriological and eschatological nature of the oracle which, in keeping with the Yahwist's global view, seems to allow a special salvific value to the woman's vocation to motherhood.

But to whom exactly does the oracle refer? Exegetes are not unanimous on the answer to this question. We shall try to point out a few opinions which are more widely accepted but which do not, for all that, settle the debate.

In the first place, Joseph Coppens stresses that there is, in this oracle, a Messianic view in the broad sense of the word. This view appears especially in the probable shift from a collective to an individual sense at the end of the verse: 'Owing to the fact that the author sets up this tangible and individual adversary (the serpent) against the posterity of the woman, one can legitimately think that, for the final struggle, the posterity will also concretely identify itself with the person of a particular warrior equipped and instructed by Providence to win a decisive victory.[8]

The translation of the Septuagint also favours the idea of the individual. There would therefore be here very old Messianic traces, even prior to Nathan's dynastic oracle foretelling the permanent existence of the house of David.[9] This Messianism is totally imbued with a hope founded on the promise made to the patriarchs.

For Coppens, however, the woman of the oracle of Genesis 3:15 is not exactly this unique individual woman antici-

pated to be the mother of the individual warrior, although he admits that the expression 'mother of the seed' indirectly points to her.[10] The woman of the oracle would be rather the whole feminine sex, a fact that Béda Rigaux clearly upholds.[11]

The collective sense of the oracle, therefore, especially highlights the mysterious solidarity of all humankind, symbolized by the woman and her descendants engaged in the struggle against evil, and the no less mysterious permanent divine benevolence promised to this same humankind, symbolized by the blessing of human fruitfulness. However, God's benevolence expressing itself throughout the history of the election of Abraham and of his posterity and the diverse forms of Messianic hopes borne by the faith of Israel will culminate in an individual Messianic maternity. In this case, the salvific maternity is itself election in the strict sense of the word, a vocation given to chosen persons directed to culminate in the person of an individual Messiah, 'the seed' of the woman and, therefore, of one precise woman.

Concerning the identification of the woman in Genesis 3:15 as the mother of a future individual Messiah, certain exegetes have resorted to the following hypothesis. Given that the Yahwist tradition is probably contemporaneous with the royal period and perhaps with Solomon's reign, it is possible that the dynastic Messianism developed from Nathan's oracle might have influenced the wording of the oracle of Genesis 3:15. This is what Walter Wifall, among others, suggests: 'Apparently Genesis 3:15 owes its present form to the Yahwist's adaptation of both the David story (2 Sam; 1 Kings 2) and ancient Near East royal mythology to Israel's covenant faith and history. The Yahwist has thus presented Israel's history and prehistory within a "Davidic" or "Messianic" framework.'[12]

We know, as much from the testimony of the Book of Kings as from the study of ancient Oriental archaeological documents, that the mother of the king, the *gebirâh*, held a privileged position at the side of her son.[13] Associated with his government, she played the role of a counsellor, of a

'wise'[14] lady for him and his household. Her position was much beyond that of the king's wife. In the oracles predicting the forthcoming deportation, Jeremiah clearly associates the queen-mother and the king in one same defeat (Jer 13:18; 22:26).

It is therefore quite possible that the viewpoint of the oracle of Genesis 3:15 foretells not only the coming of the future triumphant hero but also suggests that he is the King-Messiah and, through the salvific maternity of the woman, brings to mind the future queen-mother who will be both the mother and the consort of her son in the latter's victory over the powers of evil.

c. The messianic motherhood in Isaiah 7:14 and Micah 5:1-2

Among the exegetes who interpret the oracle of Genesis 3:15 from the point of view of a royal Messianism, there are some who base their argument on the two oracles of Isaiah 7:14 and of Micah 5:1-2 in which a link is made between the mother and the son on whom rests the Messianic hope.

In the first passage,[15] Isaiah, in order to alert the faith of King Ahaz during a tragic period of the history of Israel, promises the sovereign a sign that will confirm the consistent message: Yahweh is the one who will intervene and have the last word in spite of the king's lack of faith. Certainly, as Coppens suggests, that does not necessarily mean that salvation will come from the reigning family but[16] – keeping in mind the other predictions of the prophet (for instance in chapter 11) – it appears to be mysteriously suggested that this dynasty will emerge again on some definite but not predictable date in the future: 'The Davidic dynasty is a tree, bare, shaken, perhaps even cut down to the ground, at the moment when the ideal prince appears. He emerges, a mysterious shoot from the trunk, or what is possibly a more accurate version, from the stock of Jesse. He will rise from it in a mysterious way through the intermediary of the "almah" (the young girl of nubile age).'[17]

Thus the sign from Yahweh, coming by way of the mysterious maternity of the *'almah'* seems imbued with a soteriological and eschatological (in a broad sense) Messianic inspiration, similar to that of Genesis 3:15. And in both cases, the mother alone is mentioned: the active role of the father is glossed over.

In Micah's oracle, which recalls the time when the one who is to give birth will do so, it appears that the prophet, like Isaiah, wishes to chide his fellow-countrymen for their disbelief. He, therefore, asks them 'to focus their hopes on David's heir, the Messiah, who will come at the end of times.'[18] Thus the message of the two contemporary prophets mutually clarify each other.[19]

It is interesting to note, along with Henri Cazelles, that the one who gives birth to a child in Micah 5:3 'is no more only the mother of the king but also the pregnant daughter of Sion who will "leave" the city to go up to Babylon for her delivery.'[20] Hence we have here a first combination of a salvific motherhood in the order of a natural childbirth and the metaphorical salvific motherhood of the people on which we will subsequently focus our attention.

In the context of the eschatological royal Messianism, these oracles confirm the presence, in the faith of Israel, of the idea of a maternity, the vehicle of salvation, both sign and fruit of the free and gratuitous intervention of Yahweh.

3. The spiritualization of salvific motherhood

A spiritualization of the theme of the salvific motherhood is also discernible throughout the history of Israel. It is founded partly on the association of the idea of divine blessing with human fecundity in the perspective of salvation. This association appears in the very first chapters of Genesis.[21] If, in the beginning of chapter 4, it is said that Eve gives birth *with* Yahweh, the result of this first childbirth is nevertheless quite ambiguous. We see it culminating in a first murder and its chastisement (the account of Cain and Abel). A similar

ambiguity emerges from chapters 4-11 taken as a whole where the progressive proliferation of evil caused by the curse of sin to which humankind is bound, insinuates itself in the successive generations born of the first couple. Thus, while being aware that the gift of God continues to manifest itself with regard to human life, these chapters give us an idea of the necessity of salvation for the descendants of Adam. It is through a new blessing bursting forth in history that this salvation is initiated. Such is the meaning of the oracle of Genesis 12:2-3 in which Yahweh promises Abraham, the elect, that he will have a blessed posterity in whom (or by whom) nations will be blessed.

This innovation allows us to foresee how the subordination of the idea of blessing linked with human fecundity to that of the election will develop. It is in this perspective that the wives of the patriarchs are presented as women chosen in the midst of the people to fulfil a maternal, yet more properly salvific, mission. These women are truly 'chosen' to give birth to a posterity in the line of the promise. In this they are equals to their husbands. This fact is brought out, for instance, in the case of the maternity of Hagar, Sarah's slave. From this slave is born a son to Abraham, the chosen patriarch. However, she is not the mother-elect; Sarah is. Hagar's child, even if he is the firstborn, will not inherit the promise, for it is to Sarah that the mission of providing an heir to Abraham has been entrusted. Thus, the vocations to motherhood in Israel no longer appear to be all salvific in the strict sense of the word, even when human fecundity in the couple bears the stamp of Yahweh's action as the source of life by assuring the gift of new members to this privileged nation.

With a growing sense of awareness of the moral responsibility of individual persons, the subordination of the idea of blessing linked with fecundity to that of election takes a new turn. The gradual discernment of a remnant in Israel, who converts and sanctifies itself in the midst of the whole people constantly at grips with infidelity,[22] makes it more and more obvious that the numerical progression of the chosen people appears as a counterfeit of Yahweh's salvific design if this

growth is not accompanied by loyalty to Yahweh and to his covenant. This detail is important, for when one speaks of the purpose of human fecundity in no way is there any question of a downgrading of the eminent value of the fruit of this fecundity: the human being created by God in his image and in his resemblance through the procreative cooperation of the parents. Besides, the idea of the child symbolizing a blessing will always remain alive in Israel, so much so that even in the New Testament, as we see in Luke 1:25, barrenness is perceived as a curse and the source of great grief.

Some texts illustrate the priority given to fidelity to Yahweh by stigmatizing the degeneration of the *sons* of Israel. 'His degenerate children have dealt falsely with him, a perverse and crooked generation. ... Is not he your father, who created you, who made you and established you?' (Deut 32:5-6). And this text from the Book of Isaiah which is worded in yet more violent terms: 'I reared children and brought them up, but they have rebelled against me. Ah, sinful nation, people laden with iniquity, offspring who do evil, children who deal corruptly, who have forsaken the Lord, who have despised the Holy One of Israel, who are utterly estranged!' (Is 1:2,4).

Here, the descendants of Abraham, the usual bearers of Yahweh's blessing, are believed to be struck with a curse because of their corruption and their infidelity. The consequence of such a curse was reflected in this astonishing text in the second century BC:

Do not desire a multitude of worthless children, and do not rejoice in ungodly offspring. If they multiply, do not rejoice in them, unless the fear of the Lord is in them. Do not trust in their survival, or rely on their numbers; for one can be better than a thousand, and to die childless better than to have ungodly children (Sir 16:1-3).

The fact is that a painful experience of purification has forced the people to become aware that fidelity to Yahweh and justice are virtues which must be put first by the one who claims to be a true son of Abraham. The essential theological

view of the theme of the remnant is thus affirmed: this portion alone, poor, humble, humiliated and even barren is the chosen one; it alone will be able to act as the vehicle of spiritual fecundity. Hence, this passage which already anticipates that of the New Testament:

> Blessed is the barren woman who is undefiled, who has not entered into a sinful union; she will have fruit when God examines souls. Blessed also is the eunuch whose hands have done no lawless deed, and who has not devised things against the Lord; for special favour will be shown him for his faithfulness, and a place of great delight in the temple of the Lord (Wis 3:13-14).[23]

Surprising as it may seem, this mysterious beatitude promised to the barren woman and to the eunuch on the condition that they lead a holy life goes back a long way and is linked with an aspect of fecundity in the history of salvation hitherto symbolized by the miraculous maternities of Sarah and Rebecca, of Rachel and Hannah. It is this motherhood of the chosen people unable to bear children on its own that appears in this text of Deutero-Isaiah: 'Sing, O barren one who did not bear; burst into song and shout, you who have not been in labour! For the children of the desolate woman will be more than the children of her that is married, says the Lord' (Is 54:1).

This text, which ties up with the theme of the nuptial symbolism, leads us directly to the prophets' theme of the salvific maternity of the daughter of Sion. For the barren woman mentioned here is no longer the corporate expression denoting the natural mothers in Israel.

4. *The salvific maternal vocation of the daughter of Sion*

The theme of the salvific motherhood undergoes an important metamorphosis when a special fecundity is attributed

to the daughter of Sion. But who is she? The origin of the expression and its first application to the fortified town in the northern part of the city of David (cf Mic 4 and 5) and then to Jerusalem, the 'holy' city with its temple at the centre, were studied in detail by Henri Cazelles.[24] At first, the expression refers 'not to all of Israel but to a part, to a remnant, put to test, who brings a new hope, a new vision of triumph over the alien.'[25] Victory is assured because Sion is the holy city, its central point being the temple. Besides, this is the underlying idea in the text by Zephaniah which has already been mentioned: 'Rejoice and exult with all your heart, O daughter of Jerusalem!... The king of Israel, the Lord, is in your midst... The Lord, your God, is in your midst, a warrior who gives victory!' (Zeph 3:14-17). Ezekiel will describe the people's calamity in terms of the departure of the glory of Yahweh, of the *shekinâh* taking leave of the temple. The renewal of Sion and, consequently, its fecundity will be linked with the glory of Yahweh rising upon her (cf Is 60:1ff; 60:10; 62:1-3),[26] thus showing his presence in her midst.

This very important theme is a good illustration of the awareness that Israel had of the special presence of the transcendent God in the midst of his chosen people. But it stresses, at the same time, the proclamation of the absolute liberty of this presence and of its vivifying and salvific effect. The fact that Israel was a chosen people gave it no power whatsoever over Yahweh; the latter could abandon his chosen bride at any time should she no longer respond to his covenant. But when Yahweh returns in her midst, when the *shekinâh* reinstates herself in Sion, the people can again become pregnant with new life thanks to the action of her God in her.

This vision of victory, totally impregnated with the Messianic hope of Micah 5:1-2 concerning the glorious birth of the royal heir, comes together when the prediction of the painful childbirth of the new purified people is announced. In Isaiah, Zephaniah and Jeremiah, the tragedy of the daughter of Sion grows in intensity with the prospects of the fall of Judah and the exile. The painful childbirth becomes more and

more clearly the sign and the means of a deliverance and redemption for this new people.

This childbirth is the one mentioned in the hymn of joy of Isaiah 54:1ff where the one who was barren, is made wonderfully fruitful by Yahweh, her bridegroom. We are now in the fourth stage in the history of the conjugal relationships of Yahweh with Israel, the stage when the husband forgives his wife, purifies her, adorns her, sanctifies her, makes her fruitful. This is the hope in the fully salvific fecundity already mysteriously announced as the total salvation of all humanity promised by God (cf Is 54:9 and the reference to the times of Noah).

After the exile, a development of the theme of the birth of the new world begins in a perspective where the eschatological horizon is outlined more clearly. The prophet of the return, in Isaiah 66:7-9, will again turn to this idea of the painful birth of the new people: 'Before she was in labour she gave birth; before her pain came upon her she delivered a son.' And the prophet goes on:

> Who has heard of such a thing?
> Who has seen such things?
> Shall a land be born in one day?
> Shall a nation be delivered in one moment?
> Yet as soon as Sion was in labour she delivered
> her children.
> Shall I open the womb and not deliver?
> says the Lord.
> Shall I, the one who delivers, shut the womb?
> says your God.

This oracle refers to the begetting of a new people, distinct from the nations of rebels mentioned in Isaiah 65:2, through the action of Yahweh in Sion. Everything will truly be renewed: earth, sky, span of life, clergy (Is 65:17-25).

Nevertheless, the text seems to mention two births: the one painless, the birth of the male child, and the other painful, the birth of the people. It is certain, as Cazelles notes, that

'what is of interest to the prophet of the return is the second birth, that of the new people'.[27] However, as the same author notes elsewhere, there could be an underlying reference to the oracles at the beginning of the Book of Isaiah that the prophet of the return intended to complete and not replace in his work.[28] In these oracles, 'Isaiah had looked forward to the birth of the royal child, the Immanuel' (cf Is 7-9). Therefore, could the Trito-Isaiah be referring to this first birth? There is nothing certain about this interpretation as several exegetes tell us. Perhaps this passage only remotely suggests that there is a link between the Messianic era (and, implicitly, the coming of the Immanuel) and the birth of the collectivity. Whatever the interpretation may be, one can see that the image of the salvific motherhood of Sion as fruit of Yahweh's commitment to his purified people seems to keep a certain relation, explicitly or implicitly expressed, with the Messianic hope. It is difficult to deny this link when we are faced with a later text like that of the Deutero-Zechariah appearing at a time when the dynastic Messianism was in disfavour: 'Rejoice greatly, O daughter of Sion!... Lo, your king comes to you: triumphant and victorious is he, humble and riding on a donkey' (Zech 9:9).

The theme of the salvific motherhood of Sion recurs also in the Psalms, especially in Psalm 87. Verses 5-7, as Beaucamp says, constitute a commentary of the oracle on the first four verses,

> (Celebrate) the glory of the restored city, glory which essentially resides in a wonderful fecundity. Sion is crushed by the number of its sons (Is 49:18-21; 54:1-3), rushing up from every corner of the world. After all, this is not just a passing commotion, for the city of God, henceforth, possesses all the guarantees of stability (Ps 125:1; Is 54:11-14).[30]

To conclude, we might mention that, with the development of the apocalyptic mentality in Judaism, and especially in the intertestamentary writings, this theme of salvific ma-

ternity will reach a summit of spiritualization in a clearly eschatological and transcendent perspective.

5. Theological elements in salvific motherhood

It is now possible for us to present a synthesis of the essential theological elements of the theme of the salvific motherhood in the Old Testament.

We shall not go back here to what has been said about the salvific value, understood in its broad sense, linked with the natural human fecundity as an effect and a sign of the blessing of God on humankind. Let us nevertheless note this: the personal vocation of the woman, who becomes a mother through the active communion with the one who is for her (as she for him) a 'similar helper', seems to suppose that she has a specific right and duty towards human life and the person born of her with whom she has a special bond as 'mother of the living'.

However, it is especially at the level of the history of the election that the maternal vocation of woman has been presented to us as mainly salvific. Through the analysis we have made of the subordination of the idea of blessing linked with fecundity to that of the fidelity to the covenant, we have been able to acquire a clearer idea of the parental vocation of man and woman as members of the chosen people. If their union is expected to flourish in fecundity for the life of the people (and, of course, for the natural propagation of the human species; cf Gen 1:28),[31] it is a moral responsibility by which, as members of the chosen nation, they are destined, first and foremost, to be fruitful in holiness in their personal life and in their vocation to parenthood. Similarly, their fecundity is destined to give children to Yahweh, not only in numbers but also in quality, that is, children who will also live in faithfulness to the covenant.

By giving special emphasis to the maternal mission in this covenant context and in keeping with our interpretation of Genesis 3:15, biblical theology emphasizes the moral re-

sponsibility of the woman in her acceptance of a new life and its consequences. Thus, the woman chosen for such a maternity fulfils a task of very special importance in the midst of the people of the covenant.[32]

Besides, we might recall that what is said here is really about the vocation of a person insofar as she is chosen by God and, therefore, responsible for her response to such a calling. We are in an area that has nothing to do with forms of vitalistic determinism which assimilate the woman to mother-earth and constantly confine her to a biological function. Here again, the Bible desacralizes the generative function and, namely, the role of the mother by integrating this role within the reciprocal dialogue of the covenant.

It is in this perspective that the idea of a Messianic motherhood assumes all its anthropological and theological significance. For the mysterious feminine personality expected to fulfil this very special maternal mission cannot be presented as bearing the promised mediator in spite of herself. On the contrary, like all maternity in the midst of the people of the covenant, she is necessarily committed as a free person in her response in faith to God's choice. By the very same fact – and the delicate awareness to personal responsibility will help to understand this still better – her maternity, although it is the effect of a totally free and gratuitous choice on the part of Yahweh, can only be bound to her fidelity as a member of the people of the covenant. Besides, from this point of view, we must recall the mysterious countenance of the mother of the Messiah, the *gebirâh,* who was not only a begetter of new life but a person assuming a real responsibility. It would be impossible for the mother of the King-Messiah to have such an influence if a maternal vocation was limited to a biological generation and nothing more.

The salvific responsibility borne by the mother in Israel acquires a special depth when it is related to the theme of spiritual (metaphorical) fecundity promised to the daughter of Sion as the remnant, purified and transformed, in whom Yahweh is present. Indeed, the Messianic era, which makes its appearance and brings forth a total renewal, is the era of a

salvific fruitfulness both new and transcendent. This fecundity, the work of Yahweh, is also a fruit borne by the daughter of Sion, thanks to a restored fidelity. It is in the midst of this purified people whose loyalty is renewed that the new world will develop a new life and the kingdom of God will be established. And wherever the identity of the royal Messiah is intimated to be a person invested with the role of a mediator for the purpose of setting up this reign, this motherhood of Sion, thanks to a Christian rereading of the Old Testament, will always be presented again with the more personal traits of a particularly responsible woman.

NOTES

1. Gelin, *Le rôle de la famille dans la sanctification de l'humanité*, p. 545.
2. A. Murtonen, 'The use and meaning of the words *Lebârek* and *Berâkâh* in the Old Testament', in *VT*, 9 (1959), p. 177.
3. Armand Négrier and Xavier Léon-Dufour, 'Mère', in *VTB*, col. 745.
4. The Hebrew word for offspring could also have been translated as seed.
5. Cf Coppens, *Le Prémessianisme*, p. 172.
6. *Ibid.*, p. 173.
7. *Ibid.*, p. 174. The Book of Wisdom, while reinterpreting the account of the fall, will not speak of the serpent but of the devil (2:24). But such an identification is possibly present even in the account of Genesis 3, as Guillet suggests in *Themes of the Bible*, pp. 137-147.
8. Coppens, *Le Protévangile*, p. 57. The same type of analysis is found in Rigaux (cf *op. cit.*, pp. 339-340) and Feuillet (cf *Le triomphe de la femme*, p.14).
9. Cf Coppens, *Le Prémessianisme*, pp. 154ff.
10. Cf Coppens, *Le Protévangile*, pp. 69-70.
11. Cf Rigaux, *op. cit.*, p. 344.
12. Walter Wifall, 'Genesis 3:15 – A Protoevangelium?' in *CBQ*, 36 (1974), p. 365. On the influence of the royal customs and myths of the East, see also Henri Cazelles, 'La Mère du Roi-messie dans l'Ancien Testament', in *Mariologie, angélologie et pneumatologie*, Paris, Institute Catholique (no date), *Ad modum manuscripti*, pp. 13-19.
13. Cf Cazelles, *ibid.*, pp. 20-21.
14. Cf Pieter Arie Hendrik de Boer, 'The Counsellor', in *Wisdom in Israel and in the ancient Near East*, edited by M. Noth and D. Winston Thomas, Leiden, E.J. Brill, 1960, pp. 53-54; 60-61.
15. For a detailed analysis of the prophecy of the Immanuel, see especially Joseph Coppens, 'La prophétie de la 'almah, Is VII, 14-17', in *ETL*, 28 (1952), pp. 648-678; *id., Le messianisme royal: ses origines, son*

développement, son accomplissement, Paris, Cerf, 1968, pp. 69-76; also François-Marie Braun, 'Éve et Marie', in *La Nouvelle Eve*, I, *EtM*, 12 (1954), pp. 14-19; as well as Frederick L. Mariarty, 'The Immanuel prophecies', in *CBQ* 19 (1957), pp. 226-233 and Beaucamp, *Prophetic intervention...*, pp. 59-64.

16. This view held by Coppens and Moriarty, results in the refusal to identify the child Immanuel (the sign) with Hezekiah, son of Ahaz, and still less with a possible son of the prophet (Is 8:3-4). Even for the exegetes who identify the sign with the immediate dynastic heir of Ahaz, there remains, as the note "f" of *The New Jerusalem Bible* indicates, that 'we may sense from the solemnity of the prophetic saying and the emphatic meaning of the symbolic name given to the child that Isaiah saw more in this royal birth than immediate circumstances, namely, a decisive intervention by God, towards the final establishment of the Messianic kingdom. Thus the prophecy of Immanuel goes beyond its immediate realization' (p. 1201).

17. Coppens, 'La prophétie de la 'almah', p. 675. We do not go into the matter of the translation of the Septuagint, where the '*âlmah*, the young girl not yet a mother or newly married, becomes the *parthenos* (virgin), for this will be discussed later when we deal with the New Testament.

18. Cazelles, *op. cit.*, p. 23.

19. Cf *ibid*.

20. Cf Henri Cazelles, *Le Messie de la Bible, Christologie de l'Ancien Testament*, Paris, Desclée, 1978, p. 101.

21. Cf Henri Cazelles, 'Aperçu sur le contenu et la théologie du Pentateuque', in *Introduction à la Bible*, I, Tournai, Desclée, 1959, p. 354.

22. Cf *supra*, pp. 40ff.

23. Already in Isaiah 56:3-5, we see integrated within the people the eunuchs whom the Deuteronomist excluded as they did the bastards and certain foreigners. This text of the Book of Wisdom denotes a radical change in mentality and necessarily implies the infiltration into Israel of the idea of life after death.

24. Especially in his article 'Fille de Sion et théologie mariale dans la Bible', in *Mariologie et oecuménisme* III, *EtM*, 21 (1964), pp. 51-71.

25. Cazelles, 'Fille de Sion', p. 58.

26. This theme of glory is close to another theme, that of the *ruah* which raises dry bones in Ezekiel 37:1-14. Both themes deal with the restoration of Jerusalem.

27. Cazelles, 'La fonction maternelle de Sion', p. 55.

28. Cf Cazelles, 'La fille de Sion', p. 66.

29. *Ibid.*

30. Evode Beaucamp, *Le Psautier*, II, Paris, Gabalda, 1979, p. 78. We might recall that the universalism mentioned here is the one that views nations as being subjected to Israel and, thereby, to Yahweh.

31. Cf Maurice Gilbert, '"Soyez féconds et multipliez" (Gen 1-28)', in *NRT*, 109 (1974), pp. 741-742.

32. Clarence Vos, *Women in the Old Testament workshop*, Delft, Judels and Brinkman, 1968, pp. 131-132.

Other feminine personifications
of the people

If the personification of Israel as a bride becoming spiritually a mother in the order of salvation appears frequently in the Scriptures, there are also other feminine personifications of the people found there.

1. Later personifications of the people

One example is found in the two later books of Judith and Esther. Both women, being in the service of the people, provide the assurance of victory in tragic situations. These exemplary women are an epitome, so to speak, of the whole of Israel; they thus personify the people.

Even in the Book of Ruth, the heroine could well have such a personifying significance. Ruth – a Moabite – according to the symbolism of the names used in this account, would appear as the incarnate form of the daughter of Sion. At least, this is the hypothesis suggested by L.-B. Gorgulho.[1] Whatever the details of this interpretation may be, we can probably see in the names of the characters of the account some symbolic references to different aspects of the history of the people after the exilic period.[2]

2. Wisdom

A feminine personification of a completely different type sometimes appears in the Old Testament. It conjures up Wisdom under the guise of a woman, sometimes a young girl,

and more expressly as of a wife and mistress of a household.[3] Although this figure does not personify the people of God, it can offer some interesting points.

In the first place, Wisdom sometimes reveals itself as a kind of partner for Yahweh without suggesting in the slightest way the idea that it could be a goddess espoused to God.[4] It is close to Yahweh like the symbol of the secrets of his salvific plan, of the mystery directing his action with regard to humanity, which he wishes to reveal to his people, to make them 'wise' in their turn.[5]

Sometimes, Wisdom is seen as a bride offering herself to man 'as a blameless companion, enticing, generous and inspiring, able to live in perfect harmony with the one she loves first and who loves her in return.'[6] In this case, 'the sacred authors always want to suggest the union, profound, faithful and fruitful, which must develop between God and humanity, in terms of nuptials.'[7] We thus have another type of application, a reversed one, of the nuptial symbolism, which helps us to understand that the peak of the allegory is more in the covenant relation than in the feminine personification of the people. Indeed, in this case, man is the one who represents the human spouse, first the king, but also all the members of the people. Besides, the allegory here is set directly only in the context of the relationship between a human person and Wisdom and thus does not refer to the people as such.[8]

Elsewhere, Wisdom assumes the traits of a counsellor, of a lady, much akin to the *gebirâh* in the house of the king (Prov 9:1-5). She is the mother who wants to nourish her children, to offer them the good things of her table, that is the religious and moral teaching of the Law and the prophets.[9] She invites the Israelites to this feast gratuitously offered by Yahweh and echoed in Isaiah 55:1-3.

One must also note the parallel set up between Lady Wisdom and another feminine personification, Lady Folly, seducer and adulterer, the opposite of the first. This parallel is not outside the experience of Israel, the bride, who became the prostitute at the moment when she 'ran off wildly in the pursuit of "strange" or "unknown" divinities and powers',[10]

her lovers. Having again become faithful to the covenant after the ordeal of the exile, she could recover her titles of nobility and her spousal and maternal mission in the service of the salvific plan of her spouse. She could then also recover her resemblance to Lady Wisdom and suggest to her children the choice to be made 'between regression to a past filled with wanderings and sin – Folly – and the coming of a new world, lovingly abandoned to the divine will – Wisdom'.[11]

Here again, the overtones of the feminine personification take us back to the theme of fidelity to the election and to the covenant. In Ben Sirach, it is said that Wisdom (speaking through the Torah) resides in Jerusalem, in the holy temple of Sion (Sir 24:10-12). The bride and mother, Israel, is, as it were, consecrated in her vocation by the presence of Wisdom in her midst.

This investigation into the Old Testament has allowed us to ascertain the profound significance of the feminine symbolisms applied to the chosen community throughout the history of Israel down to the threshold of the Christian era. Generally speaking, these symbolisms have helped to manifest the elective love of Yahweh, his indestructible loyalty and the efficacy of his saving presence in the history of humankind. Moreover, they have provided, in yet greater depths, a keener sense of the very meaning of election by which Yahweh, in total freedom, has given himself a people, partner and servant in his plans. Thus, the covenant has appeared more forcefully as a dialogue of love, of communion, of transfiguration and also of fecundity in the life of the elect, thanks to the husband's saving action in her.

A question is raised at the dawn of the Christian era: where is this faithful bride, this saving mother? The many devotees within the people and in its periphery, like the Essenes, tried, somehow or other, to respond to this vocation of the chosen people, and we were able to note in the previous chapters the fragmentary nature of these responses. Did the newborn Church on her part gather these symbolisms within her experience as a new Israel? And if so, how were they accomplished in her? That is what we must now examine.

NOTES

1. L. B. Gorgulho, 'Ruth et la "Fille de Sion", mère du Messie', in *RThom*, 63 (1963), pp. 501-514.
2. Cf *TOB*, p. 1584.
3. It is especially in the Book of Proverbs that this personification of Wisdom is the most explicit.
4. Cf van Imschoot, *Theology of the Old Testament*, v. I, p. 217.
5. Cf Joseph Coppens, 'Le messianisme sapiential et les origines litéraires du Fils de l'homme daniélique', in *Wisdom in Israel and in the ancient Near East*, p. 36.
6. Pierre Emile Bonnard, *La Sagesse en personne, annoncée et venue: Jésus-Christ*, Paris, Cerf, 1966, p. 118.
7. *Ibid.*
8. This perspective, more personal, is a characteristic of the Wisdom literature. Cf Evode Beaucamp, *Man's Destiny in the Book of Wisdom*, translated by John Clarke OCD, Staten Island, N.Y., Alba House, 1970, p. 34.
9. Cf André Barucq, *Le Livre des Proverbes*, Paris, Gabalda, 1964, p. 99.
10. Beaucamp, *op. cit.*, p. 34.
11. *Ibid.*, p. 34.

Chapter 5

The bridal symbolism
in the New Testament

In Jesus Christ, the new world appeared in its plenitude, even
if this innovation is to be fully evident only at the time of the
parousia. We may, therefore, expect that the symbolisms that
helped the Israelite people to grasp in greater depths the
implications of the covenant between Yahweh and itself – in
this case, the spousal and maternal symbolisms – will con-
tinue to enlighten the people of the new economy. But they
will do so only by bearing the particular traits resulting from
their total fulfilment, thanks to the perfect covenant realized
in Jesus Christ.

1. Identification of the Messiah as the bridegroom

a. Christ, bridegroom of the nuptials in the synoptic gospels

To begin with, let us dwell on the synoptic tradition even
if the final form of these gospels was subsequent to Paul's
letters.

The presence of the theme 'Jerusalem, bride and mother'
in the teaching of Jesus may be detected from the presence of
very discreet clues. When he predicts the destruction of
Jerusalem, Jesus uses the typical language of the prophets:
'They will crush you to the ground, you and your children
within you...' (Lk 19:44).[1] Similarly, when he inveighs against
his fellow-countrymen because they refuse to accept his
message, he speaks of an adulterous generation (cf Mk 8:38;
Mt 12:39; 16:4).[2] When Matthew refers to Zechariah's text to

explain the meaning of the Messianic entry of Jesus into Jerusalem, he first points out 'the humble and peaceful character of his reign'.[3] Perhaps does he wish to suggest in this way the overall context of the accomplishment of the Messianic renewal of Yahweh's bride (cf Mt 21:5)? Finally, the words Jesus addresses to the daughters of Jerusalem on the road to Calvary (cf Lk 23:28-31) do not fail to recall the typology of the daughter of Sion and possibly even the allegorical interpretation of the Song of Songs with the role played in these passages by the daughters of Jerusalem (cf Song 1:5,7, etc.).[4]

The representation of the Messianic era under the aspects of a happy feast, most especially of a wedding feast, again echoing the theme of Isaiah 25:6, appears much more clearly in the synoptics. The traditional link in Israel between a sacred meal and the confirmation of a covenant or the commemoration of the *Mirabilia Dei* of the beginning of the covenant moves into the Messianic hope and into the allusion to the new covenant. This theme underlies the numerous real or parabolic feasts of the gospels and is also found again in the Eucharistic meal of the Christian community. It is at the centre of this allusion that we can detect our first explicit reference to the conjugal symbolics.[5] It is also there that this symbolic takes a radically new turn. For the first time, the figure of the bridegroom, which, in the Old Testament, always directly or indirectly referred to Yahweh, is identified with that of the mediator of salvation, the Messiah.

According to Richard Batey, the nuptial imagery was used in the first place to 'distinguish the role and the ministry of Jesus from that of John the Baptist (Mk 2:18-20; Mt 9:14-15; Lk 5:33-35)'.[6] The evangelists recall the joy emanating from the presence of the bridegroom at wedding feasts to explain why the disciples of Jesus, as opposed to those of John, do not fast. In those texts, however, it is not certain that the climax of the narrative applies to the traditional nuptial symbolism, no more than it is evident that the identification of Jesus as bridegroom is for its own sake. It is possible that here only the proverb of the joy associated with wedding feasts is being applied to the Messianic era.

However, such an application was probably influenced by John the Baptist's preaching since he seems to have been the first to identify Jesus as the bridegroom.[7] This hypothesis becomes more evident when we take a closer look at verse 20 of Mark's text. According to Boismard, this sentence was added in order to 'justify the practice of fasting reintroduced in the early Church to avoid being blamed by the Jews',[8] since the Christians, unlike the latter, fasted on Fridays in memory of the death of Christ. Here, the bridegroom is clearly identified; he is Jesus who, by his death, 'will be removed' from the company of his disciples.

In the parable of the guests, who find excuses not to attend the wedding in Mt 22:1-14, the nuptial theme is much more evident since the climax of the account points directly to Israel who refuses to come to the wedding feast. The parable speaks of a feast prepared by a king for the wedding of his son. The full Messianic significance of this theme is certain; it goes back to Isaiah 25:6; Matthew 26:29 and Revelation 19:7, 9. We may also detect a probable reference to the feast offered by Wisdom in Proverbs 9:2-3. The New Testament would therefore bring out a connection between the theology of Wisdom and that of the nuptials of the bridegroom with his Church.[9]

b. Christ, the bridegroom, in St Paul, St John and Revelation

The identification of Christ, the mediator of salvation, as a bridegroom is taken up again by St Paul on two instances in his letters. First, in 2 Corinthians 11:2, the Apostle writes: 'for I promised you in marriage to one husband, to present you as a chaste virgin to Christ' (cf also Rom 7:4). The same idea underlies the text of Ephesians 5:22-25 where Christ is presented as a model to the human husband. What the synoptics were suggesting in a more subtle way, Paul affirms directly: the husband of the ecclesial community, which is taking the place of the old Israel, is Christ Jesus, the Messiah, the Son sent by the Father.

In the Gospel according to St John (3:29), the identification is also clear: Jesus is the husband of the new people of God and John the Baptist is his friend, 'that is, the *shoshebin* of the Jewish weddings, whose role was to prepare the festivities... more precisely to prepare the bride by purifying her and leading her to the bridegroom'.[10] When it is reset in the whole section between 2:1 and 4:42, this text suggests that the words of the Baptist are linked, on the one hand, with the symbolism of water in the pericope on the birth from water and Spirit (Jn 3:48) and, on the other hand, with the worship in spirit and in truth foretold to the Samaritan woman, herself being a personification of the ecclesial bride (Jn 4:21-23), as we shall see later. Through the baptismal rite, John prepares the community of disciples (the old Israel) to pass into the Church, that is, to become the bride of the one who is the bridegroom, an aspect which the account of the wedding feast at Cana could also lead us to understand.

A final text confirms the identity of the bridegroom with the same clarity and in a context where the fulfillment of the Messianic era is in sight. It is in Revelation 19:7-9: 'The marriage of the Lamb has come, and his bride has made herself ready... Write this: Blessed are those who are invited to the marriage supper of the Lamb...'. Here, the bridegroom is Christ, the Lamb who is sacrificed but eternally triumphant. He shares his Father's title as husband of Jerusalem.[11] The eschatology is here fully manifested.

Thus, a radical innovation has appeared as the nuptial symbolism is taken up again in the New Testament. It deals with the transfer of the prerogatives of Yahweh as the bridegroom of Israel to his chosen one, Jesus Christ. The presence of Yahweh in the midst of his people in his temple, through the *shekinâh*, according to the preaching of the prophets, becomes a unique presence of the bridegroom to his bride in the person of the incarnate Son, the one sent by the Father, the Messiah.

2. The bride symbolism in the early Church

The identification of the community as the bride of God will also be characterized by a certain innovation or, rather, by a clearer resumption of the perspectives already broached by the theme of the remnant of Israel along with a transposition of the spousal prerogatives of Sion to the Christian community.

a. The wedded community in the synoptics

Let us go back to the parable of Matthew 22:1-4. One remarkable point to be noted is that there is no mention of a bride here than there is in the parable of the ten virgins in Matthew 25:1-13, a parable that, nevertheless, includes elements of the nuptial symbolics.[12] In the parable of Matthew 22:1-14, the emphasis is placed on the guests: a first group who rejects the invitation and another group of guests gathered by the roadside. This fact converges on Mark 2:18-20 where stress was laid not on a bride but rather on the disciples themselves identified as 'friends of the bridegroom'. In the perspective of this wedding feast, 'the "guests" who refuse to come symbolize those living at the time of Jesus in the midst of his people, while those who are invited at the last moment symbolize the pagans.'[13] Moreover, by mentioning in verses 11-13 the presence of a guest who does not wear the proper attire, the evangelist points out that the lack of purity of heart casts aside even the person who has accepted the invitation to take part in the nuptials of Christ and his Church. This reference to the wedding attire could well have been taken up again by Paul when he speaks of the necessity of being clothed in Christ. The Book of Revelation also speaks of the garment, but this time it specifies clearly that this is about the attire 'of the bride'.

The various clues in this parable of Matthew (19:7-8, 22:1-14) show that the fact of belonging to the wedded people is conditioned by the faith displayed in the moral attitude of

the guests. Consequently, the moral character of the theme of the Messianic nuptials (the necessity of being holy in the midst of the wedded people) is found to be strongly emphasized and placed in evidence even before any reference is made to a bride.

Because of this very particular approach, two major aspects of the Messianic era are brought out in the synoptics. First, the marriage of God is already a reality in the union of the Son, the Messiah, with humanity *in se*.[14] But then – and this is the second aspect – the 'time of the Church' does not yet fully appear as the moment of the decisive nuptials between God and the whole of humanity. This is what explains the absence of the image of the bride and the stress laid on the faithful and unfaithful guests. For, according to Batey, the absence of the bride in the parable 'is in part due to the fact that he (Matthew) views the Church as a *corpus permixtum* which must undergo judgment and that the good separated from the wicked. Such a separation is easier to relate in terms of wedding guests who can be distinguished on the basis of their preparedness'.[15]

b. The wedded community in St Paul's letters

In Paul's texts in 2 Corinthians 11:2, the bride appears clearly. Here she is the community of Corinth who, by accepting Paul's preaching, has been betrothed to the one bridegroom, Christ. The context suggests that insofar as the community will remain faithful to Christ according to the truth of the Gospel proclaimed by Paul, the bride will be a pure virgin. Here, we see the introduction of the analogical link between the virginity of the Church and its fidelity to the faith received from the apostles. This theme will be abundantly exploited by the Fathers of the Church.[16] Paul notes: if the community, like Eve in the garden, lets itself be seduced by false apostles, it will thus become unfaithful. By alluding here to the image of Eve, the Apostle displays his interest in the already mentioned rabbinical exegesis of Genesis 2-3. However, it is possible that, underlying his thought, there

may be a reference to the seduction exercised on Israel by the idolatrous cults. Similarly, the false apostles (as later, the false doctrines) might seduce the community, thus making it unfaithful to Christ to whom it has been betrothed.

If the bride here is the ecclesial community 'understood collectively and, as it were, personified',[17] Paul's metaphor may be applied to the Christian individuals who form this community. For, each human person is destined to become a member of Christ. And yet, it does not appear that Paul or any of the other authors of the New Testament had thought of mentioning that the individual person can be considered as the bride (or the betrothed) of Christ. The individual is seen rather as a member of the wedded community. It is as such that he bears the dignity and the responsibility derived from the organic link created between Christ and himself *as* a member of the Church. The New Testament does not go any further. Only at the time of the Fathers, and especially with Origen, possibly because of a certain influence exercised by Philo, will the spousal symbolism be applied directly to the individual soul.[18]

We have already pointed out in a note on this passage from Paul, the connection that the Apostle makes between his ministry and the function of the bridegroom's friend, the *shoshebin*. We may add another important comment. In this context, Paul invites the community to be perseverant in its fidelity while waiting for the parousia. This ultimate moment will be, strictly speaking, the moment of the nuptials. The Apostle stresses here the idea of an already present eschatology by evoking the betrothal but it will be fully evident only with the decisive nuptials at the time of the parousia. And by that very fact, as much for the community as for its members, fidelity to the demands of faith (which, according to Paul, includes the whole ethical behaviour of the Christian) is the condition to be met in order to attain to these decisive nuptials.

Let us mention two other passages in St Paul which can be related to a certain feminine personification of the community of disciples and possibly refer to the nuptial symbolic. The

first, Galatians 4:22-31, which sees a typology of the Church in Sarah as opposed to Hagar, the type of the present Jerusalem, will be studied later when we speak of the salvific motherhood of Israel and of the Church. As for the second passage, in Romans 7:1-6, it is possible, as Colson explains, that:

> The ancient theology on divorce and marriage, inaugurated by Hosea and taken up again by the prophets... may be underlying Paul's text here, but with a new meaning. For, this remarriage of humanity with the glorified Lord Jesus, after the termination of the contract of servitude, following the death of Christ 'in the flesh', makes of this humanity a reality beyond, transcending human condition, even if it lives here below.[19]

And the author goes on to show that this transfigured humanity is the community of the disciples of Jesus:

> So appears the Church: like a woman whose condition is bound by marriage to the Christ-man, first under the regime of a contract which makes them both slaves of the Law, then, after the death of Christ, by remarriage with Christ who has become "other" in his glorification, under the regime of the Spirit. A remarriage which makes of her, here below, in the human condition, a reality in hope, her husband, to whom her own condition is bound, himself already 'pneumatized'.[20]

In this text, it is clear, that the theme of marriage is used not so much to recall the teaching conveyed by the traditional nuptial symbolic as to explain the passage of the Church from the old regime to the new regime. In spite of that, such a use presupposes the conviction in Paul that a spousal analogy characterizing the union of the elect with Christ and their transformation in him is pertinent. However, this conviction is all the more evident in Paul's final text which we must now examine.

In Chapter 1, we analysed the first stage of Ephesians

5:22-32. We must now examine this passage more fully as the summit of Paul's use of the conjugal symbolism.

A preliminary question must be raised about the source of the analogy. Does the Apostle, in this passage, draw upon the Hellenistic gnosticizing lines of thought current at the time, as Schlier and other exegetes[21] suggest, or does he use the conjugal symbolism such as it is developed in the Old Testament? This question has been studied quite thoroughly by a good number of authors, among whom several adopt the second hypothesis.[22] Indeed, although the myth of the *Anthropos* (the Man) held an important place in the main streams of thought at the time of Paul, the view of the latter, in spite of a certain similarity in terms, seems to flow directly from Old Testament and Jewish categories.

In the pericope of Ephesians 5:25-33, the bride of Christ, given as a model to woman, is clearly identified. It is the Church, who is the body of Christ; 'he gave himself up for her, in order to make her holy by cleansing her with the washing of water by the word' (Eph 5:25-26). Already established in her spousal being by the sacrificial offering of Christ, the Church is shown by the Apostle as being constantly presented by her spouse 'to himself' through the cleansing waters accompanied by words which probably evoke both the nuptial cleansing of the betrothed and the baptism of the new believers: 'for he wanted to present the Church to himself in splendour, without a spot or wrinkle or anything of the kind, – yes, so that she may be holy and without blemish' (Eph 5:27). Since the link between the cleansing waters and baptism is generally accepted, one must also understand that the perspective here is essentially collective. It presupposes the purification of the bride, understood as a unique social being, in the blood of Christ.[23]

In this imagery, we thus find ourselves in the presence of the Church already holy and immaculate in itself, thanks to the sacrifice of the bridegroom. But, at the same time, Christ is constantly in the process of sanctifying it through the baptism of its members. And Schlier comments:

Once led to Christ by himself, as his bride (in the gift he made of himself), the Church is presented as such (that is as a bride) in each baptism. Christ has given himself up for the sanctification of the Church in the sense that he always presents the Church to himself as his bride at the time of the baptism of each believer.[24]

The above indicates the meaning we must give to the expression 'head' (*kephalè*): Christ is the 'head' of the Church as man is the 'head' of woman. However, the lordship exercised by the Christ, the head, over his body is unique, and it transcends that of man over woman. For Christ is the 'saviour' of his body, a saviour who precisely expresses his dominion over his body by the loving surrender of his life in order to clothe his bride with holiness, beauty and glory. This takes us back to the perspectives of the conjugal symbolism in the Old Testament where Yahweh predicts the transformation of his bride which he himself will bring about at the time of the Messianic nuptials.[25]

As for the Church, she is the bride, 'the *vis-à-vis* placed before him', Christ, the head. Indeed, it is by introducing this bridal imagery that Paul finds a special basis for the otherness of the Church who, while being the body of Christ, is also, as it were, a person facing its head, Christ. Because she totally depends on him for her existence and for her holiness, she is expected to translate this dependence into active 'submission'. This submission always recalls a submission in faith to the order established by God, to the salvific design whose major points are outlined by the letter.

In fact, the Church is subjected to Christ (5:23) because it is already established in the perfection of holiness, something which assures her of being radically faithful through the salvific action of Christ in her... Under this aspect, the Church is presented as the eschatological and celestial bride, the one who pre-exists in the hidden mystery of the will of the Father. Nevertheless, she is also a pilgrim and thus, in her members on their way towards the end, she must constantly 'become' what she is through the regeneration of individuals

in baptism and, subsequently, through their effort to achieve unity in a harmonious and complementary submission to Christ, head of the Church. For it is in him and through him that the Church, in her members, 'joined and knit together by every ligament with which she is equipped, as each part is working properly, promotes the body's growth in building herself up in love' (Eph 4:16). That is why Cambier, speaking about the ecclesial bride, can say about our pericope: 'In Ephesians 5:24, the verb "to submit oneself" expresses the ideal faith of the celestial Church, the faith of the latter being presented by the very fact as a requirement to be met by the Church on earth who wants to be perfectly united to Christ, her Lord.'[26]

In other words, Paul presents in this passage the 'already' and the 'not yet' of the spousality of the Church. This implies that what Christ has done once and for all for his bride places the latter in a position of indefectible fidelity as his body, his people. But, at the same time, the bride must 'historically' express in her members this submission in living faith to the will of the Father, a will expressed in and through Jesus Christ, 'head' (in the sense of authority and principle of vital influx[27]) of his body. That is the ultimate goal pursued by the letter.

As a conclusion to our investigation, we must explore what meaning must be given to verses 31-32 and especially to the word 'mystery': 'For this reason a man will leave his father and mother and be joined to his wife, and the two will become one flesh. This is a great mystery: I declare it concerns Christ and the Church'. In order to discover what the significance of this great mystery is for Paul, one must see what connection the word has with the quotation from Genesis 2:24. Sampley points out that this Old Testament quotation also seems to be related to the *Haustafel* where, as we have already mentioned, reference is usually made to a text of the Pentateuch to provide a proposed moral behaviour with scriptural support. We may ask ourselves then if Paul's purpose is to suggest that the text of Genesis 2:24 possibly has a hidden meaning – the mystery – to which he would have

the key. Many exegetes believe so.[28] Nevertheless, according to Cambier and to Sampley who holds a rather similar position, the word 'mystery' should be linked directly to the fact of mentioning the union of Christ and the Church since Paul says: 'I am applying it to Christ and the Church' (5:32).[29]

This interpretation appears to be confirmed by Sampley's observation: 'When a substantive like *mustérion* (mystery) is used six times in such crucial places as it is in Ephesians, there is considerable probability of some line of continuity of meaning between the uses in different contexts.'[30] And after having reviewed these different uses, the author affirms: 'It may be concluded that "mystery" in 5:32 partakes of the same range of meaning already noted in earlier sections of Ephesians... it is precisely this... deeper meaning of Christ and the Church that constitutes the mystery for the author of Ephesians.'[31]

By pursuing this analysis further, Cambier shows that the final description of the mystery in this pericope (5:22-33) provides the ultimate significance to the central theme of the letter:

> The last description of the mystery (Eph 5:22ff) underlines its fundamental characteristic which is divine love, the proper object of the mystery. The initial account had already brought this out by the inclusion (...in the love) in 1:5ff. The final page on the mystery will use the image of nuptials to signify the union of intimate love which perfectly unites Christ with his Church.[32]

And through this union of love, the mystery of the love of the Father is revealed. For, 'the purpose of the Church of Christ, the Church of which the letter has constantly spoken, is to live and to manifest the mystery of the love of the Father.'[33]

We see therefore in this text of Ephesians 5:22-33 a kind of New Testament synthesis of the conjugal symbolic such as is developed by the preaching of the prophets. But this synthesis, at the same time, goes beyond and fully accom-

plishes what until then had only been suggested by this symbolism as revelation of the mystery of the loving designs of the Father.

Before we go on to other New Testament texts concerning the espoused community, let us add here a corollary. It will reinforce our affirmations in the first chapter on the principle of perspectives that Paul introduced in this *Haustafel* in relation to the traditional view of 'the world order'. Through the innovation introduced by Christ, the old order perturbed by sin yields its place to the 'Christian' order (cf 1 Cor 3:21-23; 8:6; 11:3) in which the believers accede to the freedom of the children of God provided they are, as Cambier notes, 'bound to Christ who binds us to the Father. Thus everything is brought back to unity by Christ (cf Eph 1:9ff). The new religious regime introduced by Christ into the world, to which its formerly lost unity is thus restored, is characterized not by laws but by a spirit which is summed up in the agape.'[34] It is in this agape that all the members of the Church are invited to live and urged to translate this spirit into the various concrete situations of their daily lives by the pursuit of unity in solidarity in a reciprocal submission, in a common search for the will of God (cf Eph 5:21) and in the surrender of self through love (cf Eph 5:1-2).

This same call characterizes the vocation of a man and a woman who have become one flesh in the conjugal union. Thus by pursuing unity in truth and love, the human couple united in Christ (for the Lord, Eph 5:22) is urged to let shine forth, for the sake of their brothers, something of this nuptial union which the Father, in his design of love, has established between his incarnate Son and humankind, in the Church, his bride.[35]

c. The espoused community in St John

The Gospel according to St John also considers the community of the disciples in bridal terms. To understand this, let us start from what we have already learned about the role of the *shoshebin* attributed to John the Baptist. In chapter 3,

verse 29, the evangelist makes the Baptist say: 'He who has the bride is the bridegroom.' Earlier, in chapter 2 verses 35-36, the same Baptist 'presents' to Jesus – therefore to the bridegroom – two of his disciples so that they may follow him, the Lamb of God, the Messiah. John the Baptist fulfils his mission of giving a testimony to the light (cf 1:7) by showing his disciples that it is in Jesus they must now believe. This same idea of preparation for the encounter with the bridegroom is emphasized by the evangelist when he shows John baptizing the crowds in the cleansing waters of purification (cf 3:22-27). Thus, the twofold action of John the Baptist as a *shoshebin* purifying the disciples and presenting them to Jesus suggests that the espoused community is now this nucleus of believers who have set about to follow Jesus, the bridegroom of the Messianic nuptials.[36]

This allusion to the bride being presented to Jesus in the person of his disciples ties up with what we have already seen in the synoptics and also in 2 Corinthians 11:2. The old Israel which was the bride is admitted to her status of 'people-bride of Christ' only by the act of faith of those who believe in the one sent by God, Jesus Christ. It is all the more significant here that John the Baptist, the last of the prophets, is the one who fulfils this mission, that of purifying and presenting the little nucleus of Israel, the remnant formed by the disciples. The continuity in the use of the Old Testament symbolic is thus strongly suggested.

Even if the wedding scene of Cana probably uses nuptial symbolics,[37] predicting the affluence of the Messianic times by alluding to the abundance of wine, yet there is no explicit mention of the bridegroom, Christ, nor of the bride, the community of disciples. Nevertheless, this passage, in addition to the indirect presentation of the bride through the Johannine typology of the 'disciple' who follows Jesus, directs our attention to the eternal nuptial feast in which those who believed in Jesus (Jn 2:12) – therefore, the bride – are destined to take part.

The indirect allusion made to the bride particularly stands out in John when he refers to the believing community,

thanks to the various feminine characters whose faith is typical. The figure of the mother of Jesus appearing at the beginning of the public life of Christ (Jn 2:1-11) and then at the hour of his glorification on the cross (Jn 19:25-27) is a striking example of this. Since we shall have the opportunity of speaking again of this typical function of the mother of Jesus in connection with the salvific motherhood, we shall withhold our considerations on this personification of the believing community until later.

In his analysis of the encounter of Jesus with the Samaritan woman, Braun stresses the link we have noted between this passage (Jn 4:4-42) and the previous ones in which the nuptial theme (the wedding feast of Cana, and the identification of Jesus as the 'bridegroom'), applied to the union of God with his chosen people, is present. We know from the Acts of the Apostles that a community of believers was emerging in Samaria as a result of the preaching by dispersed Hellenists (Acts 8:4-8) as well as by Peter and John (8:14-17). This is what makes Braun say: 'that by establishing a relation between what had occurred in the early Church and the gospel account, John wished to point out that the extension of the covenant beyond Judah was an answer to the intents of Jesus: 'The saviour of the world' (IV, 42).'[38]

There is nothing more fitting than that Samaria should be represented in the gospel narrative by a woman of loose morals, if the situation of this region in the Old covenant is taken into account. As Annie Jaubert shows,

This Samaritan woman is the figure of the syncretist Samaria which turned towards alien gods. The prophets had applied to her, as they had to Judah, the image of the faithless wife (Hos 2:4; 3:1) but they had also predicted that, in the future, Samaria – along with Israel as a whole – would return to God (Hos 2:21; Ezek 16:53-61).[39]

The whole context of the episode bears the traits of nuptiality: the five husbands of the woman, the reference to the well that 'recalls biblical scenes in which the patriarchs

gave their future brides (Jacob to Rachel, Moses to Zipporah) water springing up from the well'.[40] For the symbolism of the well in the Old Testament suggested both the gift of the Law and the renewal through the Messianic gift of the vivifying waters.[41]

'Through the Samaritan woman, Jesus offers the transforming waters of the Spirit, the renewed heart of the Messianic nuptials to the whole of the faithless, tainted and scorned Samaria.'[42] At the same time, by forecasting the new form of worship in spirit and in truth, Jesus shows that the material temple of Jerusalem (still less the one on Mount Gerizim) is no longer the place where God is present to his espoused people. 'The Messianic prophecy in verse 26 leads us to think that the new temple is Christ himself (cf 2:21), the Messiah, therefore, the anointed, the consecrated one.'[43] United to him, the new Israel, the bride in whom the Jews, the Samaritans and even the pagans (cf Acts 1:8), purified by the cleansing waters of the spirit, have been renewed in depth, may now offer to the Father the only form of worship which is really pleasing to him (cf 4:21, 23).

Another feminine personification in the Gospel according to St John holds our attention. It is that of Mary of Magdala who on 'the first day of the week... came to the tomb' (Jn 20:1; and later 11-18). In the opinion of André Feuillet, 'Mary Magdalen who seeks Jesus in tears after his death seems to embody the Messianic community in quest of its saviour who is no longer vividly present to it and gives the impression that he has definitely abandoned it.'[44]

This account, as Boismard and Lamouille point out, comprises an apparition of recognition, an act of faith and the use of a formula drawn from the kerygma: Mary of Magdala comes to tell the disciples that she has seen the Lord (Jn 20:18). On the other hand, the formula *seeking/finding* underlying Mary's experience, as much as her 'turning round' at the sound of Jesus' voice[45] with the act of recognition which followed, suggests that 'Mary is the very type of the "disciple" of Jesus'.[46] But there is yet more. Mary's act of faith follows the sign given to her by Jesus: he calls her by name.

This fact illustrates, first, the attitude of the Good Shepherd who knows his sheep by name (cf Jn 10:3, 10), but it also recalls the text of Isaiah 43:1ff where Yahweh, the lover of Israel, calls his chosen people by its name. Thus it is that 'Mary, the "disciple" par excellence, (symbolizes) the new Israel.'[47] Mary of Magdala thus appears as a personification of the new community formed of those who convert themselves at the call of the Lord, who recognize him in faith and who, when they find him, accept to be his disciples and follow him.

But another element may be added to the personification of the community of the disciples by this woman. Mary of Magdala also receives a mission from Jesus, that of giving her brothers the following message: 'I am ascending to my Father and your Father, to my God and your God' (Jn 20:17). Obviously, this mission was entrusted to Mary as a person. However, nothing indicates to us that Christ's act of sending her does not symbolize also the very mission of the Church which is to proclaim the new covenant that Jesus has established between the Father and humanity through his glorious cross.

One final question may be raised: if Mary of Magdala is a personification of the community of the disciples, is there an explicit reference to spousal symbolism underlying this account? If, along with Feuillet and in the wake of Michel Cambe,[48] we can detect a possible link (which, however, must not be too strained) between this account and the Song of Songs allegorically interpreted (especially 3:1-4), we then have a certain clue to the presence of such a symbolism. However, it is difficult to go very far in this direction, unless it is to emphasize the similarity between Mary of Magdala and the bride of the Song. This bride, according to the allegorical interpretation, 'is a sinner, the chosen nation so many times unfaithful, (for whom) the author constantly opens the perspective of her total conservation making it possible for her to be loved by her divine spouse with all the ardour and the fresh bloom of a first love'.[49] Even if we cannot be certain that there is here an explicit reference to the nuptial symbolism, the unfolding of the narrative, the recognition of

Jesus by Mary, the exchange of names, the covenant context, the personification of the community of the disciples, all of these are so many indications that may suggest a certain Messianic nuptial atmosphere.

When speaking of the feminine personifications of the community of Christians in St John, one must make a quick reference to the salutation in the second letter of the apostle: 'The Elder, to the elect Lady and her children, whom I love in truth' (2 Jn 1). And further on, he repeats this title: 'But now, dear Lady ...' (v. 5). At the very end, he adds: 'The children of your elect sister send you their greetings' (v. 13). By using this metaphor, the author most certainly refers to 'the community of Christians concretely living in the world'.[50] The Lady is therefore the Church, possibly the universal Church, but residing tangibly in a specific locality. This, besides, is what would explain the allusion made to the sister elect. For we may say here along with Chavasse: 'Each Church (local) is the Church. Each Church is the bride. Yet, there is but one Church, one bride.'[51]

d. The espoused community in the Book of Revelation

The final stage of our inquiry leads us to the very end of the New Testament, to the last chapters of the Book of Revelation. Earlier in this book, that is in chapter 12, a feminine personification, the 'woman', mother of a male child and of other children, already suggested the countenance of the Church. However, since we will be speaking at length about this passage in the next chapter, let us limit ourselves by recalling that chapter 12 of Revelation (as well as chapter 17 with the feminine antithesis personifying imperial Rome) directs us in its own way towards the use of the nuptial symbolic at the end of the book.

The first reference made to this symbolic has already been noted when speaking of chapter 19 verses 7 and 9 where the bridegroom is identified with the paschal Lamb who has redeemed his people.[52] When we examine chapter 19 as a

whole, we see that it describes a celestial liturgy singing both the victory of God against the great prostitute, Babylon, that is, Rome, as the persecutor of saints, and the marriage of God with his people. Here, the nuptials of the Lamb are proclaimed as having taken place: 'For the marriage of the Lamb has come... Blessed are those who are invited to the marriage supper of the Lamb' (19:7,9). But what these nuptials are will really appear only in chapters 21-22.

One of the major points of John's text is expressed in the passage where the author describes the finery given to the bride: 'His bride has made herself ready; to her it has been granted to be clothed with fine linen, bright and pure – for the fine linen is the righteous deeds of the saints' (19:8). As George Caird notes, the dazzling white garments are a symbol of holiness (cf Gen 35:2; Is 52:1; 61:10; Zech 3:4; Rev 3:4; 6:11; 7:14).[53] The preparation of the bride for the wedding consists precisely in thus clothing herself with holiness. However,

> this dress is not of her own making; like the white robes of the martyrs to which it is closely related, it is given to her (cf 6:11). It is made of a linen which signifies the sanctity of God's people, a sanctity achieved in the great ordeal by those who 'washed their robes and made them white in the blood of the Lamb' (7:14). It is martyrdom which has provided the prothalamium in the wedding of the Lamb.[54]

This reference to the garments of the bride places us in perfect continuity with the nuptial symbolic in the Old Testament where the bride is sanctified by the bridegroom through the purifying tribulation. But this passage (19:8-9), an echo of 7:14, implies the intervention of an absolutely new and totally effective mean term: the salvation perfectly achieved by Christ. This is what the blood of the Lamb, the source of purification for the Church and the believers, suggests. Thus, we go back to the same idea found in Ephesians 5:25-27, the purifying and sanctifying love of Christ giving up his life for his spouse. However, in 19:7-8, the idea of the believers

being faithful to the point of giving the supreme testimony, a fidelity by which the victory of God is expressed in their lives, is added. The effective transfiguration of the members, an effect of the gift of God but also, at another level, of the active fidelity of the believers, constitutes the great historical preparation of the bride for the eschatological nuptials.

We may notice also that, in the case of Ephesians 5:25-27, the stress was placed on the purifying baptism which restores to the Church her splendour as a bride embellished by the bridegroom. Here, the theological and moral commitment is central (the good deeds of the saints). However, in view of the liturgical atmosphere and the form of worship of the Book of Revelation (although this form of worship includes all of life, especially its struggles and even the possibility of martyrdom), it is possible that the sacramental experience of the life in the community (Baptism, Eucharist) underlies the thought of the author. The text of Revelation 7:14 points in this direction since it speaks of a participation in the passion and death of Christ, a participation which, in a Christian context, inseparably implies sacramental life and following Christ to the end.

In this first text of Revelation in which the bridal symbol appears, we detect the presence of another perspective we already mentioned. It has to do with the two eschatological levels: one already realized and the other still to come. The eschatology already realized means that the nuptials have taken place. Besides, it is in the middle of a celestial liturgy celebrating victory that this solemn proclamation is made. This 'already' is what guarantees this triumph in the midst of history. But precisely – and this is the second level – history is not yet brought to a close. That is evident in verse 9 which is both the proclamation of a beatitude and also an interpellation:[55] 'Blessed are those who are invited to the wedding supper of the Lamb.' To have received an invitation is not enough. One must make this invitation valid by coming to the wedding feast wearing the appropriate attire (cf Mt 22:11-14). For the eschatological 'not yet' demands the option of faith and the constant tension full of hope towards the end, a

tension which essentially implies patience, fidelity and a growing holiness. The ethical horizon of the Old Testament nuptial symbolic is thus introduced here in the historical tension proper to 'the time of the Church', a tension which is characterized by the certitude that God and the Lamb will triumph in the end. This end is near, even if the date cannot be foreseen.

With the beginning of chapter 21, after the great battle and the awesome last judgment of chapter 20, John sees the appearance of that towards which all the previous chapters were directed: the eschatological triumph of God which, at last, is perfectly and totally displayed:

Then I saw a new heaven and a new earth; for the first heaven and the first earth had passed away, and the sea was no more. And I saw the holy city, the new Jerusalem, coming down out of heaven from God, prepared as a bride adorned for her husband. And I heard a loud voice from the throne saying, 'See, the home of God is among mortals. He will dwell with them as their God; they will be his people, and God himself will be with them; he will wipe away every tear from their eyes. Death will be no more; mourning and crying and pain will be no more, for the first things have passed away' (Rev 21:1-4).

Let us note first the absolutely natural movement from the symbol of the bride to that of the holy city, Jerusalem. One notices the same fusion in verses 9 and following where the description of the betrothed, the bride of the Lamb, is that of the holy city, Jerusalem. Here again, we are in perfect continuity with the Old Testament spousal symbolic.

Moreover, the new Jerusalem 'comes down' from heaven; thus it comes from God being the fruit of his eternal design totally realized in Jesus Christ and which must fully manifest itself at the close of history, a fact which also goes back to the idea of the pre-existing celestial Church.[56] But as Caird shows us, verse 3b and what follows: 'See, the home of God...' is what gives this descent its full meaning. In fact, according to

this author, the word 'dwelling' (*skènè*) 'has a long and important theological history. It is the word regularly used in the Septuagint for the Hebrew *mishkan* (tent), which was the symbol of God's abiding presence in the midst of Israel in the wilderness.'[57] Moreover, the probable echo of Isaiah 7:14 in the expression 'God-with-them', which certainly refers to Christ,[58] indicates that the decisive covenant, fully realized in Jesus Christ, is now completely unfolded since God has finally triumphed over all that was against him (v. 3): 'They will be his peoples, and God himself will be with them' – this is the great formula of the covenant. In this celestial Jerusalem coming down from above, God himself, his glory and that of the Lamb, 'come down'; they completely transfigure the bride by making her his dwelling, his tent, a wording which recalls the prologue of the Gospel according to St John: 'He lived (*eskènôsen*) among us' (1:14) and the feast of the tents of the Hebrews.[59] Thus everything that the Old Testament prophecies foretold about the transforming union of the people with Yahweh their God, about the presence of the *shekinâh* in the midst of Sion and in the Temple, is completely fulfilled. Let us recall that in Revelation, the Temple is God himself or the Lamb (cf 21:22); the light in this Temple is also God/Lamb (cf 21:23). The absolute innovation, foretold by the prophets and realized in Jesus Christ, absorbs, so to speak, the old order by transfiguring it completely: 'See, I am making all things new' (21:5).

A final reference to the bridal symbol is subtly introduced in the epilogue of the book (22:16-21): 'The Spirit and the Bride say "Come"!' (22:17). The one who 'hears' is asked to pass on the command 'Come... Amen; come, Lord Jesus!' (22:20). These passages are like the sigh of the bride in whom the Spirit inspires the desire for an actual and, indeed a final accomplishment of the salvific work of God by the return of the Lord Jesus and the bursting forth of the Reign described in the two chapters 21 and 22. It appears very probable that this 'Come, Lord Jesus' draws its inspiration from a liturgy and from a Eucharistic liturgy like the one we find in the Didachè.[60] At the heart of history, the Spirit and the bride

together, rallying every true believer with their cry especially during the liturgy of the community, ask Christ to come. And he *comes*, for, since the death and resurrection of Jesus, the eschatology is mysteriously present in the Church, especially in its worship. And *he will come* since, theologically speaking, his return is always near: one must then listen to 'what the Spirit is saying to the churches' (2:7,11,17,28; 3:6,13,22).

3. *Theological significance of the nuptial symbolism in the New Testament*

We must now conclude this chapter on the nuptial symbolic in the New Testament. We shall do so quite briefly since the essentials on the theological significance of the Old Testament use of this symbolism are found again in the New Testament.

The first theological significance of this symbolism, is the revelation of the heart of God manifesting itself in his salvific design with regard to the humanity he wants to unite to himself in a spousal relationship. Hence the second aspect: the nuptial analogy reveals with particular intensity the idea of rapprochement which the covenant between God and his people implies. But we have also seen how this symbolism illustrates, in a special way, the dialectical movement of history through which Yahweh leads his people not without some setbacks, purifications and new beginnings, towards the nuptials of the Messianic era.

It is precisely here that the great innovation of the use of the spousal symbolism in the New Testament is introduced. For the Messianic era, that of the decisive nuptials, consists, beyond all expectations, in the coming of the Messiah himself, the only son of the Father, to be the bridegroom. The Son literally embraces the human race to the extent of taking its sin upon himself, of giving himself up for it on the cross, so that he may present it to himself as a holy and spotless bride. His presence as a bridegroom to the bride reaches a unique depth; he is 'God-with-us' who has put up his 'tent' in her

bosom (with the mysterious power of his Spirit) much more profoundly than Yahweh had done so through the presence of his temple and his *shekinâh* in Israel.

A second extraordinary fact is that the wedded community is truly in continuity with what the last prophets had foretold, the faithful remnant of Israel. This remnant enters into the community of the new covenant only through a personal act of faith in Christ, the one sent by God. And each remains there only by persevering in a living and active faith, in a life of true holiness leading to the total gift of oneself following Christ's example. Thus, through the image of the systolic movement of the history of the chosen people, the qualitative Israel is presented to us as a permanent reality.

However – and here is where the radical innovation in the dialectical movement of history appears still more clearly – all the old barriers: race, class, sex, have been destroyed in the mystery of the salvific Passover of the bridegroom. The new Jerusalem, the holy bride of the Lamb, is open to all humanity, to people 'from every nation, from all tribes and peoples and languages' (Rev 7:9). Consequently, the systolic movement of the reduction of the history of Israel is overturned and becomes, starting from the one, Christ, an immense diastole of expansion,[61] welcoming in the unique people, in the unique body-bride, all those whom Christ has redeemed in his Blood. Because the Church is the bride of the new Adam, she is and must be the new humanity recreated in him. The universalism outlined in the old prophecies comes to its total accomplishment here.

One final distinction must be made from what has been said previously about the Old and New Testament use of this symbolism. A certain innovation also appears in the dialectics of history, which interplays between the 'already' of the eschatological nuptials perfectly realized between Christ and his holy bride, and the tension towards the final accomplishment in the parousia. It is into this new movement of the 'already-not yet' that the diastole of the time of the Church is introduced.

Speaking of this diastole, Bouyer writes:

And just as the first movement did not stop before it retrenched itself on the unique, the second will progressively know unlimited extension, universal expansion. Yet it is not at all to the same, original multitude, from which the movement toward unity was effected, that the movement toward fullness will tend. There is no question of some ordinary 'return', for it is not a question of again fragmenting the unity that had been acquired with so much pain. Quite the reverse: it is a question of reintegrating the whole multitude into this unity. It is a question of 'gathering in the scattered children of God', this whole, immense people for whom 'one alone' died.

Adam begot humankind in sin by a fragmentation and unending division of humankind. On the other hand, the new Adam is to rebeget humankind to life in holiness by gathering it to himself.[62]

Thus, the vocation of the Church, the holy bride of Christ, still taking part in the journey of humanity in time and space, is to be the 'sacrament' of both this quantitative and qualitative unification of humanity in Christ (we see here a beginning of what will be said later about the motherhood of the Church). Because of this vocation, the Church, although she is the holy bride, is also the betrothed reaching out to the future, a betrothed who, in her members, experiences the great struggle against evil. And she always runs the risk of being swept along, in them, by temptations to infidelity (cf 2 Cor 11:3). The oscillatory movement, 'in a spiral-like manner' (infidelity, punishment, repentance, forgiveness), will thus characterize the pilgrimage of the bride of Christ throughout the history of humanity. And yet, in spite of this painful journey in poverty and strife, she is assured she will be constantly renewed by that Spirit who, in her and with her, always prays 'Come, Lord Jesus.'

1. Cf Karl Delahaye, *Ecclesia Mater*, p. 64.
2. Cf Claude Chavasse, *The bride of Christ*, p. 53.
3. *Ibid.*, pp. 56-57. The author also suggests there is a link here with an allegorical interpretation of Psalm 45. We shall see this later when we speak about the identification of the bridegroom.
4. Cf *ibid.*, pp. 41-44.
5. Cf Pierre-Marie Galopin, 'Repas', in *VTB*, col. 1088-1090.
6. Richard A. Batley, *New Testament nuptial imagery*, Leiden, E. J. Brill, 1971, p. 59. See also Joseph Colson (and Claude Wiéner), 'Les noces du Christ', in *Un roi fit des noces à son fils*, Bruges, Desclée de Brouwer, 1961, pp. 86-87.
7. Cf Marie-Emile Boismard, 'Les traditions johanniques concernant le Baptiste', in *RB*, 70 (1963), p. 38.
8. Pierre Bonoît and Marie-Emile Boismard, *Synopse des quatre évangiles en français*, II, Paris, Cerf, 1972, p. 115.
9. Cf Colson, *op. cit.*, p. 91.
10. Boismard, 'Traditions johanniques', p.28; *id.*, 'L'ami de l'époux (Jo, III, 29)', in *A la rencontre de Dieu*, Mémorial A. Gelin, Paris, Xavier Mappus, 1961, pp. 289-295. The theme of the purification of the bride mentioned here is found again in the text of Ephesians 5:26 but, in this case, the ministerial role of the friend does not appear, while this ministry is exercised by Paul in the passage where he presents to Christ the community of Corinth (cf 2 Cor 11:2). Cf Batey, *op. cit.*, p.63.
11. Cf the role of Yahweh in the old covenant, Is 54:1,5.
12. This parable of the ten virgins refers especially to the ways of wisdom and folly in an eschatological perspective.
13. Benoît et Boismard, *Synopse des quatre évangiles*, II, Paris, Cerf, 1972, p. 345.
14. Cf Colson, *Un roi fit des noces*, p. 92.
15. Batey, *op. cit.*, p. 60.
16. Cf Plumpe, *Mater Ecclesia*, especially pp. 22-28 and 82.
17. Colson, *op. cit.*, p. 104.
18. Cf Chavasse, *The bride of Christ*, pp. 84-85.
19. Colson, *op. cit.*, p.103.
20. *Ibid.*, p. 104.
21. Cf Heinrick Schlier, *Der Brief an die Epheser ein Kommentar*, Düsseldorf, Patmos Verlag, 1962, pp. 264-276.
22. Cf Lucien Cerfaux, *La théologie de l'Eglise suivant saint Paul*, new edition brought up to date and augmented, Paris, Cerf, 1965, p. 292; Pierre Benoît, 'Corps, tête et plérôme dans les epîtres de la captivité', in RB, 63 (1956), pp. 17-18; Cambier, 'Le grand mystère en Eph 5:22-33', p. 51-55; Sampley, *And the two shall become one flesh*, pp. 34-51; Jean Daniélou, *The theology of Jewish Christianity: The development of Christian doctrine before the Council of Nicaea*, vol. I, translated and edited by John A. Baker, London, Darton, Longman and Todd, 1964, pp. 306-313.
23. Cf Pierre Benoît, 'Horizon paulinien de l'épître aux Ephésiens', in *Exégèse et théologie*, II, Paris, Cerf, 1961, p. 70. Explaining this collective view,

Cambier writes: 'Through the rite of purification, expressing and realizing through divine force the sanctifying action of Christ, the Church, here represented corporatively, that is, as a whole and as body of Christ, becomes holy and perfect' (*op. cit.*, pp. 229-230).

24. Schlier, *op. cit.*, p. 258.
25. See Sampley, *op. cit.*, pp. 38ff, who shows the link with Ezekiel 16:1-14 and also the Song of Songs 4:7 (cf p. 68).
26. Cambier, *op. cit.*, p. 229.
27. Cf Jean-Guy Pagé, *Qui est l'Eglise, corps du Christ et communion*, II, Montreal, Bellarmin, 1979, p. 30.
28. Cf Sampley, *op. cit.*, pp. 97-100.
29. Cf Cambier, *op. cit.*, p. 44.
30. Sampley, *op. cit.*, p. 91.
31. *Ibid.*, pp. 95-96.
32. Cambier, *op. cit.*, p. 231.
33. *Ibid.*, p. 233.
34. *Ibid.*
35. By applying these considerations to contemporary conjugal ethics in which the dignity of woman is better recognized, Cambier will say: 'In this day and age, it is the same ethics of the agape which is proposed to the couple: to the two is proposed the love of his spouse while respecting the personality of the other, in an equality which is not egalitarianism and a levelling off of the specific characteristics of the woman' (*ibid.*, p. 241), and we dare add: which is not either a levelling off of the specific characteristics of man.
36. Cf Boismard, 'L'ami de l'époux', p. 295. There could be, in the reference to the expression 'the voice of the bridegroom' in the following verse, a reminder of the theme of the Song of Songs 2:8ff and 5:2-5. This is the opinion held by Boismard (p. 291) as well as by André Feuillet (*Jesus and His mother*, translated by Leonard Maluf, Still River, Massachusetts, St Bede's Publications, 1984, p. 12) and by François-Marie Braun (*Jean, le théologien*, II, Paris, Gabalda, 1964, pp. 99-103).
37. Cf Ignace de la Potterie, *Marie dans le mystère de l'alliance*, Paris, Desclée, 1988, pp. 183-231.
38. Braun, *Jean, le théologien*, III, p. 95.
39. Annie Jaubert, *Approches de l'Evangile de Jean*, Paris, Seuil, 1976, p. 61. Marie-Emile Boismard and Arnaud Lamouille affirm on their part: 'the Samaritan woman, a true character, is also the symbol of the whole Samaritan people' (in *Synopse des quatre évangiles en français*, III, *L'Evangile de Jean*, Paris, Cerf, 1977, p. 137).
40. Jaubert, *op. cit.*, p. 61.
41. On this theme, cf Annie Jaubert, 'La symbolique du Puits de Jacob, Jean 4,12', in *L'Homme devant Dieu, Mélanges Henri de Lubac*, I, Paris, Aubier, 1963, pp. 63-73.
42. Jaubert, *Approches de l'Evangile de Jean*, p. 62.
43. *Ibid.*
44. André Feuillet, 'La recherche du Christ dans la nouvelle alliance d'après la christophanie de Jo 20,11-18. Comparaison avec Cant. 3, 1-4 et l'épisode des pèlerins d'Emmaüs', in *L'homme devant Dieu, Mélanges Henri de Lubac*, p. 97.

45. This 'turning round' is not without recalling the 'turning round' expected of Israel, as in Hosea 3:5; 5:15 and discreetly calls to mind the third stage in the sequence of the bridal symbolism of which we have spoken in Chapter 2.

46. Boismard and Lamouille, *op. cit.*, p. 464.

47. *Ibid.*, p. 465.

48. Cf Michel Cambe, 'L'influence du Cantique des Cantiques sur le Nouveau Testament', in *RThom*, 62 (1962), pp. 5-26.

49. André Feuillet, 'L'Apparition du Christ à Marie-Madeleine – Jean 20, 11-18; comparaison avec l'apparition aux disciples d'Emmaüs – Luc 24, 13-35', in *EV*, 88 (1978), p. 215.

50. Delahaye, *Ecclesia Mater*, p. 62.

51. Chavasse, *The bride of Christ*, p. 88.

52. See John Sweet, *Revelation*, London, SCM Press Ltd., 1979, p. 277; Joseph Comblin, *Le Christ dans l'Apocalypse*, Paris, Desclée, 1965, pp. 20-33.

53. George Bradford Caird, *A commentary of the Revelation of St John the Divine*, London, Adam and Black, 1966, p. 234.

54. *Ibid.*

55. Cf Sweet, *op. cit.*, p.280.

56. On this theme, see Cerfaux, *La théologie de l'Eglise suivant saint Paul*, pp. 289-290.

57. Caird, *op. cit.*, pp. 263ff.

58. Cf Pierre Prigent, *Flash sur l'Apocalypse*, Neuchâtel-Paris, Delachaux et Niestlé, 1974, p. 96.

59. Cf Boismard and Lamouille in the *Synopse des quatre évangiles: L'Evangile de Jean*, pp. 22-24.

60. On the text of the Didache, see the edition by Jean-Paul Audet, *La Didachè; Instruction des apôtres*, Paris, Gabalda, 1958, pp. 236-237.

61. Cf Bouyer, *The Church of God...*, p. 242.

62. *Ibid.*

Chapter 6

The salvific motherhood in the New Testament

With the coming of the Messianic era, the bride of God of whom Israel was the preparation is totally accomplished; it is the community of the disciples of Jesus. But then, that means that this royal salvific motherhood promised for these final times, has also arrived and that the new espoused people receives from its divine bridegroom this fecundity foretold by the prophets. The New Testament must be studied once more so that it may reveal these accomplishments to us.

We shall see how the two levels of this theme of the salvific motherhood constantly intermingle. For through the maternal vocation of Mary, the mother of the King-Messiah, we can already discover, in profile, the spiritual motherhood of the Church. That is why our attention will be directed first towards the one whom God chose to bear the Word made flesh.

1. The mother of Jesus in the infancy narratives (Lk 1-2 and Mt 1-2)

a. The infancy narrative in St Luke

The most important details in relation to our theme are presented to us by St Luke in the first two chapters of his gospel.[1] These two chapters are centred on Christ the saviour, the one sent by God, the Messiah. This central position given to Christ is brought out by the parallel Luke sets between

Jesus and John the Baptist. This parallel helps to underline the transfer of what is best in the people of the first covenant (the pious, the *anâwim*),[2] of whom John is the last prophet, to the community of those who welcome Jesus, the Messiah, in faith.

The salvific motherhood par excellence is revealed to us in a special way in the account of the annunciation of the birth of Jesus (Lk 1:26-38).[3] However, this passage is preceded by another similar account, the one in which the priest Zechariah receives the news of the birth of a child in spite of the barrenness of Elizabeth, his wife, and the advanced age of this 'pious' couple (cf 7:13-16). As in the case of several special vocations in the Old Testament, the fecundity of a barren woman is a sign of Yahweh's fidelity to Israel (cf 1:68-71): he remembers his holy covenant (v. 72), for he sends the precursor who 'will walk before' the one who is coming (cf 1:16-17, 76-77).

This first announcement is followed by the proclamation of the great message at the heart of the gospel: the coming of Jesus Christ, 'Son of God', he who totally fulfils the Messianic expectations of Israel. It is important to note how, in comparison with the annunciation to Zechariah, everything in this second account is intensely focused on the one to whom 'the angel Gabriel was sent': Mary, the virgin from the poor village of Nazareth in Galilee. By using such a presentation, this scene shows the great systolic reduction of the movement of the history of Israel reaching its climax and, thus, its turning point. And this climax comes about through the intermediary of the news brought to a humble woman who, by divine choice, is called to the unique vocation of being the mother of the Messiah.

It is not, therefore, by accident that Luke, as Matthew also does elsewhere in another context, uses the words of the oracle of Isaiah 7:14 to express the angel's message to Mary: 'And now, you will conceive in your womb and bear a son, and you will name him Jesus' (Lk 1:31). The fulfilment of the Messianic hopes appears clearly as is indicated by the terms Gabriel uses to speak of the child (cf 1:32-33). Moreover, the

royal perspective, in spite of the humble nature of the presentation, is not without suggesting the countenance of the *gebirâh* whose child, a descendant of David (a fact confirmed by the allusion made to Joseph of the house of David), is the one foretold by all the royal Messianic prophecies of the Old Testament.[4]

The question Mary asks in verse 34: 'But how can this be since I am a virgin?' gives the dialogue a new turn. But before we see what this new turn consists in, let us dwell on the meaning of the question. This question is understood in different ways by the exegetes.[5] We shall not go into this discussion here. We might recall, however, that the living Tradition of the Church has always affirmed that Mary remained a virgin before, during and after the birth of Jesus. In greater depths, this mystery of the virginity of Mary sheds light on the fact that this woman totally belonged to the God of the covenant and was totally committed to the coming of the 'kingdom', even before the moment of the annunciation. This state of belonging is manifest in her final consent to the angel's request. Thus, the personal vocation as mother of the Messiah and wife of Joseph, while leaving Mary 'humbly' and 'simply' devoted to the daily activities of a Jewish woman of her times, firmly establishes her in the order of realities which are intrinsically and totally planned for the Messianic work of Jesus, her son. Such is the 'theological' meaning that can probably be detected in Mary's question to the angel.

This question, which gives a new turn to the account, allows the evangelist to reveal two things: the mystery of God's commitment implied in this virgin motherhood and the truly divine character of the child: 'The Holy Spirit will come upon you, and the power of the Most High will overshadow you; therefore the child to be born will be holy; he will be called Son of God' (1:35). This sentence alone sheds unexpected light on everything that has previously been said by the angel about the Messianic titles of Jesus. In the first place, the reference to the Spirit who comes upon Mary seems to recall the Spirit of the Creator sweeping over the waters in

Genesis 1:2 in the same way that it may also suggest the action of the Spirit in Christ at the time of his resurrection (cf Rom 1:4). In Feuillet's view, there is a probable link between the Lucan words of 1:35 (which are found again in Acts 1:8) and the text of Isaiah 32:15 which foretells how the eschatological restoration of the people, who are caught up in a situation of desolation and barrenness, will be brought about through an effusion of the Spirit from above. These clues allow us to sense that 'by the very fact of (this) divine intervention, the child will be "holy", that is, properly "divine".' And Fr George adds: 'From that moment on, his title of "Son of God" assumes a properly Christian plenitude unknown in the Old Testament.' This key verse (1:35) thus unveils in a very special way the great mystery of faith which is part of this Messianic motherhood: the incarnation of the Son and the source of humankind's renewal.

But if such is the scope of the significance borne by this verse, the affirmation of the virgin conception of Jesus thus appears to be a tangible fact, essentially laden with theological meaning. This fact is a sign of the mystery of Jesus: 'the child who will be born will have no father on earth; he will have one in heaven alone (Lk 2:48-49; 3:23).'[9] Being a unique presence of the holiness of God in the midst of his people, this child is revealed to Mary as the true Son of God mysteriously born from her virgin flesh.

This perspective revealed in verse 35 also helps us to understand how the virgin conception of Jesus, as was already the case for the fecundity of barren women in the history of the first covenant, is beyond the bounds of our human comprehension. For, according to the expression used by Laurentin, 'the Incarnation was brought about according to nature but, in certain respects, it transcends nature.'[10] Biology is not denied here; it is assumed and transposed to a level of which God alone has the key.

Mary's consent brings the account of the annunciation to a close. Enlightened by the heavenly messenger's explanations, comforted by a sign (Elizabeth's motherhood), a sign which, nevertheless, she had not requested (as opposed to

Zechariah), Mary replies: 'Here am I, the servant of the Lord; let it be with me according to your word' (1:38). Two main perspectives stem from this classical title of 'servant of the Lord' and from the formula of consent 'to the word' which Luke applies to Mary. In the first place, these two expressions, suggest an act of faith. For, as the *TOB* notes about the word 'servant', 'rather than of humility, it is here a matter of faith (v. 45) and love, for to be the servant of God in the Bible is a title of glory.'[11] At the very moment she accepts the maternal mission to which she is destined by God, Mary thus inaugurates 'Christian' faith: 'she is a believer for whom God's word is enough... she is the first Christian disciple.'[12] This sheds a particular light on the answer Jesus will give later to the woman proclaiming the greatness of his mother (Lk 11:27): 'Blessed rather are those who hear the word of God and obey it!' (Lk 11:28). Jesus does not minimize the beatitude experienced by Mary as mother of such a son, but he shows that she is especially worthy of being blessed because she has listened to the word, believed in it, kept it (in her heart and in her life to be nourished by it). Besides, this reply from Jesus echoes Elizabeth's exclamation: 'Blessed are you among women, and blessed is the fruit of your womb... And blessed is she who believed that there would be a fulfilment of what was spoken to her by the Lord!' (Lk 1:43, 45).

Mary's answer also crystallizes the significance of this account as a vocation story.[13] The mother of the Messiah appears clearly as one of those persons who are the object of a very special choice in the history of the chosen people. She is the beloved of God, the 'favoured one of God' (1:28), the delicate flower of Israel who bears within herself the lowly condition of her people; 'she is the *anaw* of Israel par excellence',[14] as she declares in the Magnificat: 'He has looked with favour on the lowliness of his servant'[15] (1:48). Mary thus has nothing to fear for the Lord is with her (cf 1:29); she has 'found favour with God' (v. 30). Here, we have an echo of the divine guarantees offered to the chosen of Yahweh in the Old Testament (cf Judg 6:12,16; Jer 1:8), guarantees which allowed them to place themselves in total trust 'in the service' of the

salvific will of God. And so, in the vocation of the salvific motherhood par excellence of this humble daughter of Israel, the Messianic hope and the mysterious contribution of the descendants of Abraham towards its fulfilment reach their summit.

Other elements, related to the theme of the salvific motherhood, may be gleaned in the first two chapters of Luke. In the account of the visitation, Luke brings out the action of the Spirit in John, in Elizabeth and in Mary (cf 1:39-56), as will also be the case for Simeon and Anna (cf 2:33-40). The Spirit thus always leads persons to proclaim the Messianic era and the maternal mission of the mother of Jesus. In the case of Elizabeth, the Spirit makes her 'recognize' the 'mother of her Lord'.[16] She blesses God first for his gratuitous choice which has made Mary the mother of the Messiah, for this motherhood itself and the unique relationship it establishes between the child and his mother, and finally, for the particular faith of this young Jewish girl.

The unity in the hymn attributed to Mary, the Magnificat, stems from the fact that all the biblical allusions interwoven in the text revolve around the theme of the fulfilment of the promises. This hymn, composed of 'two rhythmed stanzas on Mary and on Israel, each concluded by an allusion to the goodness of God with regard to the generations who fear him and to the descendants of Abraham',[17] again recalls the mission of the chosen people reaching out towards the Messianic era. This mission culminates in the salvific motherhood of the one whom God has chosen to be the mother of the King-Messiah.

The account of the birth of Jesus contains a most significant expression: Mary 'treasured all these words and pondered them in her heart' (2:19). This same idea recurs later in verse 51. In the two cases, Mary records within herself these events and these words which suggest the transcendent character of Jesus and his mission. Let us note along with Fr George,

Luke does not only say, nor at first, that Mary treasured these memories: he notes how she does so... Mary does not treasure the facts or the words of the revelation in a passive way; she seeks to penetrate into their meaning... This translation (of the active verb *sùmballein*) finds firm support in Luke's three texts, where Mary's faith must make an effort to move ahead towards the mystery (1:29; 1:34; 2:51). In all these texts, Mary's faith appears as a search, not a possession. It is an openness to a later revelation.[18]

Thus, in the fulfilment of her maternal mission, Mary is always defined as the believer listening to the word of God.

The final episode of the infancy narrative in Luke – the finding of Jesus in the Temple (2:41-52)[19] – serves as a transition and foretells what the relationships of Jesus with his mother will be during his public life.[20] It is in this context that one must seek the meaning of this dialogue between the child and his mother at the heart of which are found the key words by which Jesus asserts that he must 'be in' his 'Father's house' (2:49). Coming from the lips of this twelve-year-old child, the reply proclaims an absolute duty: 'I must', a duty which flows from his being the Son of God and from his mission. And the translation 'in my Father's house' apparently must prevail upon other translations, such as 'at the business of my Father', because of 'Luke's insistence on the Temple at the beginning of his gospel (1:8-22; 2:22-38) as at the end (24:53)'.[21] Thus, it is the whole mystery of his being and of his mission, a mission which will lead him to the cross in Jerusalem (cf 9:31), that Jesus reveals to his parents, even if the latter will accede only gradually to the profound meaning of these words of 'revelation'.

This episode aptly points out the distinction between the first aspect of the life of Jesus in which he especially appears as a man among men, 'obedient' to his parents (2:51), 'born of a woman, born under the Law' (Gal 4:4), and the second aspect which is his transcendent mystery and the salvific mission which he has come to fulfil. From chapter 3 on, Luke

114

begins the account of the fulfilment of this mission (the journey to Jerusalem). At that moment, Jesus will slip away from his mother. She will be able to reach him again 'only by hearing the word of God and doing it' (Lk 8:19-21; cf 11:27-28). Luke 2:41-52 therefore directs us towards a yet deeper understanding of Mary's personal vocation with regard to this Son of whom she is – at the cost of immeasurable demands made upon her – the first disciple.

Our enquiry in Luke 1-2 has helped us understand how the biblical theme of the salvific motherhood finds an unexpected accomplishment in these chapters. This prologue by Luke makes us see in Mary the one who, through her motherhood fully assumed in faith in the Word of God, expresses in its quintessence the vocation of Israel, to serve in the accomplishment of God's promise while mysteriously proclaiming the vocation of the Community of believers. However, can we go further and speak of the mother of Jesus as a personification of Israel, as the (eschatological) Daughter of Sion? Certain expressions from these first two chapters of Luke could lead us to think so. In the first place, the initial words of the Angel: 'Rejoice, God's favoured one' (1:28), according to a good number of exegetes, seem to refer to the Messianic joy proclaimed in Sion (cf Zeph 3:14; Joel 2:21 and Zech 9:9).[22] Mary herself would thus be, as a member of the people but also in her own personal being, the personification of this people and, therefore, the one who would realize the mysterious maternal vocation foretold to the Holy City.[23] In addition to this, the expression 'in God's favour' is not without recalling the profound sense of the prophecy foretelling this transformation of Israel promised by the Trito-Isaiah (cf Is 60:66). One can see that, in Mary, as Louis Bouyer[24] suggests, the transforming action of the Word of God to open up the people and especially the small remnant, faithful to the supreme gift of salvation, has attained its full efficacy. There again, Mary appears very much as the fulfilment and therefore the personification of the chosen people, of the Daughter of Sion.

To confirm this interpretation, one can resort to another

text – an indirect one. It deals with the vision of the cloud (the *shekinâh*) covering the Ark of the covenant in *Exodus* 40:34-35 and referred to by the angel in 1:35. The divine presence would have descended upon Mary 'as it had in the past on the Ark of the covenant'.[25]

The scene of the visitation to Elizabeth, thanks to the similarity of structure of the pericope with the account of the transfer of the Ark in 2 Samuel 6, could also be used here as another confirmation of this way of interpreting Mary's countenance. One must say, however, that for certain exegetes, this parallel does not appear to be very convincing.[26]

The Lucan text of Simeon's prophecy, in the passage dealing with the presentation of Jesus in the Temple, could offer, according to the interpretation suggested by Pierre Benoît,[27] another clue to the identification of Mary as the Daughter of Sion. Simeon predicts that Jesus will be a sign challenged and rejected by the people. He then addresses his mother: 'and a sword will pierce your own soul! – so that the inner thoughts of many will be revealed' (2:35). The sword,[28] according to Benoît's interpretation, is the revelation brought by Jesus. This sword 'will pass through the nation, bringing to light the moral character of every individual, dividing the good from the bad, and bringing disaster to the wicked'.[29] And yet, it is to Mary that these words are addressed. Mary may also be presented here as the personification of Israel, the Daughter of Sion, and it is as such that this prophecy first reaches her. Of course, this sword affects Mary as a person, as the personal aspect is included in the personification. For the fate reserved for her Son will be the source of cruel suffering for Mary. Indeed, it is as a mother that she will be crushed by this suffering. This suffering comes to her as a member of the chosen people, aware of the joy that her Son, Jesus, the Messiah (cf 1:54-55) was expected to bring to the nation, a joy lost to the people who reject his message and his person.

Nevertheless, the question remains: did Luke really intend to present Mary as the personification of the Daughter of Sion and in the perspective which interests us here, as the one realizing the maternal vocation predicted to the people for the

Messianic era? Let us recall first that the motherhood predicted to the Daughter of Sion was a spiritual motherhood, that is, the mysterious begetting of sons and daughters whom Yahweh her spouse would give her. Nothing seems to indicate that this salvific motherhood of the people was a motherhood with regard to the Messiah himself. And yet, this particular Messianic motherhood was anticipated *within* the people and, especially, in the line of David.[30] Through the Messianic motherhood of Mary, Israel itself becomes pregnant with the Messiah. Consequently, the hope to see emerging at last in Sion the sons and daughters, who will form the new people of God, can break forth. In this sense, for Luke, Mary is very probably a personification of the Daughter of Sion.

b. The salvific motherhood of Mary in Matthew 1-2

Mary's Messianic motherhood is also very clearly presented in the Gospel according to Matthew, although with fewer details than in Luke. This is also mentioned in the infancy narrative (ch. 1-2). These chapters form a prologue which is part of the whole gospel.[32] They are centred on the assertion of the origin 'of Jesus Christ, son of David, son of Abraham' (1:1). The Matthean considerations on Mary's Messianic motherhood appear in the first part of this prologue (genealogy: 1:1-17, and the annunciation account: 1:18-25).

The genealogy, a literary form by which the Israelites sought to establish solemnly and legally their situation in the chosen people,[33] starts here from Abraham and cuts across three great periods of the history of Israel: 'the patriarchal period, the royal period and the period following the exile'.[34] Each period comprises fourteen generations (1:17): twice the perfect digit, seven. It is, therefore, in Jesus that 'the history of the people finds its meaning and its crowning glory'.[35] Jesus is truly 'son of David, son of Abraham', fulfilling in his person the Messianic promises linked with the royal ancestor and the ancestor of Israel.

If the genealogy shows that Jesus fulfils the history of

Israel and its Messianic expectations, this fulfilment also implies a breach of which the genealogy itself is a proof. In the third part (1:12-16), in verse 16, the usual structure 'A begot (*egennèsen*) B, B begot C', is interrupted by what André Paul calls 'a somewhat necessary irregularity which will allow God to fill in once and for all the otherwise irreductible break that had carved its way between the fidelity of God and the infidelity of man; but always on the condition that man respond and commit himself freely'.[36] This irregularity is presented in the following manner: 'Jacob begot Joseph (A – B), the husband of Mary, the woman from whom was born (*ex hes egennèthè*) Jesus, who is called Christ.' Here, it is no longer the dynast who begets. By placing the emphasis on the motherhood of Mary and on the non-intervention of Joseph, Matthew seeks to reckon with a tradition which imposes itself upon him: the virgin conception of Jesus in Mary.[37]

Yet, one must go further and make the link between this irregularity and another significant fact in the genealogy, that is, the presence of four women figuring as mothers of certain ancestors of the Messiah. These women have also received a call to motherhood in spite of the limitations which could have kept them from it. Tamar becomes a mother while remaining a widow. Ruth, the widow, forgoes motherhood and for that becomes wife and mother (according to the Jewish tradition, Ruth, barren, becomes fruitful through a direct divine intervention). Rahab is integrated into the line of ancestors even if she is a stranger destined to be cursed along with all her fellow-citizens. As for Bathsheba, Uriah's wife, she becomes a mother by David, in spite of the crime.

Recent studies, drawing upon Midrashic texts, on these three women have led scholars to detect a precise meaning to their presence in the genealogy: they manifest the priority of God's election in the choice and orientation of those who bear Messianic promises[38] in the midst of the descendants of Judah. As A. Paul points out, what these women have in common, always according to the rabbinical interpretations, is:

The irregularity – but by no means sin – through which their motherhood necessarily goes through and thus the fulfilment of the Promise; the total submission to God's plan, nevertheless, disconcerting; and finally the intervention of the Holy Spirit who (according to certain Midrashic texts) revealed the originality of their mission to these heroines of Israel and gave them the strength to be faithful to their vocation in spite of many difficulties.[39]

These four women, included in the Messianic line of ancestors leading to Jesus, foretell the motherhood of Mary from whom Jesus is born. But in Mary, 'the irregularity' – or rather the 'exceptional means'[40] – is 'pushed to its extreme'.[41] When compared to the previous salvific maternities, what happens in her, without the natural concourse of her legitimate husband, is par excellence the work of a new and ultimate divine intervention. In addition to this, like Luke, Matthew will subsequently (1:18, 20) show that the creative action of God's power in this motherhood manifests itself in and through the transcendent intervention of his Holy Spirit. The genealogy of Jesus thus also culminates in the clear affirmation of the unique salvific Messianic motherhood of Mary, the virgin mother of Jesus.

Such a culmination, nevertheless, raises a problem explicitly manifested by the irregularity of verse 16: it is the legal integration of Jesus within the Davidic line of descendants. The purpose of the following pericope (1:18-25) will be to deal with this problem by giving an account of the news brought, this time, to Joseph, 'son of David' (1:20). By resorting again to the theme of continuity-discontinuity in the genealogy, Matthew will show, although the mother alone is involved in the human generation of Jesus without the intervention of the father, how '(there) can be continuity in the Messianic line of descendants since it is God himself who is directly involved in the birth of the child'.[42]

The description of the difficulty, as it appears to Joseph who is confronted with the fact that his betrothed is pregnant without his intervention (1:19), will allow Matthew to define

clearly what the particular mission entrusted by God to this 'just man'[43] really is. He has been chosen to introduce Jesus, through legal adoption, into the line of the descendants of David (cf 1:20-21). By thus describing the proper mission of this 'son of David', Matthew is reaffirming, through the words of the angel, the traditional fact of the virgin conception of Jesus by the action of the Holy Spirit, a fact he affirms by referring to the prophecy of Isaiah 7:14. The Matthean account therefore proclaims 'a "double" recognition of paternity: this child is totally from God and, at the same time, is truly the son of David through Joseph'.[44]

Given the objective of the evangelist, the place given to the motherhood of Mary is all the more significant. The virgin conception of Jesus in Mary is presented as the sign par excellence of God's fidelity to his covenant. Besides, already in its original context, the passage of Isaiah 7:14 qualified the conception and the childbirth of this 'heir' of David as a 'sign'. Moreover, the Davidic character of Matthew 1-2 can also recall the role of the *gebîrâh*, particularly in the expression which recurs five times: 'the child and his mother' (2:11, 13, 14, 20, 21).[45] The 'sign' of the fulfilment of the Messianic era is therefore obvious.

c. Corollary: Mark's relative silence

Before broaching the theme of the salvific motherhood in St Paul and then in St John, one must at least raise a question about Mark's relative silence on Mary's motherhood. The only allusions Mark makes to her are found in the texts parallel to those of Matthew and Luke concerning her presence near Jesus with the members of his family during his public life (Mk 3:21, 31-35; Mt 12:46-50; Lk 8:19-21) and in a sentence about the identity of Jesus: 'Is not this the carpenter, the son of Mary ...?' (Mk 6:3).

If Mark's testimony is most discreet, he nevertheless takes into account this woman by whom Jesus, 'Christ (and) Son of God' (Mk 1:1), entered into the stream of the history of

humankind. Besides, when he speaks of her as the mother of Jesus, he does not name Joseph, as opposed to what we find in Matthew. Did he wish thereby to suggest the virgin conception?[46] It is difficult to say. Be that as it may, Mary's motherhood with regard to Jesus underlies Mark's testimony.

The final aspect of Mark's position, concerning the distance Jesus puts between himself and his own, ties up with the facts given by Matthew and Luke on the subordination of the order of nature and blood relationships to the new order of faith. The allusion to this subordination points directly to the disciples in whom Jesus wishes to instil a precise lesson: 'it is more a challenge to those sitting there and to the later community to join in a spiritual fellowship with Jesus by doing the will of God.'[47] Nothing tells us that Mark wished to exclude the mother of the Lord from this spiritual kinship.

2. The salvific motherhood in St Paul

The allusion to the theme of the salvific motherhood in the letters of St Paul is quite discreet for reasons we will indicate as we proceed.

a. Paul and the mother of Jesus

Paul mentions the mother of Jesus only once. This occurs in verses 4-5 of Galatians 4: 'But when the fullness of time had come, God sent his Son, born of a woman, born under the Law, in order to redeem those who were under the Law, so that we might receive adoption as children.' That Paul may have wished to speak directly of Mary for her own sake and of her salvific motherhood appears uncertain. In spite of this reserve, one must nevertheless probe yet in greater depth and attempt to grasp the precise message of the Apostle in this text.

It must be noted that Paul is never directly concerned with

the concrete references made to the events in the life of Jesus, unless they are presented in a theological perspective. This fact is most evident in this passage. This is what Cerfaux notes:

> In Galatians 4:4-5 it is obvious that the intention is to underline the abasement of the Son in his temporal mission. The woman normally brings forth her child in sorrow, and the Law has a connection with sin. This abasement is subordinated to the work of salvation: he was born under the Law in order to ransom those who are under the Law, and born of a woman in order to be able to give us the character of sons of God. The preparation by means of abasement takes on the appearance of a condition which must be fulfilled before salvation is possible.[48]

Later, the same author shows how this verse sums up in some way the soteriological perspective inherent to the Pauline theology of abasement in the Incarnation: 'Christ was born of a woman so as to be able to die in a man's body, and thus obtain for us the dignity of sons of God.'[49] In addition to the significance of the abasement of Jesus, the allusion to the Law recalls the old economy (slavery to the Law, cf vv 21 ff). This old economy, through the Redemption brought about by Jesus, opens onto the economy of grace (the freedom of the sons adopted in the Spirit, he who makes us say 'Abba – Father'). Thus, the believer may accede to the legacy promised to the 'offspring (in the singular) of Abraham' (cf Gal 3:26-29).[50]

By using this indirect presentation, Paul suggests that the motherhood of this woman, like the whole economy of the Law, is salvific since it implants Christ in humanity – the flesh – thus bearing the mark of a divine salvific will. Through its death on the cross, brought about under the Law, this flesh of sin will become a source of new life for humankind in the glorious resurrection, and that, thanks to the Spirit (cf Rom 8:5-18).

b. The spiritual motherhood of the Church in Galatians 4:21-32

If Paul does not speak explicitly of the salvific mother-
hood of Mary, he is very formal about the spiritual mother-
hood of the Church. This appears in the text of Galatians
4:21-31 where he proposes an allegory[51] to the Christians of
this Church. In keeping with the cultural habits of the Greeks,
he uses a literary genre which sets a parallel between the
present Jerusalem (v. 25), Judaism, and the 'Jerusalem above,
our mother' (v. 26), the Church, the first being compared to
Hagar, the slave, and the second to Sarah, the free woman.

The purpose of the Apostle in this pericope, however, is
not to make a statement on the spiritual motherhood of the
Church as such, but rather to pursue his polemic against those
who would like to impose the practice of the Mosaic Law
upon the Galatians. What he wants to illustrate is that the very
testimony of the Law (of Scripture), according to his allegorical
reading of it, goes against such a submission of the Christians:
'Tell me you who desire to be subject to the Law, will you not
listen to the Law?' (4:21). The allegory of Hagar and Sarah
illustrates what had already been affirmed: since the fullness
of time, Christ, through his salvific work, has liberated the
subjects of the Law by conferring the filial adoption upon
them. 'So you are no longer a slave but a child, and if a child
then also an heir, through God' (Gal 4:7).

The two women represent the two covenants (4:24). More
precisely, Hagar, the slave, is the present Jerusalem, the one
bound to the testament of Mount Sinai, who gives birth to
slaves since she and her children were unable to accede to the
legacy of the promise given by faith in Christ. Sarah represents
the Jerusalem above and, therefore, the celestial city. This
expression 'above' refers to the community of the disciples of
Christ viewed as an eschatological community in conformity
with God's eternal design.[52] The Jerusalem above is mother,
and mother according to the spirit, that is, according to the
promise. Paul probably detects a link between the promise
and a motherhood according to the spirit from the fact that
Sarah, a barren woman, has been mysteriously freed by God

from her barrenness in order to give birth to Isaac, the heir to the promise. Here, spirit is opposed to flesh, that is, to man subjected to the slavery of sin.

In order to support his declaration concerning this motherhood of the ecclesial community, Paul refers to the oracle of Isaiah 54:1 promising Jerusalem, the barren, the one abandoned for a time by her divine husband, a motherhood already opening out to the nations as a whole. The perspective here is universalist, something different from the very Judaizing original outlook of the oracle itself. By applying this quotation explicitly to the Church of which the Christians, in the manner of Isaac with respect to Sarah (v. 28), are the children, Paul shows that in Christ the Messianic era, promised to Sion by the prophets with the new fruitfulness it supposes, has come. Henceforth, thanks to the gift of adoption in the Spirit (4:1-6), Abraham's posterity includes all those who will believe in Christ, in whom the promise made to the patriarch comes true.

This transfer from the Jewish to the Christian existence thus constitutes the new birth in Christ: 'So, then, friends, we are the children not of the slave but of the free woman' (4:31), the Church. Consequently, not only are the Christians no longer subjected to the Judaic prescriptions but they are totally free with regard to the present Jerusalem (Judaism). For the prerogatives of Israel are now present in the Messianic community. The fulfilment of the Messianic motherhood of Israel, foretold in the Old Testament, is becoming a fact in the spiritual motherhood of the Church, thanks to the redemption brought about by Christ (cf 4:4 ff) and to the gift of the Spirit who makes believers the adoptive sons of the Father (cf 4:5-7).

c. The 'maternal' paternity of the apostle Paul

The Pauline letters bring us a rather special testimony of the Apostle which goes back to the theme of the salvific motherhood. In these passages Paul describes his bond with

the Christians in terms that suggest a real spiritual paternity and brings together the idea of childbirth and maternal concerns.[53]

In a first text, Paul, speaking to the Thessalonians (1 Thess 2:7-12), describes in terms related both to motherhood and to paternity, the affable, humble, discreet attitude he has had towards them even if, as an apostle of Christ, he could have made them feel his full (moral and material) weight. Writing to the Corinthians, Paul not only compares the teaching he has transmitted to them 'to milk fed to infants in Christ' (1 Cor 3:1-3), but he calls them his 'beloved children' (1 Cor 4:14) and expressly tells them: 'For though you might have ten thousand guardians in Christ, you do not have many fathers. Indeed in Christ Jesus I became your father through the gospel... I speak as to children – open wide your hearts also' (1 Cor 4:15; 2 Cor 6:13). Here again, maternal and paternal images complement each other. A final text is the one from the Letter to the Galatians: 'My little children, for whom I am again in the pains of childbirth until Christ is formed in you' (Gal 4:19).

In order to have a good understanding of what Paul wishes to express in these various passages, one must examine these texts in the light of the overall attitude he adopts towards the communities he is addressing. In the first place, they are communities founded by him. He, therefore, defines himself as sent by God (cf Gal 1:15), as the Apostle of Jesus Christ whose fundamental mission is to proclaim the Gospel, to preach Christ to the nations. The Apostle goes so far as to say that it is this proclamation that constitutes the principle of the new birth of the Christians, for it is the Word of God operating in the hearts of men that makes them to be born again in Christ, according to the consistent testimony of the Scriptures (cf 1 Jn 3:9; 1 Pet 1:23, 25; Jas 1:18-21; also Philem 10). Paul is thus truly father, having a part in the fecundity of God, because he has instrumentally transmitted 'a word of life, a germ which transforms them into children of God'[54] to the new believers.

Paul has always recognized in this paternity, a service, a

stewardship (cf 1 Cor 4:1), a cooperation with God (1 Cor 3:9; 2 Cor 6:1). He is but an instrumer... Moreover, he does not hold this authority, with which he is invested, as a possession. It is the authority of God, of Christ, of the Word of which he is but a humble servant. This explains why, in his paternal attitude, he calls the Christians 'my children' only in passing. As a rule, he addresses them as 'brothers'[55] or friends.

At the same time, for the Apostle, this spiritual paternity constitutes not a title, but a quality of the heart, the testimony of his total gift to his own, a reminder of his tenderness, of his 'maternal' solicitude, similar to that of God, and of which we find numerous echoes in the Old Testament texts.[56] In the wake of the Saviour, Paul knows he is committed to bearing with his brothers in patience, constancy and grievous love, so that Christ may be formed in them. Paul experiences this childbirth as a way of sharing the sufferings of Christ for the life of his own (cf Gal 4:19).

It must be noted that, in this last verse, Paul uses the word *ôdinô* to speak of the pangs of childbirth. We find the same word again eight verses further down, in the quotation from Isaiah 54:1 applied to the Church, where Jerusalem, which has not known the pangs of childbirth, is mentioned. This is the only other instance (besides the allusion to the creation in child labour of Romans 8:22) where this expression is used. One may well see that the Apostle's line of thought is linked to that of the birth of the Messianic era. It is from the 'oblative' qualification of his collaboration in the work of salvation, that Paul not only can, but must recommend himself as a model for the communities to imitate, as sons can imitate their father (cf 1 Cor 4:15-16): 'Be imitators of me, as I am of Christ' (1 Cor 11:1). Because he is a minister, he must refer to the one who sends him so that all the Christians may, in their turn, be imitators of this God who reveals himself in Christ (cf Eph 5:1-2). Hence, we may sense that both the special mission of the Apostle and the vocation of the Christians for mutual service in communion allow the ecclesial community to actualize its 'motherhood'.

3. The salvific motherhood in John's gospel

Our enquiry into the theme of the salvific motherhood in the New Testament reaches a special level with the testimony of the fourth gospel. We have already seen the typically symbolic character of the theology of the fourth gospel in the feminine personifications used by John. The way John utilizes characters bearing symbolic meanings to present theological themes raises particular problems about the figure of the mother of Jesus, so much so that certain exegetes question the historical truth of the scenes where she is present. We shall seek to arrive at a clear understanding of both the symbolisms related to the figure of the mother of Jesus and the immersion into the revealed mystery of which these symbols are the vehicles. But we will do so without denying the essential historical facts concerning the mother of Jesus even if they are not always clearly detectable in John's presentation.[57]

Like Mark, John makes no reference to the childhood of Jesus and Mary's role at that time of the child's life. And did he want to mention, in the prologue (John 1:13), the mystery of the virgin conception? There is no consensus on this matter.[58] The mother of Jesus appears directly in only two instances in the gospel: in the beginning of the ministry of Jesus at the wedding feast of Cana and at the foot of the cross just before the last words of Jesus: 'It is fulfilled', an expression which recalls verse 4 of chapter 17 and confirms the accomplishment of the work of salvation by Jesus willed by his Father. The two allusions to the presence of the mother of Jesus mark, so to speak, the extension of the Lord's ministry on earth.[59]

The striking point in these two pericopes is the use of the same title: 'woman', attributed to the mother of Jesus. Yet, this is an unusual way for a Jewish son to address his mother since he would rather use the expression '*imma*'.[60] Moreover, the two passages are linked to the theme of the 'hour' of Jesus; in 2:4, Jesus refers to it directly while, in 19:25-27, even if the word is not mentioned, we know that this 'hour'

has come (cf 12:23,27; 13:1; 17:1): 'the hour is the passing of Jesus to his Father in the glory of the cross'.[61]

Since these two scenes are related to each other, we may ask ourselves what they meant to teach us about the theme of the salvific motherhood.[62] In the first place, the title used by John, 'the mother of Jesus', is significant since it recalls the human roots of the 'Word (who) became flesh' (1:14). In the context of the times and with the anti-Docetist view of the evangelist, this reference to the 'mother of Jesus' ties in well with the truth of the incarnation constantly emphasized by John.

No less significant, however, is the use of the word 'woman', first in Cana (2:4) and then on the cross (19:26). John seems to want to show that Jesus, in both circumstances, intentionally disregards the fact that he is her son. At Cana, the answer to his mother's remark, even through the apparent harshness of its wording, wants to direct our attention beyond the daily realities, symbolized by the lack of wine, towards the important reality to which his mission is bound and of which his 'hour' our will be its complete fulfilment. The natural order of the need, noted by 'the mother', is transposed into the new order of faith evoked by the 'sign' as a manifestation of the glory of Jesus and as the news of the passage from Judaism to the new covenant. But it is the cross (implying the resurrection) that will be the Hour par excellence of Jesus. The mother of Jesus is asked to make an act of faith in the totality of the mission of her son.

This scene at Cana, as the scene on Calvary will show us still more clearly, directs our attention towards the identification of the person of Mary with Israel. In this perspective, Annie Jaubert writes: 'Through the words of the mother of Jesus is expressed the aspiration of Israel to the Messianic wine. But in order to take part in the wedding feast, the one where Jesus will be the bridegroom, there must be an unconditional faith leading us eventually to the 'hour' our of the cross. On this road, the mother of Jesus precedes the nation of believers and opens the way.'[63]

In the scene on Calvary, the word 'woman' is found in a

text we can qualify, along with Michel de Goedt, as an 'outline of revelation'[64] expressing itself as follows: 'He saw X and he said: Behold Y.' In this episode, Jesus sees his mother and, standing near her, the disciple whom he loved and he says: 'woman, "here is your son"; then to the disciple he said: "Here is your mother"' (19:26). The evangelist thus indicates the revelation of a motherhood/filiation relationship of a new order solemnly proclaimed by the dying man himself.

Following this proclamation, the evangelist concludes the episode with this verse which Ignace de la Potterie translates in the following manner: 'From that hour, the disciple took her into his intimacy' (19:27b).[65] By this translation, de la Potterie shows that this expression conveys more than just welcoming the mother of Jesus in the house of the disciple. Here, this disciple whom Jesus loved is the figure of the true believer.[66] The meaning of this sentence, confirmed by the Johannine themes it contains and by parallel texts, is thus rather closer to the idea of acceptance of faith in one's life. It amounts 'to receiving the mother of Jesus *in* an interior and spiritual space, in the life of faith of the disciple',[67] for the expression 'in his intimacy' has a definite meaning in John. It expresses 'the space created by (his) communion with Jesus; it is in this spiritual setting, in this communion that the disciple now welcomes the mother of Jesus as his own.'[68]

But this account has also a soteriological and, especially, an ecclesiological impact. This pericope in John 19:25-27 is directly linked with the mystery of the pangs and the glory which are inseparable in the accomplishment of the Messianic task being realized on the cross. As Jesus had so described in parable form in 16:21,[69] his hour, the hour of his elevation on the cross, is the hour of the birth of the Messianic people of whom the prophets of old had spoken.[70] Thus the mother of Jesus symbolically refers back to the new Israel, mother of the true disciples of Christ. As such, she represents the Church being born to her vocation of motherhood since, henceforth, thanks to the gift of the Spirit (cf 19:30,34; 20:21-23), it is through her that the salvific work of Christ will be

pursued.[71] The true daughter of Sion, 'the Israel faithful to the Messiah and coming into faith',[72] becomes the mother of the believers, thanks to the accomplishment in her of the redeeming work of Christ (cf 19:30, 'It is fulfilled') and to the gift of the Spirit ('he transmitted – *paradôken* [to transmit] – the Spirit' 19:30).[73]

These statements are confirmed by the structure and the parallelism of this part of the passion account devoted to the execution of Jesus, as is shown in the following chart suggested by Raymond Brown.[74]

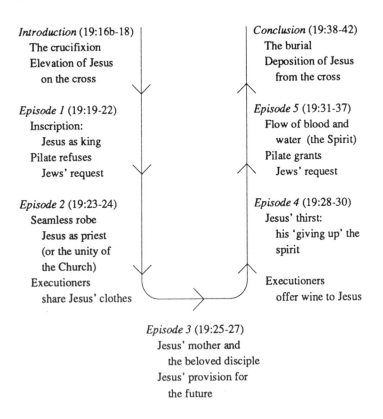

Introduction (19:16b-18)
 The crucifixion
 Elevation of Jesus
 on the cross

Conclusion (19:38-42)
 The burial
 Deposition of Jesus
 from the cross

Episode 1 (19:19-22)
 Inscription:
 Jesus as king
 Pilate refuses
 Jews' request

Episode 5 (19:31-37)
 Flow of blood and
 water (the Spirit)
 Pilate grants
 Jews' request

Episode 2 (19:23-24)
 Seamless robe
 Jesus as priest
 (or the unity of
 the Church)
 Executioners
 share Jesus' clothes

Episode 4 (19:28-30)
 Jesus' thirst:
 his 'giving up' the
 spirit

 Executioners
 offer wine to Jesus

Episode 3 (19:25-27)
 Jesus' mother and
 the beloved disciple
 Jesus' provision for
 the future

Commenting on this structure while bringing out the general direction of the symbols, Brown writes:

Episode 3 is centred on Jesus' lasting concern for the community of those whom he leaves behind (see also 17:9-19). His mother, the symbol of the new Israel, was denied a role at Cana because his hour had not yet come. Now that his hour has come, she is given a role as the mother of the beloved disciple, i. e., of the Christian. We are being told, figuratively, that Jesus was concerned for the community of believers who would be drawn to him now that he is lifted up from the earth on the cross (12:31).[75]

But a key question comes up; is the mother of Jesus, as a figure of the Church, the only one concerned in this text, or is the disciple taking in both 'the mother of Jesus and the Church as his mother'[76] at the same time? The principle of the interpretation of the Gospel according to St John is applied here, that is, the accounts always lead up to the mystery of Christ and to the history of salvation by urging us to have faith. Because of that, the meaning of the events goes beyond their materiality. The fact is that the fourth gospel is presented as the work of a witness, of this disciple whom Jesus loved and who, with the help of the Spirit (cf 16:13), confirms facts, but who also seeks to penetrate into the meaning of the scenes he describes.[77] Hence, these scenes are historically very important. One must therefore consider, as a whole, both the history and the symbolic meaning of the recorded facts. In the present case, the evangelist transmits us a twofold message, one concerning the mystery of the Church personified by the presence of the mother of Jesus at the foot of the cross, the other concerning the new motherhood of the mother of Jesus with regard to the believers.

We must not forget, however, that Mary's new motherhood with regard to the believers cannot be considered, as the text obviously shows us, without its essential reference to Christ. For salvation is the work of God realizing itself through the surrender that Christ made of his life. This is what Laurentin especially brings out when he comments on the eschatological childbirth of which the Johannine account of Calvary speaks:

This birth is a mystery that the gospel above all refers to Christ: in dying, he 'gives up the Spirit': John sees in his last breath, this breath of death, the breath of life of the Pentecost (19:30). And after that, the blood and the water, springing from his open side, are given as a sign of the birth of the Church symbolized by the fundamental sacraments of baptism and the Eucharist (19:34; cf 1 Jn 5:6-8, etc.). Briefly, Christ is the author of this mystery of birth, in which Mary is set as a feminine sign, whose impact must be appreciated in this case not as a biological fact or as a scholarly treatise on motherhood, but as a symbol: as a personification of the people who has given birth to the Messiah-Saviour and, by the very fact, to the saved people.[78]

The sense of Laurentin's observation, while not denying the personal motherhood of Mary with regard to the believers, becomes clearer in the light of the scene at Cana to which we must return. We see that Jesus, by inviting his mother to transpose her attention from the natural level to that of his Messianic mission, was asking her to make an act of faith. Indeed, if it is said that the disciples believed in him (2:11), it is not explicitly said that it was the same for the mother; however, Mary's reply, 'Do whatever he tells you' (2:5), indirectly implies her faith. Nevertheless, the fact that John reintroduces her, using the same terms at the most solemn moment of the gospel in a context where she obviously appears as the type of the believers,[79] allows us to sense that it is certainly the quality of her faith that we are concerned with here. Mary can therefore receive from God this new motherhood to which he has destined her because she is especially disposed to do his will, to hear his word in order to put it into practice up to the end.[80] That is why John could present the mother of Jesus, with the whole intensity of her being and of her commitment, as the type and model of the mother Church collaborating through faith to the spiritual childbirth of the new humanity.

4. The 'woman' of Revelation 12[81]

The last text to be analysed in the perspective of the salvific motherhood is chapter 12 of Revelation. This chapter introduces the part of the book which deals with the Church being confronted by totalitarian powers, that is, by the Roman empire.[82]

From the very outset, Revelation 12 introduces three characters on the scene: a woman appearing as a sign in heaven, a large red dragon and a male child born of the woman.[83] Towards the end of the chapter, moreover, the woman's remaining children being attacked by the dragon are mentioned.

Let us first consider the woman. She is crying out in the pangs of childbirth. But who is she and what motherhood is this? To answer these questions, let us first try to identify the child. He is a male child to whom John applies the words of Psalm 29, a Messianic psalm used by the early Christian tradition when speaking of the resurrection of Jesus.[84] The male child is therefore the Messiah, Jesus Christ.

But the birth mentioned here does not seem to be the temporal birth of the Messiah since it speaks of pains, of snatching away the child to be 'taken to God and to his throne' (12:5). The childbirth thus probably refers to the glorious birth of Christ at the time of his resurrection after the ordeal of the cross. It even possibly refers to the birth of the total Christ through the paschal mystery of the firstborn Son, as Ignace de la Potterie suggests.[85]

In this light, and given the Christological synthesis suggested by the person of the male child, one may reasonably identify the woman of Revelation 12:1-5 as the chosen people, the bride who remained faithful to Yahweh. Through this feminine figure, we touch upon the major themes of the nuptial symbolic found in the last prophets, since this faithful Sion is presented here as a great portent in the heavens: a woman clothed with the sun, standing on the moon and crowned with twelve stars. These symbols suggest possible links with certain passages of the Old Testament, possibly

with Isaiah 60:1 who speaks of Jerusalem upon which 'the glory of Yahweh has risen', and also with the Song of Songs 6:10: 'Who is this that looks forth like the dawn...' As for the crown of twelve stars, this may be an allusion to the twelve apostles or to the 'twelve tribes of the new Israel'.[86]

With the dragon's entrance on the scene, a change of emphasis will progressively come about. This dragon is well identified: he is the ancient serpent, the devil or Satan (v. 9). In the opinion of certain exegetes, there would be an allusion to the mysterious oracle of Genesis 3:15[87] underlying this scene of battle. This war is described from verse 5 on. Although the serpent seeks to devour the child of the woman as soon as it is born, he does not manage to reach him since the child is 'taken up to God and his throne' (v. 4), a reference to the absolute victory of Christ in his paschal mystery. Subsequently, the victory of Christ is symbolically transposed to heaven where Michael and his angels hurl down this accuser, the dragon, in a legal or judicial combat. Once the victory is won and the dragon is banished from heaven, the attacks he will lead on earth against the woman and her other children are but the last convulsive efforts of the vanquished who knows 'that his time is short' (12:12).

From verse 5 to verse 17, the emphasis is shifted: the woman is no longer the ideal Sion but the Christian Church on earth, the one who, with her children, is still subjected to the furious rage of the serpent-dragon. In this context of war, the seer shows us how, thanks to divine solicitude, the attacks of the dragon against the Church on earth will fail. The woman first receives from God a place of refuge in the desert (v. 6), there where 'she is nourished for a time, and times and half a time' (12:14). This computation comes from Daniel 7:25; 12:7. It means 1260 days and probably recalls the wandering of Israel in the desert. It is the 'time of the final ordeal which is also the time of the Church on earth'[88] 'previous to the establishment of the reign of God'[89] at the time of the parousia. The nourishment the Church receives in the desert seems to suggest a connection with the speech made by Jesus in John 6. As such, it would probably allude to the

manna as a symbol of the word of God and the Eucharist.[90]

Then comes the serpent's direct attack against the woman when he pours water like a river after the woman to sweep her away with the flood (12:15). This is a probable allusion to the false doctrines spread throughout the community in order 'to corrupt the Church's faith and to destroy it from within'.[91] Once again, however, the serpent fails. Then, furious about his lack of success, he wages a violent war – persecutions – against the remainder of the children (*spermatoi*) of the woman and, more precisely, against those 'who keep the commandments of God and hold the testimony of Jesus' (12:17). These *spermatoi* are the faithful remnant who, at the heart of the battle described in detail in chapter 13, remains firm through faith and obedience.

Consequently, in this second part, the woman dealt with here, even if she is the same one as in Revelation 12:1-5, must experience the tension between the assurance of the salvation which is given to her by the victory of Christ and the painful demands of fidelity that her children (and therefore she in them) are expected to accept until the end. The figure of the woman in the desert thus suggests the 'eschatological already-not yet' proper to her situation in the world and in time.

These elements allow us to determine the identity of the woman still more clearly. In the first verses, the ideal Sion was not yet truly the Christian Church born of the cross of Christ. It seems we could say with McHugh that this woman of 12:1-5 is the ideal Sion inasmuch as she is 'a symbol of faithful Sion, of those disciples who formed the remnant of Israel and the nucleus of the Christian Church'.[92]

But strictly speaking, in this nucleus, only one remained absolutely faithful and she alone is the mother of the Messiah in the proper sense, fundamentally at the beginning of the life of Jesus, but also when she becomes the spiritual mother of the disciples through her communion of faith in the salvific work of her Son (cf Jn 19:25-27). Consequently, for some exegetes, the woman, symbol of the Church, may also suggest, in the allusion to the ideal Sion (to the faithful remnant

of the old Israel), the one who represents it par excellence, the mother of Jesus.[93]

Better yet, along with Feuillet, we believe that this second allusion to the figure of Mary is even necessary. For although, fundamentally, the Church is the one represented by the woman according to God's design, the difference between the two phases of the vision, one prior to the birth of the Church and the other after, suggests that we look to Mary who alone is in touch with both phases of history. That is why Sweet calls her the 'symbolic link'.[94] The Virgin Mary sums up in her personal maternal vocation the maternal vocation of Israel, in the same way that she foreshadows that of the Church: 'it is in her that the joining of the old people of God and the Christian Church is effected, and it is in her alone that it is possible to bring into one the diverse roles attributed to the woman of Revelation 12 which appear otherwise incompatible'.[95]

The woman of Revelation 12 is therefore a composite symbol whose various aspects are all found again in the Church such as it exists in God's eternal plan: as much Israel, who prepares her, as the Church on earth, first fruit and maternal servant of its full growth when the new heavens and the new earth will come (cf Rev 21). The Virgin Mary, mother of Christ, is in some way the icon of this Church.

Consequently, because this chapter suggests, probably through an implicit allusion to Genesis 3:15, the perfect fulfilment of the history of salvation through the triumph of the male child over the serpent, and because this triumph brings victory to the remainder of the descendants of the woman, the theme of the salvific motherhood is also fully realized here. But what becomes especially clear is the kind of realization all this is about. The celestial and glorious sign of the woman, the Church according to the full scope of God's plan, and Mary, its icon, is a sign totally relative to 'the salvation and the power and the kingdom of our God and the authority of his Messiah' (12:10). And the motherhood mentioned here is ultimately the begetting, in the global birth of Christ (incarnation, death, resurrection), of a new situation

for humankind where the offspring of the woman can triumph over the powers of evil 'by the blood of the Lamb and by the word of their testimony, for they did not cling to life even in the face of death' (12:11). The woman, the Church, is the spiritual mother of these descendants, for, in her, this victory of Christ is shared by those who freely 'keep the commandments of God and hold the testimony of Jesus' (12:17) and who live with her in the desert, protected and nourished by God throughout the whole duration of the ordeal. As Mary, the mother of Jesus, participates with her fully living faith in the original begetting, she is subsequently mysteriously present as a spiritual mother because 'from that hour, the disciple took her into his own home' (Jn 19:27b).

5. The theology of salvific motherhood

a. The Messianic motherhood and the gift of the Son of God

We now have a better understanding of how the salvific motherhood, which finds its total fulfilment in the real birth of the Messiah-Saviour in Mary, is the sign par excellence of the reality of the salvific commitment of God to humankind. All the hopes for God's decisive intervention in the midst of history are now realized in the proclamation that the Father is sending his only Son in the flesh, 'born of a woman' in the midst of the people of the first covenant. This particularly stands out from the allusion, discreet in Luke and explicit in Matthew, to the oracle of Isaiah 7:14 in which the *parthenos* – the virgin – who conceives and gives birth through the mysterious action of the Spirit, appears as the great sign of this incredible presence of God in the flesh at the heart of the tragic history of humanity. Furthermore, the New Testament facts, considered as a whole, allow us to see in the salvific motherhood of Mary, as it were, the prologue to the drama of salvation through which Christ will give birth, in his paschal mystery, to a new humanity. That is why the motherhood of this young Jewish girl – a motherhood which brings about in

a unique way the co-operation that Yahweh expected from his people – finds its proper salvific significance in the fact that through her, God gives himself to the world in his incarnate Son, Messiah and saviour.

b. The Messianic motherhood of Mary

We have pointed out how the Old Testament placed a rather strong emphasis on the responsibility of the women chosen for a maternal mission in the history of salvation. The testimony of the New Testament concerning the mother of Jesus takes up this consideration again and explores it still further. Her maternal vocation is clearly presented here, especially in Luke, as a gratuitous choice through which God calls a young Israelite girl, whose ardent faith typically embodies that of the 'anawim of the people, to a particular motherhood. As in all the great 'callings' in the history of Israel, Mary commits herself as a humble servant of God with the will to accomplish this word spoken to her. Even the other elements of the synoptics, seeking to show the difference between the carnal bonds and those of faith by separating, so to speak, Mary from Jesus, emphasize in their own way how the personal fulfilment of Mary's vocation to divine motherhood essentially resides in her faith and in her will to fulfil God's plan. John stresses the intensity of this living faith in Mary by showing the mother of Jesus at the foot of the cross, in communion with the mission of her Son and thus collaborating in the begetting of the Messianic people. Thus, the positive outcome of the great war between the dragon and the descendants of the woman really integrates Mary, the icon of the Church, into the victory brought about by Jesus, her Son and saviour, thanks to her active commitment as a believer. It is in this sense that the motherhood of Mary, as the motherhood of a believer, may be truly defined as the motherhood according to faith, a spiritual motherhood. And that occurs at two levels. The first concerns her physical motherhood with respect to the incarnate Son. Mary, as the Fathers have

explained so well, conceived Jesus in faith before she conceived him in her flesh. The second level reveals to us that it is thanks to her commitment in faith (acting through charity) that Mary co-operated in an eminent way with her Son to the spiritual birth of the believers. That is why she can be described as the 'model and type' of the mother Church.

c. The salvific motherhood: symbol of the regeneration of humankind in Christ

What we have just said directs us towards a yet more profound understanding of the theological significance of the theme of the salvific motherhood in the New Testament. If the early Old Testament prophecy of a salvific motherhood involving the natural generation of the Messiah, mediator of salvation, is fully realized in Mary, the prophecy of a transformation of Israel (and through her of humanity) under the sign of the birth of the Messianic people directs our attention towards another level of realization. In the New Testament, the global mystery of Christ the Redeemer and, especially, his passage from death to a glorious resurrection is presented as such a birth. The theme of the spiritual salvific motherhood foretold to Sion thus can also be used as a symbol to speak of this renewal of humankind brought about by Christ, thanks to his unique sacrifice as the New Adam. Thus, beyond the real motherhood of Mary, who personifies the Daughter of Sion, the spiritual salvific motherhood foretold to the chosen people points directly to the Elect, the New Adam, the Mediator par excellence and towards the salvific work that the Father gave him to realize for humankind.

d. The spiritual motherhood of the Church

We can now better determine in what the motherhood of the 'Jerusalem above' consists (Gal 4:26). If the begetting of sons and daughters of God to new life is the fruit of the

passover of Christ, it is then evident that the motherhood of the Church is, by nature, an instrumental one, 'sacramental' as we shall see in Chapter 10. Through the mysterious action of the Spirit 'transmitted' by Christ (cf Jn 19:30; 20:22-23), the ecclesial community receives this new life from God. This community is expected to give this new life to those, men and women, who accept in faith the Word proclaimed according to the mission received from God. This motherhood is thus given to the Church by the fact that she was born of Christ as his bride. Christ, the bridegroom, is the one who protects this bride, purifies her constantly in his blood, nourishes her, transforms her and makes her fruitful through the gift of the Holy Spirit who dwells in her as the *shekinâh* dwelt in the temple of old. Better yet, this Church itself is the new temple of the body of Christ, enlivened by the Spirit, a living organism which progressively builds itself up through the action of Christ and the co-operation of the 'believers' moved by the Spirit. We thus see how the spiritual motherhood of the Church embodies the effective accomplishment of all that had been foretold to Israel concerning the Messianic era.

In our analysis of the theme of the salvific motherhood, we have also come across the Apostle Paul's affirmation of a maternal paternity with regard to the Christians. What we are saying about the maternal sacramentality of the Church in relation to the salvific work of Christ and the transforming action of the Spirit, ties in perfectly with Paul's affirmations. This ministerial action of the Apostle actualizes, in its own special way, the sacramental motherhood of the ecclesial bride of Christ of whom he is a member. Moreover, because of the attitude of tenderness and of total gift that the Apostle adopts towards his own, his maternal paternity refers back to the paternal-maternal tenderness of the Father as well as to the similar attitude of Jesus in his commitment of love carried to its ultimate expression in his sacrifice for the life of the world.

The following consideration must be added: the reference made to Mary's eminent spiritual motherhood as well as the allusion to Paul's participation in the mission expressed in an

attitude of maternal surrender of himself, an attitude he asks Christians to imitate, shows us that the motherhood of the Church must actualize itself in a special way through the holy life of her members. All the fruitfulness of holiness that God brings about in his espoused people is suggested here. All the baptized are invited to be part of this people but Mary is the one who will always bear this fruitfulness of the ecclesial bride in a unique way.

e. Summary of the three fundamental axes of the theme of the salvific motherhood

All the above perspectives may be brought together in three fundamental statements that summarize the contribution proper to this image. First, this theme proclaims the absolute priority of the gratuitous initiative of God intervening in history for the salvation of humanity and manifesting his operating presence by the choice of the persons concerned: the mother (an individual or a collectivity) and the child (an elect or elects). Secondly, since this is about motherhood, that is, a mission committing the mother in a responsible manner to a task directly linked to the vocation of the chosen people, this symbolism illustrates in a particularly significant way the possibility for one person to realize in a truly human manner, through this maternal mission, his or her vocation as a member of the people of the covenant. Thirdly, this theme, especially in the New Testament, casts a very precise light on the nature of salvation. It appears there as a new birth of a supernatural order, granted to the human person in the midst of a community which is the family of the adoptive sons and daughters of the Father in the firstborn Son, through the gift of the Spirit.

Having come to the end of this first part, it has become obvious that the Old and the New Testaments offer us, among their various ways of speaking about the chosen people, a feminine personification in terms of spousality and of motherhood. This feminine personification constitutes a means (among others) of bringing out distinctly the mystery of the

elective love of the Father who wanted to make the adoptive filiation accessible to humankind by sending his Son and pouring out his Spirit. In order to make it possible for all humans to accede to his intimacy, he wanted to give himself, in the 'person' of the Church, a collaborator (or an associate) for this work of supernatural childbirth. Through his bride and in her, each member of the ecclesial community may (and must) participate in this maternal mission of the whole Body. It is finally in this responsible commitment of each member of the Church – and the commitment of Mary here is typical as is also, at another level, that of Paul and the other apostles – that the maternal vocation of the bride of Christ takes on all its full significance and becomes a total reality. That is what we will be in a better position to understand, we hope, from the syntheses presented in the coming chapters.

NOTES

1. Cf Charles Perrot, *Les récits de l'enfance de Jésus: Matthieu 1-2, Luc 1-2*, Paris, Cerf, 1976, p. 35.
2. On the Lucan characters seen as *anâwim*, see Gelin, *The poor of Yahweh*, pp. 91-92, where the author speaks especially about Mary.
3. These accounts of announcements follow a pattern also found in the Bible and in the Jewish Haggadic traditions (cf Perrot, *op. cit.*, p. 42). A similar pattern appears in Matthew 1:18-25.
4. Cazelles, *La Mère du Roi-Messie dans l'A. T.*, pp. 25-26.
5. Cf George, *op. cit.*, pp. 436-437; René Laurentin, *Structure et théologie de Luc I-II*, Paris, Gabalda, 1957, pp. 183-188; Feuillet, *Jesus and his mother*, pp. 103-104.
6. 'L'Esprit Saint et la mère du Christ', in *Le Saint-Esprit et Marie*, I, EtM, 25 (1968), pp. 45-57.
7. George, *op. cit.*, p. 438. See also Lucien Legrand, *The Biblical Doctrine of Virginity*, p. 106; see also his article 'Fécondité virginale selon l'Esprit dans le Nouveau Testament', in *NRT*, 84 (1962), p. 789.
8. George, *ibid.*
9. George, *ibid.*, p. 438.
10. René Laurentin, 'Bulletin sur Marie', *RSPT*, 54 (1970), p. 303.
11. *TOB*, note p. 193.
12. The ecumenical study, *Mary in the New Testament*, edited by Raymond E. Brown, Philadelphia-Toronto, Fortress Press, 1978, p. 126.

13. On the function of this account as a story of a vocation, see Gelin, *Hommes et femmes de la Bible*, pp. 223-226.
14. Cf J. Terence Forestell, 'Old Testament background of the Magnificat', in *MS*, 12 (1961), p. 239.
15. On the meaning of this word, see Walter Vogels, 'Le Magnificat, Marie et Israël', in *EgT*, 6 (1975), pp. 284-287.
16. This is the first designation of Jesus as 'Lord', cf. Perrot, *op. cit.*, p. 74.
17. *Ibid.*
18. *Ibid.*, p. 446.
19. We gloss over, for the time being, the scene of the presentation of Jesus in the temple and the words of Simeon spoken to Mary. We shall come back to this later when we speak of the daughter of Sion.
20. For this account, we refer to the study by René Laurentin, *Jésus au temple, mystère de Pâques et foi de Marie en Luc 2, 48-50*, Paris, Gabalda, 1966, p. 278.
21. George, *op. cit.*, p. 229.
22. For an exhaustive analysis of the application of this personification to Mary, see Laurentin, *Structure et théologie de Luc I-II*, especially pp. 148-161.
23. Cf John McHugh, *The mother of Jesus in the New Testament*, London, Darton, Longman and Todd, 1975, pp. 51-52.
24. Cf Louis Bouyer, *The Seat of Wisdom: An essay on the place of the Virgin Mary in Christian theology*, translated by A. V. Littledale, New York, Pantheon Books, 1962, pp. 103-130.
25. *Ibid.*, p. 102.
26. For an explanation of this interpretation, cf Laurentin, *Structure et théologie de Luc I-II*, pp. 79-81.
27. Pierre Benoît, '"Et toi-même, un glaive te transpercera l'âme!" (Lc 2,35)', in *CBQ*, 25 (1963), pp. 251-261.
28. The image of the sword bearing the same meaning recurs in Is 49:2: 'He made my mouth like a sharp sword'; also in Eph 6:17; Heb 4:12; Rev 1:16; 2:16; 19:13-15 (cf McHugh, *op. cit.*, p. 108).
29. *Ibid.*
30. In Chapter 3, when referring to the text of Isaiah 65:2, which predicts the birth of the new people, we indicated the possibility of interpreting the first birth, that of a male child, as suggesting a relation between the Messianic maternity in the people – that of the Davidic Messiah – and the Messianic maternity of the people which is the central theme of this prophetic text.
31. For this section, we refer especially to Perrot, *Les récits de l'enfance de Jésus*, pp. 17-27.
32. Cf Perrot, *op. cit.*, p. 18.
33. Cf Paul, *op. cit.*, pp. 9-13.
34. Perrot, *op. cit.*, p.19.
35. *Ibid.* We should remember the value of the digit 7 and of its multiples as a symbol of perfection. In Luke 3:23-28, the Davidic line goes up to Adam, possibly to suggest that Jesus is the new Adam.
36. Paul, *op. cit.*, pp. 28-29.
37. We refer again to Laurentin's study quoted earlier (note 10).
38. See Paul, *op. cit.*, pp. 30-34. The author gives examples of Midrashic texts.

Midrashic elements on Rahab are found in the Letter to the Hebrews (11:31) and in the Judeo-Christian accounts, as Jean Daniélou has shown in 'Rahab, figure de l'Eglise', in *Irén*, 22 (1949), pp. 26-45.

39. Paul, *op. cit.*, p. 35.
40. Masson suggests replacing the term 'irregularity', which may be ambiguous and 'pejorative', with 'unexpected means, exceptional means' (p. 504).
41. Paul, *op. cit.*, p. 36.
42. Cf Perrot, *op. cit.*, p.22.
43. Ignace de la Potterie very aptly explains the sense of the intervention of the angel in the life of Joseph. The latter, informed by Mary of her unique maternity, finds he is not worthy of taking Mary and that son with him. The angel confirms the mission God entrusts to him: even if the child comes from the Spirit, he must nevertheless take it and its mother with him.
44. Perrot, *op. cit.*, p.22.
45. This is what Brian Nolan suggests in his thesis, *The royal Son of God: the Christology of Matthew 1-2 in the setting of the gospel*, Göttingen, Vandenhoeck & Ruprecht, 1979, pp. 42-43.
46. On this subject, see Béda Rigaux, 'Sens et porté de Mk 3:31-35 dans la mariologie neótestamentaire', *Maria in Sacra Scriptura,* IV, Rome, 1967, pp. 532-535. See also Manuel Miguens, 'Mary a virgin? Alleged Silence in the New Testament', in *MS*, 26 (1975), pp. 126-179.
47. Rudolf Schnackenburg, *The Gospel according to St Mark*, vol. 1, translated by Werner Kruppa, London and Sidney, Sheed & Ward, 1970, p. 68.
48. Lucien Cerfaux, *Christ in the theology of St Paul*, translated by Geoffrey Webb and Adrian Walker, New York, Herder and Herder, 1959, pp. 162-163.
49. *Ibid.*, p. 169.
50. Cf Pierre Grelot, 'La naissance d'Isaac et de Jésus, sur une interprétation "mythologique" de la conception virginale', in *NRT*, 94 (1972), pp. 482-484.
51. Cf Plumpe, *Mater Ecclesia*, pp. 1-13.
52. Cf Rudolf.Schnackenburg, *The Church in the New Testament*, translated by W. J. O'Hara, Montreal, Palm Publishers, 1965, pp. 79-80.
53. For an analysis of the Pauline texts on spiritual paternity, see Pedro Gutierrez, *La paternité spirituelle selon saint Paul*, Paris, Gabalda, 1969, especially pp. 87-239.
54. Saillard, *op. cit.*, p. 40. Also Gutierrez, *op. cit.*, pp.135-156.
55. Cf Gutierrez, *ibid.*, pp. 170ff.
56. Ex 4:32; Hos 11:3-4; Is 49:15; 66:10-13.
57. For a good presentation of this question, see Xavier Léon-Dufour, *The Gospels and the Jesus of history* (ch. 4, 'The Gospel according to St John'), translated by John McHugh, New York/Tournai, Desclée Company, 1968, pp. 78-107.
58. This would be so if one was to read a singular in this verse as *The New Jerusalem Bible* suggests: 'he who was born not from human stock or human desire' but of God (see note k, p. 1745).
59. Cf Raymond E. Brown, *The Gospel according to John, XIII-XXI (The Anchor Bible*, 29A), Garden City, N.Y., Doubleday, 1970, p. 925.
60. Cf F.-M. Braun, *Mother of God's people*, Staten Island, N.Y., Alba House, 1967, pp. 50-51.

61. Jaubert, *Approches de l'Evangile de Jean*, p. 75.
62. The interpretations of these passages, especially of 19:25-27, are often very divergent. On this subject, see Braun, *Mother of God's people*, pp. 77-93.
63. Jaubert, *op. cit.*, p. 76.
64. Michel de Goedt, 'Un schéma de révélation dans le Quatrième Evangile' in *NTS*, 8 (1961-62), pp. 142-150.
65. Ignace de la Potterie's detailed analysis of this passage appears in two articles: 'La parole de Jésus "Voici ta Mère" et l'accueil du disciple (Jn 19, 27b)', in *Mar*, 36 (1974), pp. 1-39 and '"Et à partir de cette heure, le disciple l'accueillit dans son intimite" (Jn 19, 27b)', in *Mar*, 42 (1980), pp. 84-125. On this passage, see also John Paul II, *Redemptoris Mater*, no 45.
66. On the figure of the disciple, cf. Jaubert, *op. cit.*, pp. 41-47.
67. De la Potterie, 'Et à partir de cette heure', p. 120.
68. De la Potterie, 'La parole de Jésus "Voici ta mère"', p. 37.
69. On the meaning of this particular form of parable, see Luc Simard, *Exégèse de Jn 19,25-27*, thesis for a Mater's degree in theology, Faculty of Theology, Laval University, 1975, pp. 37-52.
70. André Feuillet has thoroughly analysed the connection between the 'hour' of Jesus foretold in Cana and the accomplishment of this 'hour' in John 19 with the parable on the hour of the woman in John 16:21. He has made a synthesis of his studies on the subject in the book: *L'heure de la mère de Jésus. Etude de théologie johannique*, Prouille, Marie Dominique Ed., 1969, p. 120. The author quotes the following prophetic oracles: Is 13:8; 21:3; 26:17-18; 37:3; 66:7-8; Jer 4:31; 6:24; 13:21; 22:21; 30:6; 50:43; Hos 13:13; Mic 4:9-10; Ps 48:7 (pp. 45-46).
71. Cf Boismard and Lamouille, *op. cit.*, p. 443.
72. Jaubert, *op. cit.*, p. 76.
73. On the meaning of this delivery of the Spirit, see especially Braun, *Jean le Théologien*, III, pp. 151-152.
74. Brown, *The Gospel according to John XII-XXI*, p. 911.
75. Brown, *ibid.*, pp. 913.
76. De la Potterie, 'La parole de Jésus "Voici ta mère"', p.120.
77. Léon-Dufour, *The Gospel according to St John*, pp. 80-81.
78. Laurentin, 'Le sens de la femme dans le Nouveau Testament', p. 129.
79. This aspect is consistently emphasized by Brown. See, among others, his article, 'Roles of Women in the Fourth Gospel', pp. 698-699.
80. Cf also McHugh, *op. cit.*, pp. 391-392.
81. For this passage, we use first the general studies made on this book and already mentioned, as well as the studies by McHugh, *op. cit.*, pp. 404-432, and by Feuillet, *Jesus and his mother*, pp. 17-33.
82. Cf in collaboration, *Une lecture de l'Apocalypse*, Paris, Cerf, 1975, pp. 27-32. The period of Domitian is discussed.
83. On the possible mythical backdrop of these antagonists appearing on the vault of heaven, see the presentation by Caird, *The Revelation of St John the Divine*, pp. 147-149. See also Sweet, *Revelation*, pp. 194-198 and 203-205.
84. Cf Comblin, *Le Christ dans l'Apocalypse*, p. 78.
85. Cf de la Potterie, *Marie dans le mystère de la Nouvelle Alliance*, p. 274.

86. Cerfaux and Cambier, *L'Apocalypse de saint Jean lue aux chrètiens*, p. 103.
87. Feuillet, *Jesus and his mother*, pp. 21-22.
88. Prigent, *Flash sur l'Apocalypse*, p. 62.
89. Feuillet, *op. cit.*, p. 24.
90. *Ibid.*
91. Caird, *op. cit.*, p.159.
92. McHugh, *The mother of Jesus*, p. 416.
93. This is Feuillet's opinion. Cerfaux and Cambier, as well as Sweet (*op. cit.*, p. 203), tend to the same view.
94. Sweet, *ibid.*
95. Feuillet, *op. cit.*, p. 27.

Contemplating the 'facets' of the 'mystery'

Symbols 'provide food for thought'. The purpose of the next phase is precisely to help us 'think through' the mystery of the Church in the light of the biblical analogy of the 'nuptial' relationship between God and his people, with the promises of fruitfulness arising from this relationship. Our reflection, conditioned by a contemplative openness to the mystery, will nevertheless present an authentic 'systematic' content.

In practical terms, we shall first speak about this God who initiates and realizes this covenant by giving himself a partner: the Church. The first phase will therefore be entirely devoted to the mystery of God, Father, Son and Spirit, as he reveals and gives himself to this 'espoused' humanity in his incarnate Son. This prolonged gaze cast on the mystery is, as it were, the 'heart' of this second section, since it is from God and his design of love for humanity that we can discover the key to the understanding of the ecclesial mystery and of our own personal mystery.

In the two subsequent chapters, we shall dwell on the human subject of the covenant relationship with God. The bridal and maternal symbols will help us to define better the scope of two aspects. First, they will allow us to determine who, both on the collective level and on the individual one, is this covenant partner God has given himself (Chapter 8: The Church Person). They will then help us determine better how the communion between this people and God gives the ecclesial bride the power to collaborate truly in the work of salvation (Chapter 9: The motherhood of the Church and its

members). In the subsequent Chapter (The mystery of the 'femininity' of the Church), we shall attempt to see if it is possible to speak of a certain 'feminine' qualification of the Church, and then we shall point out what essential meanings could emanate from such a personification. The final Chapter ('Femininity' of the people of God and ecclesial renewal) will bring to light certain contributions this approach to mystery could bring to the life of the Church.

Chapter 7

The benevolent design of God revealed by the nuptial and maternal symbolisms

The symbolization of the election of the Church as a bride, destined to take part in the salvific birth of the new world, unveils, in a privileged manner, the 'heart' of God to us. Our first gaze shall be cast precisely on this God of benevolence and mercy. This Chapter will help us understand in greater depths the benevolent design of God, Father, Son and Spirit, and the 'economy' implied in the commitment of each divine person in this fruit of their love.

1. The 'economy'[1] in the election of the Church as bride

What first appears in the mystery of the Father's election of humanity to become the fruitful bride of the incarnate Son is the benevolence of God. It is the gratuitous love of this God, Father, Son and Spirit, who, as such, is 'economically' committed to the realization of this project of spousal communion with humankind. This is the first important conclusion revealed in this investigation.

a. The Father's love which spousally unites his Son to humanity

The nuptial covenant between Yahweh and Israel metamorphoses itself, in the Messianic era, into an analogy of an undreamt-of realism, that of the union of the Son with hu-

mankind 'in one flesh' through the redeeming incarnation. St Augustine strongly emphasizes this realism: 'The conjugal union is that of the Word and the flesh: the bed of this union is the womb of the Blessed Virgin: the Word, indeed, has united itself to the flesh; that is why it has been said: "They will no longer be two, but one same flesh".'[2] The Church, in this first moment, is already, as it were, radically made 'body of Christ': 'The Church recruits itself in the midst of humankind in order that the flesh united to the Word may become the head of the Church and all the other believers, members of this head.'[3] The first nuptial covenant is thus this consubstantiality that the Word has assumed with humanity.

But the realism of the nuptial relationship between the Son and human nature must also be ultimately considered at a second level. The union of the Word with humanity means his assumption of the tragic existential condition of human beings, tragic because of their separation from God with all the consequences this entails (cf Phil 2:6-8). 'For us men and for our salvation he came down from heaven' as the Nicene-Constantinople Creed declares. On the cross and in his mortal flesh, for the sake of his bride, Christ experienced the passage from this world of sin, of suffering and of death into the world of the resurrection and eternal life with the Father. The priestly and sacrificial act of Jesus, a supreme act of love flowing from his heart as Son and saviour (cf Jn 13:1), an act that purifies and sanctifies the ecclesial bride (cf Eph 5:25-28), radically consummates these nuptials between God and humanity. That is why Augustine can say: 'When was she (the bride) loved? When she was still in all her ugliness. He obliterated her ugliness and gave her beauty.'[4] It is by identifying himself with this ugliness of sin that Christ, who became – especially on the cross – 'without form or majesty' (cf Is 53:2), brought about this transformation of the bride.

What is manifested in the gift of the Son – 'while we still were sinners' (Rom 5:8) – as 'the atoning sacrifice for our sins, not for ours only, but also for the sins of the whole world' (1 Jn 2:2), is fundamentally the love of the Father. The marriage of the Word with humanity and its consummation

on the cross constitute the summit of the revelation of the efficacious elective will of the Father, as Paul expresses in a very powerful text in the Letter to the Ephesians:

> But God, who is rich in mercy, out of the great love with which he loved us even when we were dead through our trespasses, made us alive together with Christ – by grace you have been saved – and raised us up with him and seated us with him in heavenly places in Christ Jesus (2:2-6).

b. Union between Christ and the Church in and through the Holy Spirit

This mystery of the salvific election of humanity by the Father is, equally and indissociably, a pneumatological mystery. Here again, the nuptial analogy is particularly eloquent, especially in the use of the image, cherished by Tradition, of the birth of the Church from the pierced side of Christ on the cross, like Eve drawn from the side of the slumbering Adam.[5] The scene of the cross in St John, as we have seen, is that of the birth par excellence of the new world, and the 'mother' who is giving birth here, is in a sense Christ himself, the saviour of humanity who, according to the expression used in the Letter to the Hebrews, 'through the eternal Spirit offered himself without blemish to God' (Heb 9:14). For the Spirit, who 'lay' upon Jesus since the incarnation, intervened at the moment of his sacrifice to set his heart of incarnate Son aflame with this charity which would make his sacrifice agreeable to the Father. This is what Jesus signified at the Last Supper when he gave himself up totally under the species of bread and wine: 'Take and eat, this is my body given ... Take and drink, this is my blood poured ...'. The gift of his life was an act of total freedom in the Spirit. Thus, the act of love, by which Christ gives himself up to the Father, is the act of his human will, but raised to the loftiest heights by the dynamism of the Spirit. It is this act of love, in the power

151

of the Spirit, that is formally the birth of the new humanity.

The exegesis of this Johannine pericope on the 'hour' of Jesus offers an essential complement. Verses 30 and 34 of Chapter 19 suggest that the Spirit (*pneuma*) Jesus received in plenitude at the time of the incarnation and of his baptism, has been freed by his death, just as it is first the Spirit that seems to be aimed at by the symbols of water and blood springing from his pierced side even if these are a reminder, on a second level, of the ecclesial communion of the Spirit through the Church as 'sacrament' and through the sacraments of the Church. The birth of the bride from the side of the new Adam thus simultaneously reveals two points. It manifests the Christic birth, with the breath of the Spirit, of the new humanity whose premises and sacrament are the ecclesial bride herself destined to become a mother. This scene also recalls the mystery of the communication of the Spirit of Christ to this new humanity in view of building it into the body of Christ and into the temple of the Spirit, a communication of which the scene in John 20:22-23 and especially the event of Pentecost (Acts 2:1-13) will be its historical manifestations (the visible mission of the Spirit as understood by Thomas Aquinas and the classical theologians).[6] The unique economy of salvation, according to the unique design of the Father's wisdom, is thus expressed in two missions, both co-instituting principles of the Church,[7] that of the Son and that of the Spirit, the two hands of the Father, a beautiful expression used by St Irenaeus of Lyons.[8]

The use of the nuptial symbolism can yet further explain this economy. The text of Ephesians 5:25-27 has shown us how Paul links the birth of the Church, that is, its constitution as holy bride, to the surrender Christ made of himself for her. This 'nuptial bath' of the Church constantly actualizes its effect through the baptism of new members. We find again quite a similar idea, although more developed and expressed with more imagery, in Methodius of Olympus in his *Symposium*.[9] Speaking of Adam's mysterious slumber in Genesis 2:21, which he compares to the death of Christ, he explains:

The Church grows day by day in size and in beauty and in numbers thanks to the intimate union between her and the Word, coming down to us even now and continuing his ecstasy in the memorial (*anámnesis*) of his passion. For otherwise the Church could not conceive and bring forth the faithful by the water of regeneration unless Christ emptied himself for them too for their conception of him, as I have said, in the recapitulation of his Passion, and came down from heaven[10] to die again, and clung to his spouse the Church, allowing to be removed from his side a power by which all may grow strong who are built upon him, who have been born by the water and receive his flesh and bone, that is, of his holiness and glory.[11]

The commemoration (*anámnesis*) mentioned here is not only the historical paschal mystery of Christ. It is, according to Delahaye's expression, 'the mystery of Christ, founded on this historical event, which henceforth endures and continues to act for all times in view of the salvation of men and the world'.[12] What Methodius is referring to, then, is the sacramental economy of the Church – in this case baptism[13] – not excluding, but presupposing the memorial of the passion par excellence (cf 1 Cor 11:26), that is, the ecclesial celebration of the Eucharist.

A text from the Letter to Titus (3:5-7) clarifies what Ephesians 5:25-27 only mentioned about the nuptial bath by explaining clearly 'that the Spirit plays a part in baptismal purification and regeneration':[14] 'He saved us... through the waters of rebirth and renewal by the Holy Spirit. This Spirit he poured out on us richly through Jesus Christ our Saviour, so that, having been justified by his grace, we might become heirs according to the hope of eternal life' (Tit 3:5-7).

What emerges here is the affirmation of the historical permanence of this Christic and Pneumatic economy in the time of the Church so that the latter may be built into the spousal body of the Son.[15] This permanence is nothing but the establishment and the preservation of the Church bride in her maternal role (cf Gen 4:21-32). As was shown, both in the

scene at the foot of the cross, where the symbolic role of the mother of Jesus suggested the birth of the ecclesial community, and in the figure of the woman of Revelation 12:3-4, the Church is born to her maternal vocation in the act that makes her exist as bride and eschatological community. It is truly this act, of which the Memorial renders the purifying and sanctifying virtue (cf Eph 5:25-27) present, that gives the Church the capacity to be sacramentally the spiritual mother of the new humanity begotten by Christ in the Holy Spirit.

c. The entry into the Trinitarian communion

The description of this Christic and Pneumatic economy in the mystery of the Church leads us to a better understanding of the purpose of that mystery of election: the call made to human persons to the Trinitarian communion. We have already seen how the nuptial symbolic was essentially one of rapprochement and union, particularly apt to interpret the mystery of the covenant. Certainly, the analogy of the body applied to the covenant union of Christ with the Church allows one to express, in a unique way, this summit of proximity which becomes real through the redeeming incarnation of Christ and the gift of the Spirit. But it is by introducing the analogy 'bridegroom-bride' that the dialogical and, therefore, the communional character of this union is particularly made evident. For this analogy insists, as Louis Bouyer points out, 'on the radical and untransmittable distinction of two persons united but forever inconfusible and, more particularly, of a dependent person attaining its full maturity through this very dependence'.[16]

When, in the next Chapter, we seek to determine who is the Church Person, we shall see how the dialogue, called for by this covenant, corporatively commits the Church herself as a unit. What matters to us here is to see how the fundamental existential dialogue of Christ and his bride comes about, in fact, only thanks to the presence of the Spirit of Christ in the Christians, he in whom the communional unity of the mem-

bers of the Body is precisely secured in the divine communion. For the ecclesial bride is 'personally' in a covenant dialogue with her divine spouse only if she herself is a communion of persons in and through the Spirit, the source of a personalizing communion for each person. That is why Bouyer can write:

It is here that the Pneumatological ecclesiology is finally articulated on basically Christological ecclesiology, for although the work of the Spirit proceeds in us entirely from the work of Christ and consummates our union with Christ and our unity in Christ, it also consummates our personal existence in this union. This is the merit of the Russian Orthodox school of theology, illustrated especially by Vladimir Lossky: to have emphasized with incomparable force that the work of the Spirit is certainly a work of unity, but of essentially interpersonal unity, in which far from doing away with their distinctness, persons succeed only in being themselves.[17]

In this light, we can say, therefore, that the dialogical communion between the bridegroom and his ecclesial bride is first and foremost the one the Spirit establishes and fosters between Christ, and each Christian, thanks to his passover, has become in him a new creature yet always realizing itself in and through communion with the whole Body of the Church. Still, at greater depths, every Chritian enters into a filial communion with the Father, in Christ, thanks to the presence within him of the Spirit who makes him say: *Abba*. Consequently, the dialogical image 'bridegroom-bride' extends beyond itself since it ultimately suggests that the believers – adoptive sons and daughters of the Father – enter into the Trinitarian communion which absolutely transcends every created form of communion; hence, the sheer impossibility of adequately rendering this reality by means of any image however eloquent it may be.

This entry into the Trinitarian communion also supposes the necessary interrelation of the Christians among themselves.

For the bride is the new people of God formed of multiple members – a 'fraternity of persons'[18] – called to live corporatively and in communion within the definitive covenant. For the latter, rooted in the union of each member of the people with Christ in the Spirit, is essentially the 'communional' union of the individual believers in the divine *agape* (cf Rom 5:5) and in fraternal mutual help (cf 1 Pet 4:10). Of course, this communion comes about or ought to come about in all the formal ecclesial gatherings and, at their summit, in the liturgical gatherings through the participation of each one in the priesthood and the cult of Christ. But it must also be translated into the fabric of the daily, secular, ordinary life, not only among Christian brothers and sisters, although it should be there in the first place, but also among all the men and women to whom the Church has been sent in the name of Christ.

In addition to this, Christian communion, as much at the level of ordinary life as at the properly liturgical one, is formally theological, for it always receives itself from the Father through Christ in the Spirit. Thus, in spite of being more or less imperfect during the pilgrimage of the Church and of Christians through poverty and strife, in spite of the prejudicial presence of sin in the members of this Church, it becomes a mysterious participation in the Trinitarian communion.[19] It is the 'communion of saints' of Catholic dogma, a communion already perfectly fulfilled among the members of the bride who have attained the fullness of life and who attend to their brothers and sisters *in via*. But it is also realized, even imperfectly, among the members of the Church on earth.

One may and even ought to say, according to the traditional expression *Ecclesia a justo Abel*, that this communion mysteriously extends itself to the exchanges among all those who through faith are 'in a vitalizing and saving relation with Christ, the unique, sovereign and universal mediator, whose virtue (transcends) all temporal or spatial determination'.[20] Among these are found the righteous of the Old Testament but also all those who, through no fault of their own, are only

in an imperfect communion (or even only *in voto*) with the unique Church of Christ.[21]

Finally, it is in this ultimate vision of a 'communional' unity of human persons in the Church, the eternal temple of the Trinity and the historical sacrament of Christ, that, by means of the nuptial analogy, our grasp of the mystery of the election of humanity by God reaches its culminating point. One thus understands why Tertullian could boldly write the following words: *'Ubi tres, id est Pater et Filius et Spiritus Sanctus, ibi Ecclesia quae trium corpus est* (Where there are the three, the Father, the Son and the Holy Spirit, there is the Church which is the body of the three').'[22]

2. *From the fatherhood of God to the motherhood of the creature*

The motherhood symbol, for its part, is particularly apt to reveal the 'heart' of God and, especially, a fundamental aspect of his project of love. This aspect is the following: salvation is the 'begetting' of humans into a new life. It is this new life that the ecclesial bride is expected to pass on 'maternally'. However, she can do so only by continually receiving this life herself from elsewhere, that is, from God the Father, through and in Christ, head of the body, thanks to the gift of the Spirit. In this perspective, it is important to understand the spiritual motherhood of the ecclesial bride by situating it in relation to the Father, the Son and the Spirit.

a. Transcendence of God as absolute cause of salvation

A first question arises: is it possible to translate the mystery of the creature's collaboration into the salvific work of God by means of the motherhood symbolism of the Church without recalling the mystery of the fatherhood of God, a mystery which is one of the central considerations of the New Testament revelation? In other words, how must the moth-

erhood of the creature be set in relation to the fatherhood of God and the 'economic' commitment of each of the divine Persons in the work of salvation?

When the Scriptures speak of the creature's salvific motherhood, it is never directly concerned in those moments with the fatherhood of God. The symbolism of the spiritual motherhood of the Church must absolutely not be assimilated to those mythical superhuman or even human forms of begetting which would make God and the creature appear as natural and equal co-principles in an act of generation.[23] The analogical character of the biblical recourse to the theme of the creature's supernatural motherhood must therefore safeguard three aspects: the absolute transcendence of the divine causality, the secondary and instrumental character of the creature's participation and the fact that there would be no supernatural 'motherhood' of the creature without this transcendent fatherhood of God.

b. The attitude of Jesus and his teaching

In order to understand the notion of the fatherhood of God which, in itself, transcends all idea of human fatherhood/motherhood, one must start with Jesus manifesting the person of his Father. He is the Father of love and mercy whose salvific design for humanity is revealed and realized by the incarnate Son he has sent. It is this Father that the New Testament always presents as the one from whom and towards whom all things proceed. The Father eternally begets the Son and is the origin, through (and with) this Son, of the eternal procession of their common Spirit, the three persons being consubstantial and perfectly equal to each other.

But then, are we justified in preserving the way the New Testament speaks of 'fatherhood' to express the primacy of the Father as origin and end of all, not only in the depth of the Trinitarian mystery, but also in the work of salvation at the heart of creation? In the first place, let us recall that what matters first here is not the problem of analogically applying

the fatherhood to God as a masculine image. What is important to understand is the analogical meaning of every parental title (father and/or mother) referring to the act of generation when it is applied to God.

Properly speaking, the notion of fatherhood (that of motherhood as well) implies the idea of 'a generation from oneself of another being similar to oneself'. The theme of the fatherhood of Yahweh with regard to Israel precisely excluded this notion of generation: Yahweh was said to be the Father of the people because Israel had been adopted by way of election and of covenant, not by generation.[24]

However, such is not quite the case in the New Testament, for the analogy of fatherhood applied to God takes on a meaning much more explicitly related to the idea of generation, even for Christians, without negating the idea of an election. In order to understand this, one must go back to the elucidation of this fatherhood of God revealed by Jesus, the Only Son of the Father. When Jesus expresses the unique relationship he has with the one he calls *Abba,* Father (cf Mk 14:36),[25] he reveals something of the mystery of his eternal generation from the Father, and thus something of the mystery of the substantial fecundity existing in God himself, in the trinity of the persons starting from the Father.

It is this same Father who, from all eternity, elected humanity for the adoptive filiation (cf Eph 1:4-5), just as it is he who, through the twofold mission of the Son and the Spirit, communicates to human beings the grace which makes them participate in his mystery. Hence, every salvific work realized in Christ and through the Spirit, while being common to the three divine Persons, constitutes not only a revelation, but a true communication of life coming from the Father. The Christian is thus really born of God, begotten 'anew, not of perishable but of imperishable seed, through the living and enduring Word of God', as the First Epistle of Peter says (1:23). Although this new birth is always a covenant election and communion, there is true generation, that is, a gift to men and women of a created filiation with respect to the Father, this Father from whom comes 'every perfect gift' (Jas 1:17).

In this manner, the Christian also can say in all truth 'Abba, Father' (Gal 4:6), 'our Father' (Mt 6:9), not only in lip service but by entering, through the action of the Spirit in him (cf Gal 4:6), into the filial communion of knowledge and love of the incarnate Son with his Father.

We thus see that the title of Father given to God in the New Testament is a revelation *sui generis*. As such, this fatherhood is absolutely distinct from the attribution by human beings to a divinity of some sort of natural fatherhood with regard to creatures. The God of Jesus Christ is the Father; it is his proper name just as Yahweh was his proper name to the Israelites.[26] The fatherhood of God is thus the reality and Source which, as such, radically transcends every notion of human parenthood, of paternity and maternity, although the traits of this 'parenthood' may, by analogy, make the mystery of this eternal fecundity, more accessible to us.[27]

c. The birth of the new humanity through the redemption brought about by Christ

Jesus realizes this manifestation of the Father by being his 'sacrament'. For us humans, he is 'the way, the truth, the life', the true revelation of the Father and a living communication of this life of grace he possesses in plenitude (cf Jn 1:16; 4:6, 8). It is especially in and through his sacrifice, in which he completely gives himself up out of love for the sake of all, that Jesus expresses and fulfils his vocation of 'sacrament' of the Father.

Jesus himself has compared this passage (passover) 'from this world to the Father' to a mother's pangs in child labour, the fruit of which leads the disciples to the joy of bringing a new man into this world (Jn 16:21). This childbirth was accomplished by Jesus in his human nature as the representative of the whole of humanity and, particularly, as a descendant of Abraham and a member of the chosen people, of Sion, which, as it were, was concentrated in him, the only One. Thus the Israelite people, insofar as representing all humankind according to God's eternal plan, and so humanity

160

itself, was the one 'in labour' on the cross in this triumphant struggle of the obedience and love of the ultimate Adam against the forces of evil. And in his resurrection by the Father, Jesus was the firstborn of a multitude of brothers entering into the heavenly sanctuary, thus opening to all humans the access to the world of God beyond the barriers of sin and evil. Hence, in a very precise sense, it is this priestly and sacrificial begetting of a new world which constitutes the absolute and unique sacramental event by which, through the gift of the Spirit, the Father, through the Son, communicates a share of his own life to all humanity.

This approach to the supernatural childbirth of humanity rests on the possibility of determining, in the salvific act in question, the authentic human action of the one who is true man while being true God, the union of these two natures occurring in the *hypostasis* of the Son. Christ gave himself up through love in the most complete trust of a 'creature' of God the Father. One may then truly apply the motherhood symbolism to this sacrificial act when this symbolism, according to the Scriptures, suggests the commitment of the human creature in the work of salvation. But, at the same time, this priestly and sacrificial act of Christ is salvific only because his divine person applies a coefficient of infinity to the value of his total surrender for the glory of his Father and the salvation of the world. Moreover, in the same paschal mystery, by the fact of the resurrection and the gift of the Spirit poured on humanity, the divine efficiency of the redeeming act is not only manifested but truly acquired for all humanity in the glorification of Christ. It is therefore essentially this Christic mystery of childbirth that constitutes the ultimate significance of the symbolism of the salvific motherhood.

d. The birth of humanity through Christ and the true motherhood of the Church

For all that, one must not forget that it is the Church that is born in this salvific act realized by Christ. This same act, by which the bride is born from the new Adam, gives her the

161

capacity to be her bridegroom's collaborator in the transmission of a spiritual regeneration to successive generations. The instrumental motherhood of the Church is thus completely dependent with respect to the 'economic' commitment of the Father, of the incarnate Son and of the Spirit who give her existence and make her fruitful through a life she can only receive. In other words, it is due to the salvific action of the incarnate Son, the unique mediator and high priest, in the power of the Spirit, that the paternal gift of God to humanity is 'sacramentalized' in the bride who thus becomes in Christ the 'maternal' sacrament of the fatherhood of God. Origen's famous comment, reworded in various ways by other Fathers, acquires here its full significance: 'One who does not have the Church as mother cannot have God as father.'[28] By means of this same parenthood symbolism, this expression brings together the two fundamentally distinct and yet intrinsically bound levels we are concerned with in the spiritual regeneration of humanity: first, the absolute transcendent level of the divine causality; then, the secondary level of the instrumental causality of the human creature. However, in the same way that the transcendent level is sacramentalized in the Son's commitment, the second level exists only thanks to the same Christ in his paschal act (implying a true instrumental causality of his humanity)[29] and to the gift of the Spirit. In this way alone is it possible to speak of a spiritual instrumental motherhood of the ecclesial community, in the same way that a Trinitarian perspective alone can make one understand how the Church Person and her members effectively exercise their mission of motherhood.

NOTES

1. Here we use the word 'economy' as it was understood by the early Fathers of the Church. Delahaye gives us the following definition: 'The *oikonomia* means the whole action of God revealing itself in clemency and mercy and giving itself in this revelation...' (*Ecclesia mater, chez les Pères des trois premiers siècles*, p. 134).

2. St Augustine, 'Homélie sur le Psalm 44', no 3, in *Les plus belles homélies de saint Augustin sur les psaumes*, Paris, Beauchesne, 1947, p. 69.
3. *Ibid.*
4. *Ibid.*
5. For an overall view of patristic developments of this image, see Luis Arnoldich, 'La creación de Eva, Génesis 1:26-27; 2:18-25', in *Sacra Pagina*, I, Brussels, 1959, pp. 346-357.
6. See, for instance, question 43 of the *Summa Theologica* by St Thomas.
7. Yves Congar, *I Bbelieve in the Holy Spirit*, vol. II, 'He is Lord and giver of life', translated by David Smith, New York/London, The Seabury Press/ Geoffrey Chapman, 1983, pp. 5-14.
8. Cf St Irenaeus of Lyons, *Against Heresies*, V, 6, 1, translated by John Keeble, London, Oxford and Cambridge, James Parker Co., p. 460.
9. St Methodius, *The Symposium: A treatise on chastity*, translated and annotated by Herbert Musurillo, New York, N.Y./Ramsey, N.J., Newman Press, 1958, p. 249.
10. Methodius speaks here in symbols, for he does not claim that the celebration of the Eucharistic banquet is anything but he 'commemoration' of the unique sacrifice of Christ who dies once and for all. The author had compared Adam, that is, the man who leaves his father and mother to cling to his wife, with Christ who leaves his Father 'to cling to his spouse' (Logos 3, VIII, *ibid.*, pp. 65-66).
11. *Ibid.*, pp. 66-67.
12. Delahaye, *op. cit.*, p. 124.
13. Cf Plumpe, *Mater Ecclesia*, p. 113.
14. Congar, *I believe in the Holy Spirit*, vol. II, p. 55.
15. Behind this expression, we find the Hebrew meaning of the 'body' of the bride as a kind of extension of that of the bridegroom.
16. Bouyer, *The Church of God...*, p. 491.
17. Bouyer, *ibid.*, p. 492.
18. Congar, *op. cit.*, p. 16. For an analysis of the implications of this fraternity, see Joseph Ratzinger, *Christian brotherhood*, translated by W. A. Glen-Doepel, London and Melbourne, Sheed and Ward, 1966, p. 94.
19. We shall come back, in the next Chapter, to the question of the 'already/not yet' of the ecclesial communion when we speak of the Church as a bride, but still in a state of betrothals until the consummation of the nuptials at the time of the parousia.
20. Yves Congar, 'Ecclesia ab Abel', in *Abhandlungen über Theologie und Kirche*, (Festschrift für K. Adam), Düsseldorf, 1952, p. 97.
21. Cf Pagé, *Qui est l'Eglise?*, II, pp. 162-175 and III, pp. 54-59. The author explains the teaching of Vatican II on this subject.
22. *Tertullian's Homily on Baptism* (ch. 6, no 2), edited with an introduction, translation and commentary by Ernest Evans, London, SPCK, 1964, p. 17.
23. We have noted on several occasions the radical difference between the use of the theme of the salvific maternity in the Bible and the myths of the fecundation of humans by the gods.
24. Cf Witold Marchel, *Abba Père, La prière du Christ et des chrétiens*, Rome, Pontifical Biblical Institute Press, 1971, especially pp. 39-41. Roger Le Déaut in *La nuit pascale*, Rome, Pontifical Biblical Institute, 1963, quotes

a Jewish Targum which says: 'Yahweh adopts Israel as his child; he is not its father for having begotten it' (p. 86, note 45).

25. This word *Abba* applied to God has an unprecedented character in the Jewish religion. See especially Joachim Jeremias, *Abba, Studien zur neutestamentlichen Theologie und Zeitgeschichte,* Göttingen, Vandenhoeck & Ruprecht, 1966, especially the first Chapter. See also Robert Hamerton-Kelly, *God the Father: theology and patriarchy in the teaching of Jesus,* Philadelphia, Fortress Press, 1979, pp. 72-75.

26. This is what Claude Geffré brings out in his article '"Father" as the proper name of God', in *Conc,* 143 (1981), pp. 43-50.

27. For a brief and clear presentation of this question, we refer the reader to the article by Jean-Claude Sagne, 'De l'illusion au symbole, la reconnaissance du Père', in *LEV,* 104 (1971), pp. 38-58. See also the study by Hamerton-Kelly mentioned earlier.

28. Origen, *In Leviticum,* Hom. II, c. 3, quoted by de Lubac in *Les églises particulières dans l'Eglise universelle,* Paris, Aubier Montaigne, 1971, p. 148.

29. On the ecclesiological point concerning the traditional affirmation of the role of the humanity of Christ in the economy of salvation, see Congar, *Le Christ, Marie et l'Eglise: pour le quinzième centenaire du Concile de Chalcédoine* (October 451), Bruges-Paris, Desclée de Brouwer, 1955, pp. 26-49.

Chapter 8

The 'Church Person'
as the bride chosen by God

The last contemplation of the God of the covenant and his
design of love for humanity leads us to the central theme of
our study: the mystery of the Church. We shall dwell, in this
Chapter, on her being as the holy bride of Christ eternally
chosen by the Father. Who is this Church Person, this cov-
enant partner that God has given himself in his gratuitous
love? Such is the first question we shall ask ourselves. But the
answer to this question will raise a second one: how can one
understand the mystery of this bride who, through the histori-
cal and also the transhistorical victory of her bridegroom,
Christ, is already holy from the very holiness of her Lord, and
yet not fully the one whom the glorious return of Christ alone
will cause to appear in all her splendour?

1. Who is the Church Person?

The distinctive personality of the ecclesial bride is re-
vealed to us in a very special way through the nuptial analogy.
The latter sets the Church before Christ the bridegroom first
and foremost as a distinct subject, a *person*[1] ontologically
united to him but, at the same time, distinct from him, placed
'face to face' with him in a living dialogue of love and
fidelity. In that, the image of the Church as a bride completes
that of the Church as 'body of Christ'. We also know that in
St Paul these two images are in continuity the one with the
other, as illustrated in the passage of Ephesians 5:21-33

studied earlier. For him, the 'communional' unity of the spouses is thus rooted in the continuity between the body of the bridegroom and that of the bride (and vice versa) united to make 'one body'.

But if the ecclesial bride is a 'person' facing Christ, her bridegroom, who is she really? The answer to this question will reveal something of the mystery of the Church both with regard to her necessary union to Christ and to her 'personal' realization in humanity. We shall also understand how each individual person for his part actualizes the Church Person.

a. The *una persona, Christus et Ecclesia,* in the Holy Spirit

One cannot speak of the personality of the bride, the Church, without first affirming the depth of unity that exists in the ecclesial body of Christ, between the incarnate Son and those who are incorporated in him. Tradition tells us that the Church is *una persona, Christus et Ecclesia* (one person, Christ and the Church)[2] or *una persona mystica* (one mystical person).[3] The *una persona mystica* is, therefore, the total Christ (the *Pleroma*), the new humanity, including each of its members made participants in Christ of the communional unity of the three divine persons.

This transcendent principle clearly shows that the Church cannot have her own personality apart from Christ and the Spirit who together are the subject and the agent of the gift of divine grace, of the very being of the Church.[4] For the Church Person is ultimately the unity 'of the grace of filiation given since the Firstborn (Rom 8:29)'[5] and communicated to humans through the Spirit of the Father and of the Son.

Because of that we must affirm that '"the supreme personality of the Church" is the Trinity and, by appropriation, by virtue of an efficiency and a more immediate inhabitation, the Holy Spirit'.[6] But at a more specific level, it is Christ the Lord who 'is, properly speaking, the Me of the Church',[7] since he is the one, the Word-Son, who 'assumed a humanity that is consubstantial to our humanity. He united it to himself in a

unity that is personal and substantial.'[8] In short, the ecclesial bride is constituted in her own personality by this twofold mission of the incarnate Son and of the Spirit as mentioned in the preceding chapter.

b. The bride: 'the other' as the 'vis-à-vis' of Christ the bridegroom

The nuptial analogy, nevertheless, suggests the necessity of attributing a personality proper to the Church and, in a sense, distinct from the person of the incarnate Son and of that of the Spirit. For it is very obvious that the hypostatic union of the Son with a particular human nature does not communicate itself as such to the ecclesial Community.

The text of Ephesians 5:21ff provides a first key enabling us to grasp what this distinct ecclesial personality, symbolized by the term 'bride', consists in. In this passage, we see Christ giving himself a woman 'companion' distinct from himself through his salvific offering. The *Letter to the Ephesians* as a whole will give us a hint of the identity of this companion. In this letter, Paul explains to the Church he is addressing what the 'mystery', of which he is the herald, consists in. It is the 'mystery' of God's salvific design revealing itself in the election of all humanity in Christ to become a people of adoptive sons for the Father. From this overall view, we understand that for the Apostle, the bride, and therefore the Church Person, is this humanity itself, the object of a choice of love by God insofar as she is called to salvation. The Church Person is thus the collectivity of the elected ones set aside by God (redemption, purification, cf Eph 5:26), to be corporatively (and personally) united to Christ, the bridegroom (2 Cor 11:2), in 'one only flesh' (Eph 5:31). She is God's global project considered as 'mystery', unveiled in the fullness of time in and through the 'mystery' of Christ who is the sum of all things (Eph 1:10).

But this same letter shows that this choice made by God is eternal and transcends the concrete existence of individuals. In this sense, the Church Person, understood as God's global

project, is first and foremost this heavenly bride of whom the Scriptures and the Fathers occasionally speak, that is, this covenant partner who pre-exists in the thought and will of God. In this sense, the Church Person is eschatological. This means that, although she is fully constituted in her fundamental being by the victory of Christ the redeemer, she will reach her full stature only at the end of time when the bride will be introduced forever into the house of the king (cf Rev 21:2).

c. The Church Person and the individual persons

But then how does the Church Person become incarnate in the people of God journeying through the present moment of history? How can the individual persons, of whom this people is formed, be the Church? In order to answer these questions, let us go back to what we were saying earlier: there can be no question of the Church having her own personality without being dependent on Christ the Lord in the Spirit, since the Church exists only in and through the communication of divine life received from them. By the express will of Christ, this dependence signifies itself and effects itself fundamentally by the 'means of grace born of the incarnation and which can be called 'institutions of salvation'.[10] What are these means of grace if not the Church herself as sacrament of salvation (joined to Christ) and in her, the word of God, the sacraments of the Church with the Eucharist at their summit, as well as the ministries and the charisms? All these put together is what Henri de Lubac calls the *Ecclesia congregans*, the ecclesial community which actively 'congregates in an assembly', as an Institution of salvation to which Jesus has entrusted the mission of proclaiming the Good News and of communicating the new life procured for humanity in his passover.[11]

This *Ecclesia congregans* and the means to salvation she has received as a dowry from her bridegroom are formally placed in the service of human persons in order to communicate to them a share in the life of God. On this subject, von Balthasar points out that the institution of salvation 'requires

its material complement, the faithful themselves, who only become the people of God when "informed" by the Church-structure, and only represent the full reality of the bride of Christ within this structure'.[12]

That is why, along with Congar, we may define the Church (the Church Person) as 'an interdependent whole of what (the) intention of God aims to do and realizes: at the same time the sum or the communion of the "saints" and the totality of the means of grace. This design of God, as such, aims at a whole and a plenitude.'[13] The Church Person is this whole entity, which is the body of Christ and the temple of the Spirit.

What has just been said helps us to understand that the ecclesial bride necessarily transcends the material sum of the individuals who make her up. If her perfect fulfilment is eschatological, nevertheless, there remains the fact that, effectively, she exists in time as the bride whom Christ gives to himself only *in* the persons who are a part of her. That is why one can say that she actualizes herself concretely in the 'we' of the Christians.

But the question rebounds again: who is the 'we' of the Christians? It is that concrete ecclesial community set within history that Tradition has described as one, holy, catholic and apostolic. It is the universal *Ecclesia* of which the interior bond of unity is the Spirit and the exterior bond, the Bishop of Rome who presides over the episcopal college in communion with him.

But the *we* is also, the Eucharistic community of a determined portion of the people of God celebrating together presided by its 'pastor', a successor of the apostles, and experiencing the concrete implications of this celebration in the common proclamation of faith in every form of worship and prayer, of fraternal communion and of service (cf Acts 2:42). The 'we' of the Christians is thus these particular Churches who are each the Church of God sojourning in this or that determined locality, but always in a living communion with the universal Church of which the Church of Rome is the centre.[14]

And yet, one must go still further. The ecclesial bride actualizes herself in the Christians only insofar as there is effective communion (in the grace of the Spirit) of each member with Christ, in and through the means of grace, that is, in and through the sacramental ministry of the Church. This is what makes Bouyer say that 'this personality, so often attributed by Scripture to the Church exists only in human persons *that have arrived at their perfection*'.[15] And this perfection is totally achieved when each person is a configuration of Christ.

Now that does not come by accident. We touch here upon the very project of the covenant in all its depth such as it is pursued by God who, through the salvation of the Church as a whole, wishes to elicit the response of faith in each individual person to make of him a truly new creature. Thus, God's project of making all of humanity his 'holy' people comes to a final realization in the transformation of each person at the innermost core of his being through union with God. For, ultimately, there is a 'holy' people only through humans sanctified by faith, hope, love and a moral life in conformity with the new being received from God.

This theological and moral perspective has clearly appeared to us in the use of the metaphor of the Messianic nuptials, especially in the gospels. There the stress is laid particularly on the act of faith of the individual person who welcomes the invitation to accept salvation and thus enter into the Community of the disciples. We have also emphasized the application which can be made of 2 Corinthians 11:2-3 to the individual person. Ephesians 5:25 also suggested that the bride is sanctified through the baptism of her members in the same way that Revelation 19:7-18 stressed how the good deeds of the individual Christian embellish the bride (because he has washed his robe in the blood of the Lamb). In this sense, the ecclesial bride actualizes herself in the individual members transformed by the grace of Christ.

That is why Tradition very soon applied the spousal symbolic to this transforming interpersonal communion between Christ and his disciple, each considered individually.

Far from seeing this phenomenon as a deviation,[16] one must consider it as an ineluctable consequence of God's plan and of the mystery of election. That is what makes von Balthasar say when speaking of the encounter between the structural element of the Church and the Christians (the material element):

This encounter which, at its maximum intensity, merits the name of marriage is personal and takes place between God as person and man as person; though all that gives this encounter an ecclesiological stamp is its prerequisite only, and is not the encounter itself. Admittedly, the whole complex of those things instituted by God for salvation is the most sublime, the richest in mystery, the most inaccessible to the human mind, of all that is. Nonetheless, it is there for the sake of the individual creature, and only fulfils its purpose when he is reached and brought home to God.[17]

Therefore, one can say in all truth that the election of humanity by the Father, as a bride for his Son, contains and implies the call made to each individual person in his unique mystery. That is why Louis Bouyer, in his synthesis of the teaching of the Tradition, can affirm that 'the spouse of Christ strictly speaking, and she alone, is the Church. But in the Church each soul is, individually, spouse of the Word, as if each were the only one'.[18]

A complementary remark must be added to this. Insofar as each person is effectively united to Christ, one can say that he represents the ecclesial bride, that he makes her present. That has appeared to us at a metaphorical level through the personifications of the ecclesial community, especially in St John. But, at a much greater depth, the New Testament has presented to us the individual believers as true representatives of the Church, thanks precisely to their faith, that is, to their union with Christ as living members of his body.

Certainly, there is a particular mode of representation among the Twelve, and in a special way in Peter, a mode

171

rooted in the call from Christ making of these men his messengers, those standing in his stead. Such a form of representation is linked with the charisms distributed by the Spirit for the good of the whole. The ministerial charism is what structures the Church and is sacramentally communicated by the imposition of hands.

However, the representation we are speaking of here is set at the fundamental level of the believer's being, enlivened as he is by the charity of the Spirit and destined to reproduce the image of Christ in his concrete existence. In this line of thought, the Johannine figure of the disciple whom Jesus loved leads us in a special way towards the understanding of this ecclesial representation realized by the individual Christian. As one can then see, such a representation implies the obligation for each person to grow spiritually so that the 'being received' may become a 'life experienced' in an authentic and operating faith and love.

Among the models of exemplary believers presented by the New Testament, the mother of Jesus holds a place of her own. She appears as the person who manifests the mystery of the ecclesial bride in the most perfect manner.[19] By assigning her to a union of a unique intensity with the Son, redeemer of the world, her vocation to be the Mother of God committed her to share with him, as his collaborator in faith and love – and this as early as the annunciation – the mysterious plan of the Father. By virtue of this, Mary presents herself as 'a most excellent personal realization of the response of the Church and even of all of humankind, to the offer of a spousal alliance with God'.[20] That is why the Church Person actualizes itself in her in a unique way: she is truly the 'figure' of the ecclesial bride and a certain crystallization of her mystery. Or, as Haymon of Auxerre would say, she is 'the personified representation of the Church'.[21]

The representation of the Church by each disciple of Jesus, a representation of which Mary is the archetype, must nevertheless remain subordinate to the overall view of the Church Person in order to have the whole truth. For, we might recall along with Congar that 'the Church Person is constituted

by the gifts of grace made to persons, but in such a way that they make them all participate in a unique being who transcends individuals without swallowing them up, much to the contrary, by perfecting their personal being'.[22] Consequently, because the Church Person as a whole transcends the individuals, the vocation of each person remains in relation with that of the ecclesial bride who alone is the total Christ on his way towards his complete fulfilment. Thus, no individual may claim to realize fully his personal vocation – and therefore to actualize in himself the ecclesial bride – if he does not live as perfectly as possible in communion (at least virtual) with the whole, that is, with Christ in his body organically structured as a sacrament of salvation.

In practical terms, in order that this communion with the ecclesial body be total, it must be lived by participating in all the elements of which this Church is formed. These elements are the life of the Holy Spirit, the profession of the same baptismal faith, the celebration of the Eucharist by which the Church 'assembles together and grows',[23] a fact which supposes, with the guidance of a validly ordained minister, communion with the successors of the apostles, and with the first of these, the Bishop of Rome. To these elements are added, as a test of truth, the acceptance of all humans, especially the poorest, an acceptance which expresses itself concretely in service and in love.[24] Such a complete participation in the life of the Church is the goal towards which all its baptized members must move with perseverance in order to be a truly authentic representaton of the Church Person.

2. From the betrothed to the bride

We have attempted to determine clearly who the Church Person is and how it is one, although it is made up of a multitude of members. However, what precedes opens the door to another problem. The mystery of this bride, who is already holy of the very holiness of her Lord, is a 'mystery' on two counts when we consider the difference that exists

between, first, her glorious situation fully in view at the end of times and, second, her peregrinating condition totally characterized by limitations in the midst of history.

Here again, the nuptial analogy will help us probe, in greater depths, the heart of this mystery in order to grasp better the profound meaning of God's covenant for humans. Indeed, one of the principal theological meanings borne by the analogy of a 'conjugal covenant' between the new people of God and its divine bridegroom is the historical nature of the covenant. As a matter of fact, the essential difference between Israel and the Church precisely appears in that the ecclesial community alone is characterized as already indefectibly holy and without blemish (cf Eph 5:27). And yet, this radical holiness imprints itself only gradually on the humans called to become 'holy and blameless before God in love' (Eph 1:4). In other words, the Church is both bride and betrothed, and the passage from one expression to the other symbolizes precisely the 'mystery' of the progressive journey implied in the ultimate stage of the history of salvation which is the 'time of the Church'.

a. The Church on earth is already the holy bride

We must note first that the word 'holy' must be understood here in the sense revealed by the Old Testament which suggests a nearness to God and a certain participation in his holiness. A reality is holy insofar 'as it is dependent upon God, comes from him, belongs to him, is totally in reference to him.'[25] In this sense, the Church is holy because it totally belongs to God who has chosen her, to Christ who has united her to himself by giving himself up for her, to the Holy Spirit who enlivens it, communicates the life of God to her and makes her take part in the living worship of Christ. This is what makes Congar say that 'the primary value we come across in the affirmation of the holiness of the Church stems from what makes, of this Church, the thing of God: election, vocation, covenant, consecration, indwelling; the

Church is the place where God is worshipped as he wishes to be.'[26]

This holiness of the Church is given to her first of all in and through the revelation, the Gospel of salvation which Christ has entrusted to her, through the mediation of the apostles, in order that she may bring the Good News to the world. In this sense, the actual holiness of the Church reveals itself first, in the unity of faith – the apostolic faith preserved and transmitted by the Church of whom the successors of the apostles are, at the same time, the first ones to bear responsibility for it and be its safeguards. The Holy Church has thus received from her bridegroom, through the action of the Spirit in her, the grace to be indefectibly faithful to the apostolic faith, and it is this fidelity that the Fathers have termed 'the virginity of the Church'.[27] For fidelity to the apostolic faith and fidelity to Christ-bridegroom are one and the same thing for the Church.

This unifying and sanctifying fidelity in faith finds its summit in the liturgical gathering of the community, especially in the Eucharistic sacrifice. In this celebration, Christ, head and bridegroom, who is present to his bride in various ways,[28] becomes so in a yet more sublime manner in the offering he makes of himself to the Father through the ministry of his priests, an offering by which he builds his ecclesial body (cf Eph 5:25). Such a constant edification of the bride in the offering of Christ is synonymous with her unceasing renewal through the action of the Spirit who makes her thus participate in the holiness of her Lord. And at this source, the Eucharist, are grafted, in order to draw their vitality and to mete out its effects, all the other sacraments, and particularly baptism thanks to which, according to Paul, the Church is constantly immersed in the holiness of her bridegroom (cf Eph 5:26).

It is as an institution of salvation (the *Ecclesia congregans* mentioned earlier) that the Church receives this radical holiness from Christ and from his Spirit. And yet, if the Church Person actualizes itself effectively in the *we* of the Christians and ultimately in the individual members, this mystery of holiness must effectively leave its mark on the concrete

persons. In fact, the Christians receive a radical ontological participation in the holiness of their Lord by being incorporated in him through baptism. They are thus recreated by God in an initial fundamental holiness. St Thomas Aquinas, quoted by Congar, explains in what the holiness of the faithful consists:

The believers of that assembly (*congregatio*) are made holy in four ways. In the first place, just as a church is, at the time of its consecration, materially washed, so too are the believers washed by the blood of Christ, Rev 1:5: 'he loved us and washed us from our sins in his blood', and Heb 13:12: 'Jesus, in order to sanctify the people through his own blood'... In the second place, by an anointing: just as the church is anointed, so too are the believers anointed in order to be consecrated by a spiritual anointing. Otherwise, they would not be 'Christians', for 'Christ' means the 'anointed one'. This anointing is the grace of the Holy Spirit: 2 Cor 1:21, 'he who has anointed us is God'; 1 Cor 6:11, 'You were sanctified in the name of the Lord Jesus Christ (and in the Spirit of our God'). In the third place, by the indwelling of the Trinity, for where God dwells, that place is holy! Gen 28:13: 'Truly this place is holy!' and Ps 93:5: 'Holiness befits thy house, O Lord.' In the fourth place, because God is invoked; Jer 14:9: 'Thou, O Lord, art in the midst of us and thy name is invoked over us.'[29]

St Augustine developed a similar idea when he declared that the virginity of the ecclesial bride characterizes the being of every Christian when the *Mater Ecclesia* begets him to faith by presenting him to Christ as a chaste virgin to a unique bridegroom (cf 2 Cor 11:2).[30] And in the same line of thought as Paul's in his Second Letter to the Corinthians, he adds that in order to remain thus a chaste virgin, the baptized individual must persevere in faith, a fact that implies also a life lived in conformity with this faith, therefore, a life of charity and moral integrity. It goes without saying, indeed, that this

'received' holiness must be assumed and show itself in the theological and ethical becoming of each member.

However, thanks to the first sanctification of the members through the grace of Christ, thanks then to the effective progress in holiness of the 'faithful' in the strong sense of the word, one can and must say in truth that the Church on earth already possesses a radical holiness in her members.

Further, the peregrinating Church on earth is not solely the bride. Or better yet, the Church holds a dimension which is not of this earth, not only in her head, Christ, but also in her members already in possession of the final legacy. For these are also, in their special right, the unique bride of Christ. In that, the holiness fully displayed in their lives and in their deaths also belongs to the Church of this earth.[31] The Council alludes to this mystery of the communion of saints in one unique Church when it declares: 'being more clearly united to Christ, those who dwell in heaven fix the whole Church more firmly in holiness.'[32]

It goes without saying that among these blessed, the mother of Jesus holds a special place since in this human creature, the holy bride, which is the Church, possesses its most perfect realization and actualization.

But the Church on earth herself, in the theological and ethical life of her members journeying in time, as the Council says, 'is endowed already with a sanctity that is real though imperfect.'[33] By seeking to achieve day by day through strife, failures and new beginnings, an ever-increasing conformity with this radical holiness, the baptized existentially display this radical holiness. They thus allow the ecclesial bride to radiate more and more the holiness of her bridegroom.[34] And in fact, in the opacity of the history of humanity, the Holy Spirit always rekindles, according to the expression used by Congar, 'the radiation of holiness'.[35]

b. 'Holy Church of sinners'[36]

As holy as the Church may be, she nevertheless actualizes herself during her journey on earth in the particular com-

munities who bear the effects of sin and in the members who are truly sinners. And this situation is not ascribable solely to the moral sins of the individuals, but also to the failings of the ecclesial community as such in relation to the demands made by her mission in history.[37] In other words, between the holiness of the Church and the one already accepted by the faithful of Christ and the theological and ethical working of grace in the personal and collective existence of the believers journeying in history, there is a discrepancy that only the final triumph of Christ will eliminate at the end of time, as the Book of Revelation shows us.

The affirmation of this permanent coexistence, in the life of the Church, of a fundamental holiness and of her constitution from a humanity of sinners is a constant theme of the Scriptures and of Tradition.[38] This is what the Second Vatican Council has summed up by saying: 'while Christ, "holy, blameless, undefiled" (Heb 7:26) knew no sin (2 Cor 5:21) but came only to make a sacrifice of atonement for the sins of the people (cf Heb 2:17), the Church, which contains sinners in her midst, which is holy and, at the same time, must be forever purified, constantly seeks penance and renewal.'[39]

For many, this situation presents a real paradox, not to say a scandal. And yet, here again the nuptial analogy helps to undertand how the tension, implied in this situation of the Church on earth, is part of her mystery as 'chosen' bride of God in the heart of history. Indeed, the mystery of the election of humanity by God comes into play through a dialectical historical movement, as we have already pointed out.[40] To the systolic movement of the reduction of Israel until the coming of the One sent by God, the messenger par excellence to be the ultimate Adam, succeeded a diastolic movement of expansion. It is this last movement that characterizes the dynamics of the Church of Christ opening the access to salvation to successive generations of human beings throughout history. As long as the history of humanity goes on and there are some human beings yet to be touched by the salvific grace of Christ, this community, although a sacrament of salvation for

the world (*pars pro toto*), will be only the betrothed of Christ. The decisive nuptials (Rev 21-22) are yet to come. The quantitative deployment of the bride is thus the embodiment of this mysterious plan of God as he directs the journey of history towards its summit and its restoration in the total Christ.

But there is also another aspect. As long as the sinners, who have become members of the holy and blameless bride, have not, each for his own part, been totally transformed 'from one degree of glory to another' into the image of the firstborn Son (cf 2 Cor 3:18; Rom 8:28-30), the Holy Church of Christ here will still be no more than the betrothed. As we have already intimated, even this vast diastolic movement of expansion of the time of the Church must accept to be characterized by a certain oscillatory spiral-like movement with its own ups and downs. As in the case of ancient Israel, although in a different way, the Church of Christ on earth must accept to experience in her members and, even under one aspect, in her structures (in that these bear the imprint of humanity from which they are formed, but not as means of salvation dependent upon Christ), a kind of purifying systolic movement. Urged to a constant conversion, the ecclesial bride must accept to be this small 'Remnant', poor and abased, this 'small flock' to which, nevertheless, Jesus has promised the final victory (cf Lk 12:32; also Rev 12:13-17).

A 'systolic movement', yes, but 'secondary', for such a purification and reduction cannot be of the same nature as those of the Old Testament. The access to salvation for all humankind has been decisively acquired by the redemption brought about by Christ. Because of that, the total rejection of the unrepentant sinner is not for here below. As long as history goes on the arms of the merciful Father are open to receive the prodigal son. Otherwise, the Church would be a sect. The gospel parable about the darnel and the wheat unveils a view of the ecclesial Community such as is willed by Christ in which every chance is given to each individual person.

This purifying systole is not a matter of fate, a 'last resort'. On the contrary, it is an integral part of the mystery of the bride in her earthly pilgrimage. It gives her the opportunity to participate in the vocation of substitution of her bridegroom, giving herself up for the salvation of everyone. If he, Christ, a pure and undefiled victim, has accepted to take upon himself the sin of the world, how much more his bride, tainted by nature, but saved, purified, as the Fathers loved to repeat,[41] must accept to wear the humble and poor livery of her bridegroom.

Moreover, as the ecclesial bride is constantly inclined to fall again in sin,[42] she must always acknowledge her need of purification which she must receive constantly for herself and for all her members from her sacramental participation in the surrender that her bridegroom has made of himself once and for all. At the same time, the Church must purify herself effectively through penance, through her struggle against evil and sin, as much in her individuals as in her groups and structures.

Such a necessity of constant purification constitutes a prerequisite of truth for the very being of the Church as the holy bride. But it is also a prerequisite linked with her mission, for she must, as the Second Vatican Council lets us understand, 'enlighten all men with the light of Christ resplendent on (her) face'.[43]

But if constant conversion, is a prerequisite for the ecclesial bride in her historical situation ultimately the only true subject of conversion is the individual person. If the Church Person actualizes herself in each individual person, and if each one, according to his or her personal mystery, represents in some way the whole Church, the actualization becomes the moral responsibility of each individual Christian, in conformity with the particular call God has made to him or her. Every Christian thus carries the responsibility of the holiness of the ecclesial Body. In this context, how could one not recall these thought-provoking lines written by a great poet and wise man, Félix-Antoine Savard:

The direct line between the soul and God. Basically, the main problem in all the Churches is the intermediaries who should be transparent.

The actual revolt is not directed so much against God. It is the revolt of man against the opacity of man: 'Get out of my Sun'.[44]

NOTES

1. In the following developments, the word 'Person' has an analogical meaning when it denotes the Church composed of many persons. For this question, the reader is referred to various authors of whom the main ones are Bouyer, *The Church of God...*, pp. 491ff and 654-673; von Balthasar, 'Who is the Church?', in *Church and World*, translated by A. V. Littledale and Alexander Dru, New York, Palm Publishers, 9167, pp. 112-165. Jacques Maritain, 'The Personality of the Church', in *On the Church of Christ: The Person of the Church and her personnel*, translated by Joseph W. Evans, Notre Dame/London, University of Notre Dame Press, 1973, pp. 15-23.
2. Cf St Augustine. See some references given by Emile Mersch in *Le Corps Mystique du Christ: études de théologie historique*, II, Paris, Desclée de Brouwer, 1936, pp. 86-87.
3. We find this expression in St Thomas Aquinas, for instance in *Super ep. S. Pauli lect.*, in Col 1, lect 6, quoted by Congar, 'La Personne "Eglise"', pp. 616-617.
4. On this subject, see the developments made by Congar (*ibid.*, p. 635).
5. *Ibid.*, p. 637.
6. Pagé, *Qui est l'Eglise?*, II, p. 107. The texts within quotation marks are quoted from Journet.
7. Karl Adam, *Le vrai visage du catholicisme*, Paris, Grasset, 1931, p. 28, quoted by Congar, *op. cit.*, p. 636.
8. Congar, *I believe in the Holy Spirit*, vol. II, p. 20.
9. See for instance the *Pasteur d'Hermas* (Vis. 1, 2, 3; Vis. 4, 1), Paris, Cerf, 1958, pp. 83 and 135-137. On this text (also on the *Deuxième Epître de Clément*), see Jean Daniélou, *The theology of Jewish Christianity...*, *op. cit.*, pp. 300ff.
10. Congar, 'La Personne "Eglise"', p. 637.
11. Quoted by Congar, *I believe in the Holy Spirit*, vol. II, p. 54-55. This Community is, at the same time, the *Ecclesia congregata*, that is the community assembled in one single Body of believers by the word of Christ and the gift of the Spirit. These are two facets of the same mystery which must always be considered ontologically as one same ecclesial reality. Otherwise, we would be faced with an ecclesiological Nestorianism.
12. Von Balthasar, *Church and world*, p. 125.

13. Congar, 'La Personne "Eglise"', p. 637.
14. On the subject of the particular Churches, cf de Lubac, *Les Eglises particulières dans l'Eglise universelle*, pp. 30-69. See Also the study by J.-M. R. Tillard, *Eglise d'Eglises; l'ecclésiologie de communion*, Paris, Cerf, 415p. This raises the question of the realization of the Church Person in the other Churches and Christian Communities, not in full communion with the Church of Christ which 'subsists' in the Catholic Church. The Second Vatican Council has shown that there is a more or less perfect actualization of the Church Person in a separated Community according to the more or less perfect communion in the means of salvation Christ has provided for his Church. On this question, see Pagé, *op. cit.*, II, pp. 16.4-175.
15. Bouyer, *The Church of God...*, p. 492.
16. On this question, see Louis Beirnaert, 'La signification du symbolisme conjugal dans la vie mystique', in *Expérience chrétienne et psychologie*, Paris, Epi Ed., 1964, pp. 417-431.
17. Von Balthasar, 'Who is the Church?', p. 128.
18. Louis Bouyer, *The Seat of Wisdom...*, p. 178. As for Congar, he writes: 'The Church, then, is a bride and a temple, but strictly speaking every believing soul is a bride, and every believer is a temple; this is in the New Testament and is proclaimed again and again by the Fathers. At least since Origen, whose influence was very great, but even before him – Hippolytus for example – the Fathers and other early authors said that "every soul" is the Church. Every soul is a bride and every soul is a temple. The liturgy passed from one to the other and from the singular to the plural, using the singular first. For the earliest Christian writers, the Church was the "we" of Christians' (in *I believe in the Holy Spirit*, vol. II, p. 53). This ecclesiological point of view is important as the basic root for the understanding of the 'mystical' aspect of any Christian journey, and must always be present in a wholesome spiritual theology in order to assure its authenticity.
19. Cf Joseph Coppens, 'La Mère du Sauveur à la lumière de la théologie vétérotestamentaire', in *ETL*, 31 (1955), pp. 16-17.
20. Congar, 'La Personne "Eglise"', p. 640.
21. Quoted by Hans Urs von Balthasar, in *The Office of Peter and the Structure of the Church*, translated by Andrée Emery, San Francisco, Ignatius Press, 1986, p. 200.
22. Congar, *op. cit.*, p. 632.
23. *Lumen Gentium*, No 26, 1.
24. On these elements of communion, see Pagé, *op. cit.*, II, pp. 166-175. This statement is of worth for those who know Christ, his Gospel, the Church in an explicit way. We shall speak later of those who, through no fault of their own, do not know Christ and his Church.
25. Yves Congar, 'L'Eglise, Une, Sainte, Catholique et Apostolique', in *Mysterium salutis: Dogmatique de l'histoire du salut*, XV, Paris, Cerf, 1970, p. 125. See also the explanation of the term given by von Balthasar in *Le complexe antiromain*, p. 221.
26. Congar, *ibid.*, p. 127.
27. On this theme of the virginity of the Church of which the Fathers and especially St Augustine speak, let us point out the study by Marinus

Agterberg, '*Ecclesia-Virgo*', *étude sur la virginité de l'Eglise et des fidèles chez St Augustin*, Louvain, Hist. Inst. Augustin., 1960, p. 133.

28. On these various ways by which Christ is present to his Church, see *Sacrosanctum Concilium*, no 7.

29. Congar, *I believe in the Holy Spirit*, vol. II, pp. 53. The italics are mine.

30. Cf Plumpe, *Mater ecclesia*, pp. 18-34. The sentence from *L'Epitaphe d'Abercius* (around 180) is most significant: 'Faith used to lead me everywhere, everywhere it served me a nourishment in the form of a fish from a spring, very large, pure, caught by a holy virgin; she constantly gave it to her friends to eat' (quoted by Delahaye, *Ecclesia Mater*, pp. 79-80). It is possible that beyond the image of this holy virgin (the Church), we have an allusion to the Lady Wisdom who nourishes her children (cf Prov 9:1-5).

31. This union of the Church in heaven with the Church on earth was brought out in depth by the Second Vatican Council (*Lumen Gentium*, nos 49-50).

32. *Lumen Gentium*, No 49.

33. *Ibid.*, No 48.

34. This central idea opens the dogmatic constitution *Lumen Gentium* (no 1) and urges the Church and each of her members to transform themselves in order to radiate the light of Christ on the world.

35. Congar, *op. cit.*, p. 58.

36. The expression is from Karl Rahner.

37. Cf Congar, *op. cit.*, II, pp. 57-58.

38. Cf Pagé, *op. cit.*, pp. 227-232.

39. *Lumen Gentium*, no 8.

40. Cf *supra*, pp. 59-66 and 124-126.

41. Cf Congar, 'La Personne "Eglise"', p. 639.

42. Bouyer goes so far as to write: 'she (the Church) bears within her an invincible tendency to separate herself from him (Christ)' (*op. cit.*, p. 494-495).

43. *Lumen Gentium*, no 1.

44. Félix-Antoine Savard, *Le Bouscueil*, poems and prose, Montreal, Fides, 1972, p. 181.

Chapter 9

The 'sacramental' motherhood
of the ecclesial bride
and of her members

The Church Person, the bride of the incarnate Word, is the global project of God for humanity. Concretely, it concerns the ecclesial community and each of its members who, for his part, constitutes on earth the new humanity on its way to fulfilment. This historical community, formed of persons in communion with each other through the Spirit, is called to become the collaborator, the associate of Christ, in order to bring the treasures of salvation to all human beings. The ecclesial bride is destined to be a mother. To speak of the motherhood of the Church is thus to speak of this collaboration of the people of God in the work of salvation.

1. The salvific maternal mission

In what does this 'maternal' mission, for which God has chosen the ecclesial bride, consist precisely? In other words, what is the exact content of this 'part' that the Church is expected to assume in the begetting and the rearing of the new humanity?

In order to answer this question, nothing is more enlightening than what the New Testament has told us concerning the salvific maternal vocation par excellence, that of the mother of the Saviour-Messiah, Mary, model and figure of the spiritual motherhood of the Church and of all spiritual motherhood within the Church.[1]

a. Starting point: comparison with Mary's fulfilment of her maternal mission

In the presentation of the New Testament, Mary appeared to us first and foremost as the believer par excellence, the beloved chosen by God from among the *anâwim*, the little purified remnant of which she is, as it were, its crystallized expression.[2] We have seen her, moved by the Holy Spirit, give her consent to the Word and accept in the name of all her people (and of all of us) the salvation of God, the Word coming 'to wed' humankind in her womb. Thus conceiving Jesus in her spirit through faith, according to the profound intuition of the Fathers and especially of St Augustine,[3] Mary surrendered herself truly with all the sinews of her being to God's salvific design. In this way, she allowed the Word to become, from her and in her, one of us, the 'son of Abraham, son of Adam' (Lk 3:34,38).

Mary accomplished this acceptance of the One sent by God, by a living faith acting through charity, by intimately associating herself in the most complete way with the whole life of her Son and with the mystery of his mission, so often a paradox for her. And rightly so, at the final hour of the cross, after the long and painful journey 'from Cana to Calvary', it is in the terms of a crystallization of the faith of the Church, or better yet, of a perfect image of anticipation and eminent realization of the ecclesial faith, that John presents us the mother of the Saviour who 'from that hour' effectively becomes the mother of the disciples of her Son.

We thus see that the particular choice of Mary by the God of the covenant to be the 'mother of Christ and (the) mother of men, and most of all those who believe',[4] entails for her a real participation, both free and voluntary in the work of salvation. In other words, it is as a believer, freely committed in her faith, that Mary surrenders herself to God in order to fulfil her special maternal vocation. Thus, her maternity is fundamentally salvific because she gives birth to the Saviour and, secondly, because she collaborates with him in the salvific birth of the new world. One then understands that the

formal reason for Mary's salvific motherhood (and, subsequently, that of the Church), is the very gift of God.[5]

Nevertheless, further clarification is necessary. This motherhood is salvific for Mary and constitutes her own part in the work of salvation only thanks to this total and effective surrender of herself in love, a surrender implied by her commitment as a believer. That is why one can say that Mary's own part in this maternal mission, for which she was chosen, is realized essentially through her faith: a living faith operating through love. Besides, it is this approach to Mary's maternal vocation that makes the observation from St Irenaeus of Lyons quoted by the Second Vatican Council meaningful: 'Mary, being obedient..., became both to herself and to all humankind the cause of salvation'.[6]

These words from the Bishop of Lyons, however, can come as a surprise. In order to understand their meaning, one must determine more accurately Mary's contribution to the work of Christ, the only saviour. Besides, a similar perspective will enable us to have a better understanding of the role of the *Ecclesia Mater* in the communication of salvation.

First, we must recall the following principle: 'Redemption is an act of the saving God, who is himself both salvation and redemption.'[7] This redemption was brought about in a concrete manner in humanity and through humanity thanks to the human action of the God-Man who became the new Adam representing all of humankind in need of salvation. All men and all women are thus truly saved in Christ, the new head of the new humanity; everyone, man and woman, in principle, is born to the new life, thanks uniquely to his redeeming sacrifice.

But we must, by the grace of the Holy Spirit, appropriate this salvation, and make it fruitful until we reach our full stature in Christ. That applies also to humanity, as a group, which progressively becomes the total Christ through its members' appropriation of salvation. It is through faith and the mediation of the sacraments in faith, as situations and means of having vivifying encounters with the saviour Christ in the Holy Spirit, that humankind can appropriate this salvation for itself in each of its individual members. A person who

thus adheres in faith to Christ effectively receives salvation. Even the initial act of faith, necessarily a free action, already means that salvation is at work in a person, for this act is the fruit in him of the action of the Holy Spirit who unites him with Christ the saviour and brings about his allegiance to him in the unity of his ecclesial body.

This appropriation of salvation amounts to an authentic collaboration in the redemption of Christ. This is what led some Fathers to say that the individual person, by thus committing himself or herself through living faith, helps to bring about the birth of Christ Jesus in himself or herself.[8] In other words, the individual person collaborates in his or her own transformation into the image of the Firstborn (cf Rom 8:29) and as a living member of his body.

What we have just said can be applied in a supereminent way to Mary's active acceptance of the salvific will of God becoming flesh in her in the person of the Word. It is first her own salvation that Mary was thus accepting. For she also is a redeemed person, although this is so in a unique mode, by a preservative redemption.[9] But one must go further, for it is truly the salvation of humankind that this humble daughter of Israel accepted. Her anticipation, indeed, embraced in hope and charity of a unique quality, fruit of the 'plenitude' in her of the 'divine benevolence', not only her people's cry for salvation, but much beyond that, the thirst of all humankind in search for the true life. But her anticipation also embraced the thirst of God himself for the salvation of humankind (his *hèsèd we èmèt*, his tenderness and fidelity), a thirst which had expressed itself in many ways in the Old Testament and of which Mary had accepted the testimony in her meditation on the Word of God. Thus, when it is said of Mary that she conceived in her spirit the one she would give birth to in her flesh, this attitude of active acceptance, elicited and nourished by the Holy Spirit, became in her a true appropriation in principle of the salvation for everyone. And what was realized in a radical and intensely loving acceptance at the annunciation was pursued all along her faith journey with Jesus as his 'disciple',[10] up to the ultimate identification of

her heart with the heart of her Redeemer-Son on the cross.

Thus, Mary is both the model and the type of all maternal collaboration of the Church and in the Church. And in the wake of this Marian mystery, we can foresee that the 'maternal' service entrusted by God to his people, the 'part' which is hers in the work of salvation, will be directly linked with the faith of the ecclesial bride.

b. The place of faith in the maternal mission of the Church founded on the apostles

The central place given to living faith in the life and mission of the Church clearly emerges from the call of Jesus to the disciples. This is particularly the call addressed to the new Israel in the person of the Twelve, the official witnesses to Jesus, the living revelation and the foundations of the Church.

One illustration of this call to faith of the Twelve is the scene in Caesarea Philippi, especially in Matthew 16:15-19. Jesus directly challenges his disciples inciting them to profess their faith: 'But who do you say that I am?' (16:15). Simon Peter receives the light and the strength from above to testify publicly in the name of them all: 'You are the Messiah, the son of the living God' (16:16).[11] Jesus then goes on:

> Blessed are you, Simon son of Jonah! For flesh and blood has not revealed this to you, but my Father in heaven. And I tell you, you are Peter, and on this rock (*Petros*) I will build my Church, and the gates of Hades will not prevail against it. I will give you the keys of the kingdom of heaven, and whatever you bind on earth will be bound in heaven, and whatever you loose on earth will be loosed in heaven (Mt 16:17-19).[12]

This text of capital importance wishes to illustrate first the fundamental role that Christ has assigned to the Twelve, epitomized here in the person of their leader, Peter.[13] But what

is of special interest to us is the bond that the evangelist establishes between Peter's profession of faith and the proclamation that Jesus wants to found his Church on this living 'rock' which has become a witness to faith. In no way does this text suggest that the special ministry entrusted to Peter is given to him as a reward for his faith, something which would go against the mystery of the absolute gratuity of election and salvation. Matthew's pericope wishes to indicate rather that Peter's profession of faith is the fruit in him of divine grace. Moreover, this profession of faith shows that the divine grace received by Peter will enable him, objectively and subjectively, provided he freely gives his assent in return, to exercise his particular mission of being the official witness to Jesus, the Christ and Son of God.

This passage clearly brings out what our allusion to the maternal mission of Mary, figure and model of the Church, allowed us to foresee. The rising community, whether it be personified and eminently actualized in the person of Mary, or inaugurated and crystallized in the nucleus of the Twelve and their leader, Peter, is chosen to carry out the mission of bringing salvation to the world only inasmuch as it is a community of disciples. In other words, the sacramental mission of the Church is, so to speak, 'all included' in her faith, this faith that the Holy Spirit indefectibly awakens in her and thanks to which she receives the life of God by freely 'professing' her acknowledgement of the mystery revealed and communicated in Jesus, this saviour to whom she surrenders herself in obedience and love (Eph 5:24).[14] It is this living and active faith, the fruit of grace in her that, properly speaking, constitutes the maternal mission of the Church, 'her' motherhood as bride, that is, 'her part' in the begetting of humanity to a new life through Christ.

c. Who is the subject of this all-inclusive faith by which the Church is mother?

From what we have just said on the role of living faith (professed and lived) as the proper form of the maternal co-

operation of the Church in the communication of divine grace, we may now attempt to determine the adequate subject of this faith by which the Church is mother.[15]

If this faith is the fundamental attitude of the people of God who thus profess their adherence to the mystery, revealed and transmitted by the preaching of the apostles, the subject of this faith and, therefore, the all-inclusive subject of the ecclesial motherhood is necessarily the Church Person herself, a subject transcending the sum total of the Christians but which actualizes itself in these Christians in the measure of their effective communion with Christ. Let us examine more precisely what this affirmation entails.

This faith of the Church is first and foremost 'the apostolic faith', the faith received from the apostles. The subject of the faith of the Church is, therefore, in a special sense, the apostolic College with Peter as its head. That is why any profession of faith in the Church will be the faith of the Church only insofar as it is the very faith transmitted by the ones sent by Christ and, therefore, insofar as it is the apostolic faith of the apostolic Church.[16]

But in order to have a good understanding of this affirmation, one must make another essential point: what we have just said fundamentally concerns the mission that Christ has entrusted to the Twelve (and to Paul): 'Go therefore and make disciples of all nations...' (Mt 28:19ff); 'You will be my witnesses in Jerusalem, in all Judea and Samaria, and to the ends of the earth' (Acts 1:8). When we say that the apostles are in a special sense the subjects of the faith of the Church, basically, we are saying that by their election they have received the mission of transmitting, instrumentally and sacramentally, the Word of the faithful God, Jesus Christ himself, sacrament of the mystery of his Father and of his salvific will for humankind. This depository of faith (*depositum fidei*) has been entrusted to them and to them alone by the grace of the Holy Spirit and the mandate of Christ, so that they may be the first and fundamental witnesses of this faith, while being themselves believers among others and with whom other believers will join subsequently. And their

testimony is normative, for it is through it and in it that the living Word of God is conveyed to human beings.

But then, who carries forth this apostolic faith today? Basically, the whole Church does. She is the one who, corporatively, transmits this faith from generation to generation. The apostolicity – that of the faith in the all-including sense – is a characteristic of the whole Church. But, at the same time, Christ wanted the fidelity of the Church to the faith of the apostles, a work of the Spirit, to be assured by an external principle of fidelity:[17] that of the episcopal college with, at its head, the Bishop of Rome who continues to assume throughout the ages the mission of the apostles and of Peter in its transmissible aspect.[18]

If, in this fundamental sense, it is truly the whole Church that is apostolic, it is also 'the unity of all', of which Congar was speaking earlier,[19] which, as such, through this professing of her faith bears this maternal vocation entrusted by Christ to his Church. This spiritual motherhood, attributed to the *Ecclesia Mater* in her relation with the apostolic faith, has been expressed in many ways by the Fathers and most particularly by St Augustine.[20] For him, it is the faith of the one Church which makes her a mother. And Congar explains: it is in unity that 'children individually begotten by the Church, the faithful exercise the spiritual motherhood common to the whole Church.'

Two aspects are directly implied in this expression. If it is the *one* Church that carries out adequately the maternal mission entrusted to her by her bridegroom, she alone can be recognized as the full subject of this fruitful faith by which believers are begotten to supernatural life. Besides, this is why the valid communication of the grace of the sacraments is not impeded by the lack of subjective faith of the minister, as St Augustine has well demonstrated in his struggle against the Donatists. In his response to their objections, the Bishop of Hippo maintained that the sacraments – in the present case, baptism – are, in their objective principle, actions of Christ and not of Paul, Apollos, Cephas, Marcion, Donatus. Because of this, the sacraments draw their efficacy from the

word of faith (the form) which makes them exist, this word being the gospel word received by the Church and coming to her from Christ. As he sums up Augustine's idea, Louis Villette writes:

Whenever and wherever[21] baptism is celebrated according to the evangelistic and ecclesiastical rules, it is founded on the catholic faith expressed in the very form that constitutes this sacrament. It is this faith that gives the sacrament its meaning and makes it a sacred sign. It is again this faith, conveyed by the words of the gospel, that makes it an 'integral, true and holy' reality everywhere, whenever these words are respected. Thus founded objectively on faith, baptism cannot be affected by the disbelief or the perfidy of the ministers or of the subjects.[22]

What Augustine safeguards here is the validity of any sacrament insofar as it is a gift from Christ to his bride, the Church, and through which, in the power of his Spirit, he acts faithfully. On the other hand, he shows that the faith of the holy bride of Christ is so guaranteed by her bridegroom that it becomes a transcendent faith that acts instrumentally when a sacrament is ministered according to the form received from Christ and preserved by the ecclesial tradition and magisterium, even in a community that has become schismatic or heretical.

Therefore, it is always this indefectible faith of the ecclesial bride that operates maternally in all communications of grace and, when necessary, compensates for the limited faith in individuals. That is so true that even if the faith of particular Christians, of communities and even of one or several particular Churches, is but a purely material faith, even deficient, not to say openly heretical, never will the ecclesial bride as such cut herself off from the apostolic faith and consequently from the indefectible communion in the Holy Spirit with the mystery of Christ.

But there is also this other aspect. If the fruitful faith is that of the *unitas* itself, the ecclesial bride does not exist outside

the 'we' of the Christians, that is, of individual persons who profess this faith in unity and in an integral manner. Consequently, each person, insofar as he or she makes this faith of the Church his or her own is, for his or her part and in the measure of his or her faith, the subject of this faith. By that very fact, he or she personally collaborates in the sacramental mission of the *Ecclesia Mater*.

We must make another important and precise point. The actualization of the faith of the Church in the baptized individual implies two elements: the integral and objective profession of the apostolic faith, and a life of faith enlivened by charity. In this perspective, two extreme cases can emerge. There is the case of baptized individuals who materially profess the apostolic faith while being separated from God. One cannot say they have no faith, but their faith is dead and unable to survive in them indefinitely. On the other hand, there are many who cannot be called believers because they do not know the Christian faith or they know it too inadequately to be able to receive the 'seal' of the sacramental baptism. These may have the salvific faith through the mysterious action of the Spirit in them and through their fidelity to the dictates of their conscience. The first actualize the faith of the Church only in a purely material fashion without truly having faith in the integral sense. Their participation in the motherhood of the Church is thus purely exterior and has little or no value. The second ones are formally believers without explicitly being so. That means that although the motherhood of the Church does not actualize itself officially in them, the salvific value of their real faith is undeniable and, by the very fact, their life exercises a certain salvific influence in the history of salvation, although this influence is difficult to measure.

2. The exercise of spiritual motherhood by the Church

We are now able to move into the other phase of our study by attempting to determine more clearly how this salvific motherhood of the ecclesial bride of Christ is exercised.

a. A motherhood through the proclamation of the Word and the celebration of the sacraments

In his synthesis of a doctrine unanimously accepted by the Fathers, de Lubac interprets the mystery of the *Ecclesia Mater* as follows: 'It is the mystery of a social and visible Church existing in the world, acting through men and exercising her motherhood through the Word and the Sacrament.'[23] Let us dwell on the last part of this sentence. This is essentially a return to the affirmation repeated time and again: salvation is brought about through the supernatural generation of humankind accomplished by Christ on the cross. The effect of this birth is instrumentally communicated in space and time by the Church, the sacrament of salvation, and by the sacraments of the Church ('Word and Sacrament'). Thus, the total Christ is fundamentally 'built' by the ecclesial proclamation of the Word and the celebration of the sacraments of Christ, especially baptism, as a new birth, and confirmation and, at another level, reconciliation, as a permanent source of healing, as well as the Eucharist, centre, source and summit of the incorporation of believers 'into one body' in divine communion.

Note that we are always dealing with the 'Word and Sacrament indissolubly united'. If de Lubac speaks in this way, it is because the Word is already sacrament, just as the Sacrament is also Word. Moreover, in the Christian economy, the proclamation of the Good News (the Word) leads to the encounter with this same Word, that is, with Christ himself, the incarnate Word in the efficacious signs that actualize his salvific presence (Mt 28:19-20 and the whole Johannine context). Of course, when they speak of this motherhood, the Fathers sometimes lay emphasis on the birth of the Christian through the Church in the Sacrament, sometimes on the proclamation of the Word. But, the author goes on,

> one should not see there an opposition, nor even a properly so-called duality. Indeed, the Sacrament is never without the gift of the Word, and the Word itself is already Sacramental: it is the living Word proclaimed by the

apostles, the Word of God itself handed over and explained to men. The transmission of this Word by those who are its 'servants' is not simply a teaching, pure 'catechesis': it is the communication of the life of Jesus Christ, the Word of the Father, to whoever is willing to open his heart to it.[24]

b. The exercise of the ecclesial motherhood through the 'profession of faith'

These assertions could lead one to believe, however, that they contradict what we have said previously about the specific contribution of the Church, a contribution that is truly hers, to the birth of the new world. There is no such contradiction, for the two expressions: 'motherhood of the Church exercised through the means of salvation' and 'motherhood of the Church exercised through living faith' are two assertions intrinsically bound together. Each one simply goes back to our two previous affirmations concerning first, the redemption perfectly accomplished for humankind in its head, Jesus Christ, and communicated by the Spirit to human beings in time (objective faith) and secondly, the necessity of an active appropriation of this salvation by individual persons (subjective faith).

The meeting of these two inseparable axes helps us to have a deeper understanding of the way the Church exercises her spiritual motherhood. She does so every time she effectively accepts salvation by publicly professing her living faith in the bridegroom-Saviour who actually gives himself to her and, through her, to the world. And since this public profession of her faith is expressed at its summit, there where the gift of Christ is actually made present while being perfectly signified, that is, first in the public proclamation of the Word and, then, in the celebration of the sacraments, it follows that it is mainly in the liturgy that the Church can fully exercise her salvific motherhood. And we recall that this liturgical activity is the fact of the Church understood corporatively since it is

the *unitas* itself that is the adequate subject of this profession of faith.

Why is this profession of faith of the Church through liturgy the summit of the confession of ecclesial faith? It is because the liturgical activity is not only the public act of the priestly people expressing the virtue of religion, but also the 'situation and means' par excellence in which the Church exercises her maternal co-operation in the birth-nutrition-education of the sons and daughters of God. This last aspect clearly emerges from the fact that it is in 'offering', as Assembly, the gifts (bread and wine), symbols of everyone's concrete life, then in 'pronouncing' the words of faith transmitted by Jesus while asking the Spirit (*epiclesis*) to effect the work of salvation by means of the sacramental signs through the special mediation of the ordained ministry, that the Church instrumentally actualizes the salvific work.

St Thomas Aquinas goes so far as to say in his *Commentaries on Sentences*[25] when he quotes a text from St James (5:3-16) about the anointing of the sick through the saving 'prayer of faith': 'It is not "the anointing" but "the prayer of faith"; this is not about the one who anoints but about the Church herself in whose faith the sacraments are administered. As in the other sacraments, it is not enough to believe in one's heart, but there must be a profession of faith in a spoken word. That is why the verbal form is part of the integrity of the sacrament, the form, we mean, of this word by which "the prayer of faith" becomes expressive. And that is part of the very institution of this sacrament.'[26]

These views are of capital importance. One must nevertheless add another comment: if the Church exercises her mission in a special way in the liturgy and in the manner that St Thomas has just indicated, one cannot restrict her maternal activity to forms of worship. In the first place, the prophetic mission of the Church goes much beyond the framework of its worship, as the Second Vatican Council has made clear: 'The liturgy does not comprise the whole activity of the Church for, before men may accede to the liturgy, they must be called to faith and conversion.'[27] The Church, through the

activity of her members acting in faith, thus also exercises her motherhood by calling human beings, in various ways, to conversion.

Moreover, it is through the very tangible life of the Christians in the midst of secular realities, particularly through the activity of the lay people, that the Church, in the power of the Spirit, consecrates the world by purifying it through their moral effort (in union with the non-Christians of good will); thanks also to their concern to direct the human activity towards the ultimate end that the Father has determined for it and has revealed in his Son Jesus Christ. Such a consecrating and sanctifying activity of the Church is also the exercise of her maternal mission since this activity is a true profession of faith in the salvific gift of the living Word of God acting through the history of humankind, thanks to the Holy Spirit. An activity of that kind is a living and sometimes a verbal proclamation of this Word, the acceptance of the Word's power of salvation and commitment in order to let the Word bear the fruits it is capable of producing in the world.

Such an exercise of the motherhood of the Church amongst earthly realities cannot, however, be separated from the liturgical activity. For in the diversity of these commitments, the Church carries out a maternal activity only insofar as these actions are animated by faith, by this faith precisely professed in the liturgy and which is, in Christ, a living intercession with the Father and the Spirit as well as an acknowledgement and an effective reception of the salvific gift given *hic et nunc* to the community and through it to the world. Such is the profound meaning of the words of the Council: 'Liturgy is the summit towards which the action of the Church is directed and, at the same time, the source from which flows all her virtue.'[28]

In the light of the above, we could sum this up in the following way. The maternal co-operation of the Church in reality is no different from the priestly activity of the people of God.[29] For in the end, this is what the preceding development sums up: the election of the *Ecclesia Mater* in view of her service of active co-operation in the work of salvation is

synonymous with her election as a priestly people. And it is the worship of Christ, including the concrete offering of the whole community and its members, that constitutes, in its plenitude, the profession of faith of the *Ecclesia Mater*, the one through which she collaborates with her bridegroom in the work of salvation.

c. The individual's share in the exercise of the Church's spiritual motherhood

Every Christian has been empowered by baptism and confirmation to exercise, in communion with the whole assembly of the faithful, this 'priesthood of life' rooted in the living and vivifying offering of Christ. Consequently, each person has not only the right but the duty to do his share in the exercise of the motherhood of the Church by committing himself or herself through faith, in a precise and real way, in this corporative priestly activity. Such a right and such a duty flow directly from his or her election as a member of Christ in his Body, the Church.

This right received in baptism and confirmed by the anointing of the Spirit stems from the fact that the person has been stamped with the seal of the adoptive sons and daughters of the Father. This seal 'delegates' the faithful to the worship of the Father in Spirit and in truth, and to the testimony of the holiness of God in this world. Correlatively speaking, by constituting the integral offering of the priestly people, this effective and vital commitment of the baptized is what gives the *Ecclesia Mater* the possibility to accomplish her maternal mission in all its dimensions.

We must make a precise point here. When we speak of the election of the individual person, we must take the following detail into account: every human person, without exception, according to the central statement of the New Testament, is radically the object of a fundamental election to the adoptive filiation in Jesus Christ. But historically and in conformity with the mystery of the economy of salvation, for a person to become explicitly a member of the ecclesial Body implies for

him what we could call 'an election to the second power'. Such an election is, properly speaking, the explicit election as a part of the priestly people, an election which sets a person aside as a member of the ecclesial bride of Christ and a participant in her maternal mission in view of communicating divine grace. This election 'to the second power' as a member of the Church does not exclude the possibility for an individual person, who accedes only implicitly to salvation, of co-operating, through his or her concrete existence lived in honesty and sincerity, in the realization of God's plan. His or her good deeds and even his or her being are 'ordained' to be mysteriously integrated into the life and fruitfulness of the people of God.

With respect to the many members of the Church, the full awareness of such a participation in the mission of the people of God is more or less non-existent. However, the ecclesiological image of the vine and the branches helps to understand that the member effectively in union with Christ through a living faith is 'fruitful' even if he or she is not aware that this maternal mission as a whole personally concerns him or her.

This fruitfulness, which stems from the commitment of the individual person, expresses itself at two levels. There is the fundamental level by which each baptized person is called to commit himself or herself in faith and love and live in conformity with the will of God. This is the essential service of the holiness of one's life. This first service is prior to any particular form of commitment in individual vocations and is the soul of all particular calls, in the same way that faith acting through charity 'informs', so to speak, the exercise of spiritual motherhood by the Church. For all maternal fruitfulness of the Church essentially consists in participating in the communication that God makes of his own life – which is by nature agape (gift and communion). Thus, for the human creature, the fact of collaborating in this communication (by first receiving its effects within himself or herself) implies that he or she do so in a love that is gift, communion and service.[30]

But at this first level, one must add another consideration.

If the first requirement of any service in the order of salvation is the pursuit of the perfection of love, this requirement is not understood outside the 'communional' and 'corporative' commitment of the Church. In other words, what the Spirit kindles in the individual believer is essentially a desire to accomplish a service in conjunction with the project of the whole Christian community and to accomplish it there in love and in communion with others. Since what Christ wanted for his Church is a community that has such an organic and hierarchical structure, the will of the Christian, when it is truly moved by the Spirit, will necessarily tend towards the ecclesial communion. And that will express itself in an effort to love, to serve and to share with his or her Christian brothers and sisters as well as with all the men and women of good will. It will further find expression in the effective acknowledgement of the sacramental mediations of authority instituted by Christ for his Church and for service in this communion.

This service provided by 'the holiness of one's life', nevertheless, does not realize itself outside the very personal call that God addresses to each one of us, and this is the second level of commitment of baptized individuals. The New Testament shows us that every individual called to existence by God is elected in Jesus Christ (explicitly or implicitly) to reproduce in a unique way something of the traits of the firstborn in whose image he was created and re-created in grace. In the perspective of the sacramental economy of the Church, this personal and personalized election is expressed in the unique mission devolved upon each baptized person. This mission manifests itself, among other things, in the various gifts distributed by the Spirit in view of the good of the whole (cf 1 Cor 12:7ff; Eph 4:11ff). Thus there exists an existential conjunction in the life of the baptized person between his or her vocation to holiness, with the salvific fruitfulness resulting from it, and his or her particular vocation according to the design of the wisdom of God. An important example of this conjunction has appeared to us clearly in the vocation of Mary, the humble daughter of Sion

and the mother of Christ, as well as in the apostolic call of the Twelve and especially of Peter.

It is important to mention some of the consequences of this conjunction. By putting to use his or her gifts received from God, the Christian concretely expresses his or her faith and love. Such is the consistent teaching of the Gospel, as in the parable of the trustworthy steward in St Luke (12:42-43). The First Letter of Peter 4:10, in its turn, makes this yet more explicit: 'Like good stewards of the manifold grace of God, serve one another with whatever gift each of you has received.'[31] Christian service in faith and love is necessarily expressed through the effective working of the natural gifts and graces received from God.

This call of each baptized within the Church and the gifts allotted to him or her according to his or her vocation depend upon the salvific will of God who chooses 'whom he wishes' with respect to his designs of wisdom (cf 1 Cor 12:11; Eph 4:7, 10). It follows that, for the baptized, the fact of receiving salvation in living faith and of using effectively the gifts received for the service of God and for his work of salvation, are two complementary aspects which come together in one same faithful response to divine election. Thus, it is also through such a faithful acceptance by her members that the *Ecclesia Mater* herself fulfils, in fidelity, her maternal mission in view of building the total Christ (cf Eph 4:12-14).

A very eloquent image helps to express what has been said above. It is the comparison between the salvific work of the ecclesial bride and the performance of a magnificent symphony. The masterpiece to be played is that of the eternal design of the wisdom of the Father, incarnate in the unique mystery of Christ redeemer and recapitulator. It is through the interior action of the unique Spirit that all Christians, men and women, execute this unique masterpiece in faith, hope and love as well as in the harmonious communion of their particular vocations. It is under the unifying direction of this musician, the director of the orchestra, that is, the principal and structuring ministry, that all the musicians of the orchestra can give the best of themselves. Even if this unified whole

is what performs the work, each member must play his or her part as competently as possible. And yet, when all is said and done, everything comes from the composer who has expressed something of the riches of his inner mystery in the composition flowing from his inspiration. The same is true of this 'sacramental' maternal mission entrusted by the Father to the ecclesial body of his Son made flesh.

3. The spiritual motherhood of the Church

Before concluding this Chapter, there remains for our consideration a final point on the exercise of spiritual motherhood by the Church. We have already shown how the perpetuation by the Church of the mission of her head and bridegroom implies the necessity of participating in the mystery of substitution lived by him. Like Christ, the *Ecclesia Mater* must take upon herself, out of love, the sufferings of humankind by identifying herself with the poorest, by concretely bringing to them the Good News of their liberation in the passover of Jesus. This substitution is not reduced, however, to an ethical obligation, although this is implied. The Church and her members are expected to make themselves available to God by accepting to share the Messianic sufferings of the Saviour according to the words of the Apostle who exclaims: 'I am now rejoicing in my sufferings for your sake, and in my flesh I am completing what is lacking in Christ's afflictions for the sake of his body, that is, the Church' (Col 1:24).

It is really in the light of this configuration of the Church with Christ that our previous developments take on their full meaning. We have seen the 'birth' of a new humanity presented in John 16:21 by means of the parable of the woman in the pangs of labour and about to give birth to a man. This woman, the people of Israel (who in turn represents all humanity), and subsequently the Church, appeared to us as truly 'in labour' on the cross in the priestly and sacrificial offering of the one (Christ) in whom this people and all

humankind are centred. In other words, the commitment of the human creature in the spiritual birth of the new humanity is brought about in the immolation of the love of Christ, the new Adam who offers himself to the Father for the sake of all his human brothers and sisters with whom he has placed himself in total solidarity in everything except sin. Because of that, the actual maternal commitment of the ecclesial bride and of her members cannot be understood in any other way except in terms of participation in this *kenosis* of love of the Son, the only true salvific 'birth' of the new world. That is true first for all believers because 'no one can have greater love than the one who gives up his life for those he loves' (Jn 15:13, translation based on the *TOB*); the *Ecclesia Mater*, in her members, is precisely called to exercise her motherhood through such a love. But this is true also because 'servants are not greater than their master. If they persecuted me, they will persecute you; if they kept my word, they will keep yours also... In the world you face persecution. But take courage; I have conquered the world!' (Jn 15:20; 16:33).[32] Because the Church is the bride of the one who was the Suffering Servant for the sake of his own people, the maternal mission which her bridegroom has entrusted to her necessarily bears the paradoxical traits of the mystery of suffering which has characterized the pangs of labour of humanity being born on the cross.

In such a context, the figure of the mother of Jesus, the type and model of the *Ecclesia Mater*, the one who, at the foot of the cross, already foreshadowed the mystery of the woman of Chapter 12 of the Book of Revelation, stands out in a particular way. And that is true not only with regard to the countenance of the sorrowful mother as a personification of the Church, but also at the level of the personal vocation of this woman as a model for the believer. For every Christian, like Mary, is expected to live his or her faith commitment by accepting the will of the Father, whatever that may be, in a total and fully loving surrender, thus accepting to 'live in love' (Eph 5:1-2) in the paradoxical path of the beatitudes, a road mapped out and followed by Christ himself. Finally, it is

such an imitation of Mary, in the wake of Christ, that allows the *Ecclesia Mater* and her members to exercise fully, like her, their motherhood, that is, to realize fully in and through Christ the 'service' for which the ecclesial bride was 'chosen' as a priestly people and a sacrament of salvation.

NOTES

1. It is quite evident that when we thus refer to the figure of Mary and her maternal mission, we do not claim that between the two subjects of comparison, Mary and the Church, there are only similarities. On the contrary, we are faced here with an analogy where 'the differential factors', according to an expression used by Mgr Gérard Philips ('Marie et l'Eglise', *Marie*, IV, *op. cit.*, pp. 406-411), must in no way be neglected in order that the true sense of the comparison may appear clearly. See also Congar, 'Marie et l'Eglise dans la pensé patristique', in *RSPT*, 38 (1954), pp. 3-38, as well as Aloïs Müller, 'Place et coopération de Marie dans l'evénement Jesus-Christ', in *Mysterium salutis: Dogmatique de l'histoire du salut, Le déploiement de l'événement Jésus-Christ*, XIII, Paris, Cerf, 1972, especially pp. 31-51, 85-101 and 163-170.
2. This affirmation underlies the appropriateness of the privilege of the Immaculate Conception with regards to the mysterious love story between Yahweh and his people which implies a constant purification of the latter (systolic movement) in order to dispose it to see the holy seed of God being born from it (cf 1 Ezr 9:2; Mal 2:15). See the already mentioned study by Louis Bouyer, *The Seat of Wisdom...*, pp. 103-130.
3. For instance, in his sermon 215, 4 (PL, 38, p. 1074).
4. *Lumen Gentium*, no 54. The two aspects of Mary's salvific maternity must be understood each at its proper level but indissolubly linked to each other in a same decree of election. Mary's maternity with regard to Christ is the first and fundamental one, the one related to humanity is a maternity in the order of grace and is mysteriously implied in the first.
5. Cf Congar, 'Marie et l'Eglise dans la pensée patristique', p. 35.
6. St Irenaeus of Lyons, *Against Heresies*, Book III, 22, 4, p. 296. (This text is quoted in *Lumen Gentium*, no 56.)
7. Edward Schillebeeckx, *Mary, Mother of the redemption. The religious bases of the mystery of Mary*, translated by N.D. Smith, London and New York, Sheed and Ward, 1964, p. 49.
8. Cf de Lubac, *Les églises particulières dans l'Eglise universelle*, p. 170, where the author quotes a text from Hippolytus in his commentary on Daniel.
9. It is the very grace of the Immaculate Conception which expressed itself existentially in the life of Mary by her total consecration to the God of the covenant and to the mission of her people.
10. Cf John Paul II, *Redemptoris Mater*, no 20.

11. In the parallel texts of Mark and Luke, the profession of faith is limited to the Messianity of Jesus.
12. For an exegetical analysis of this Matthean pericope, see Pagé, *op. cit.*, III, pp. 427-430.
13. Cf *ibid.*, p. 430.
14. On this notion of an all-including faith of the Church, we refer you especially to von Balthasar: see, for instance, *The Office of Peter and the Structure of the Church*, pp. 183-225. The same notion is developed in 'Who is the Church?', pp. 127-153 and in the Chapter 'Le principe marial' of his book, *Points de repère*, Paris, Fayard, 1973, pp. 76-86.
15. This development takes up again, while being more precise, the analyses of the previous Chapter on the Church Person.
16. We have already mentioned a similar faithful profession of the apostolic faith when we spoke earlier about the virginity of the Church in faith. Cf *supra*, p. 176-177.
17. The inner and transcendent principle of fidelity is, of course, the Holy Spirit.
18. That is why the ministry ordained in the succession of the apostles is an apostolic ministry, a fact that implies a particular responsibility at the level of this apostolic faith for the persons who are consecrated in this ecclesial service.
19. Congar, 'La Personne "Eglise"', p. 637.
20. See the quotations in the study by Congar, 'Marie et l'Eglise dans la pensée patristique', pp. 33-34.
21. The same may be said of all sacraments.
22. Louis Villette, *Foi et Sacrement*, I, *Du Nouveau Testament à saint Augustin*, Paris, Bloud and Gay, 1959, pp. 238-239.
23. De Lubac, *Les églises particulières dans l'Eglise universelle*, p. 155. De Lubac has made a detailed account here of the tradition of the Fathers concerning this motherhood of the Church exercised through the word and the sacraments (pp. 155-156).
24. *Ibid.*
25. IV Sent., dist. 23, a. 1, q. 4.
26. Quoted by Villette, *op. cit.*, II, pp. 78-79.
27. *Sacrosanctum Concilium*, No 9.
28. *Ibid.*, No 10.
29. On this priesthood of the people of God as a participation of the Church in the unique priesthood of Christ, one may consult several studies. Here, we would like to mention especially: Jean-Guy Pagé, *Qui est l'Eglise, op. cit.*, III, pp. 87-164 and Albert Vanhoye, *Old Testament priests and the new priest according to the New Testament*, translated by J. Bernard Orchard, OSB, Petersham, Massachusetts, St Bede's Publications, 1986, p. 332.
30. Cf Bouyer, *The Church of God...*, pp. 534-535.
31. See also the texts of Paul which express the same line of thought: 1 Cor 12; Rom 12:3-8; Eph 4:2, 12.
32. Moreover, we might recall how Paul, speaking of his self-devotion for the Galatians, compared his sufferings for them to the pangs of labour in childbirth, thus referring to the comparison used by Jesus in Jn 16:21 when speaking of his passion and death (cf *supra*, p. 126).

Chapter 10

The mystery of the 'femininity' of the Church

The Church of Christ is both bride and mother. She is this woman whom the seer of Patmos saw appear as the glorious sign in heaven (Rev 12:1ff), the Jerusalem from above identified by Paul as the mother of the believers (Gal 4:26). But then can one legitimately speak of a certain 'feminine' qualification of the chosen people? What precise meaning could we read in this expression? What overtones could such an expression carry?

1. Two approaches to define the femininity of the Church

We shall first look into the precise notional content attributed to the expression 'femininity' of the Church from the facts gathered in the previous chapters. We shall then add another contribution to the question with a brief enquiry into the field of humanities.

a. A first approach in the light of the previous chapters

When we go back to the main considerations in the preceding chapters to find out what they tell us on this subject, we must note one basic fact: the symbolic substratum of the 'feminine' representation of the chosen community in the Scriptures is not just any ideal or mythical vision of 'femininity'.[1] It is the concrete historical figure of the Israelite woman in this reciprocal relationship with her husband

such as is experienced within a conjugal pact. The 'feminine' personification of the Church, according to the Scriptures, thus assumes, as a fundamental symbolic element, this idea proper to the human species according to which 'femininity' and 'masculinity' are bound to the relational character of any person destined to realize the plans of God for him or her in and through relationships with others. In this perspective, the ecclesial 'femininity' symbolizes first and foremost the love relationship and the faithful commitment that the covenant brings about between the chosen community and its divine bridegroom.

The 'feminine' qualification also symbolically goes back to the 'historical' aspect of the covenant as well as to this dynamics of a 'progressive spiral-like movement' with its stages of purification and expansion. For it is in such a historical journey that the divine bridegroom makes his chosen bride progressively able to be faithful to him.

The symbolic reference to the mystery of the covenant borne by the feminine human person implies yet another aspect. By concluding such a covenant with his people, God entrusts the latter with the responsibility of collaborating actively in the full realization of his design of love. The ecclesial bride of Christ, in the wake of Israel, thus receives the mission to participate 'maternally' in the salvific birth of the new world. The 'femininity' of the people of God thus constitutes also a means of interpreting this collaboration symbolically.

But one point must be clarified: we have seen how this maternal collaboration of the Church is fundamentally exercised through a living faith, that is, by an active acceptance of the gift of the new life communicated by the Father through the unique mediation of Christ the saviour as well as by the gift of the Spirit. The 'femininity' of the *Ecclesia Mater* thus goes back especially to this fundamental attitude of active receptivity, of a living and operating faith which is the heart of the covenant relationship between the Church and her Lord, and as such, the inner source of our fruitfulness in the work of salvation.

Briefly, the 'feminine' qualification of the chosen people, according to Scripture, is essentially a symbol which reveals the mystery of the covenant, bringing out in the latter the relationship of love and commitment which will enable the Church to live with God. This is the relationship that transforms the chosen bride and gives her the power to collaborate actively, through a living faith, in the full development of the fruits of salvation that Christ has realized for all humankind once and for all.

b. Second approach: quality of the Church and the human polarities of the feminine and the masculine

But can we move on to a second stage by resorting to certain facts drawn from the experimental sciences in order to determine, at the language level, a specific content in the expression 'femininity'? A line of investigation of hypothetical value seems open to us if we base our research on the fact that there exists two polarities in human beings: the pole of the masculine and the pole of the feminine.

At the human language level, the expression 'femininity' and its counterpart 'masculinity' necessarily have, like any verbal expression, an objective meaning. This meaning, however, is difficult to determine. Of course, it is usually easy to identify 'a man' or 'a woman', to determine the sex of a person on the biological level and to note what function this person is enabled to perform genetically from his or her biological and physiological structure. But it is altogether another matter when one must determine what it means '*to be* man' or '*to be* woman', and more precisely, in what the 'masculinity' and the 'femininity' consist, both terms understood as polarities in the human being. For what we are speaking about here is really polarities.

To speak of polarities, nevertheless, pre-supposes first the awareness, at the concrete level, of a specific difference between the sexes, as well as the consequences of this specificity with respect to sexuality. Besides, one must not

forget that, when dealing with human sexuality even if, at the biological level, the fact of being male or female makes humans have something in common with animals, there is an essential difference between the one and the other species since human beings enjoy the use of freedom. Because of this freedom, the exercise of human sexuality is endowed with a finality and a significance which transcend the biological aspect and reach the level of interpersonal communion.[2]

This last statement directs us to another preliminary consideration. One cannot speak of the 'masculine' and 'feminine' poles and ignore a general philosophical view which holds sexuality as an integral part of the human fact without for all that reducing oneself to it; hence the complexity of the matter. Several philosophical theses have broached this difficult question. In one of the main theses of her works, Simone de Beauvoir claimed that 'femininity' was a product of culture – a morbid one at that, according to her – the fruit of domination by males.[3] Other philosophers, such as the Dutch phenomenologist Buytendijk, have attempted, with the help of an existential psychology, to describe the mode of being feminine.[4] A similar initiative, with many shades of meaning, was pursued by Abel Jeannière in his *The Anthropology of Sex*.[5] These two last authors wanted to reject the idea of a feminine 'nature' or of a feminine 'essence' while attempting to determine what it is 'to be woman'.[6]

Let us now try to arrive at an overall view of a few objective facts which would show us what these two polarities could be, their relational value and, from these, their particular symbolic capacity.[7] First of all, this whole discussion should be grounded on an empirical evidence seldom denied, that is, the apparently complementary nature of the masculine and feminine poles such as they manifest themselves in the attraction of the two sexes. At the level of common sense, it appears that these two poles are not identical, yet, for all that, not without links and affinities. We can thus expect that the one and the other poles may be characterized by specific traits.

To help us see this more clearly, let us recall certain

theories drawn from experimental sciences and the humanities, particularly from psychology. Basing ourselves especially on the synthesis made by Gilbert-Dreyfus[8] and the study by Daco, we can say first, and in a rather general way, that the pole of 'masculinity', especially because of the genetic and hormonal influence predominant in the persons of the masculine sex, seems to predispose especially to activity, aggressiveness and to other analogous traits. The feminine polarity seems to be characterized more by stability, receptivity, sensitivity, to name only the most important traits. Buytiendijk considers each polarity as 'dynamic patterns'.[9] This author sees the dynamics of each polarity express themselves through 'movement'. Thus, for him,

> the masculine movement comes to an end an infinite number of times, while the feminine movement goes on indefinitely. The masculine act is divided in clearly delimited and marked parts. The entire act is moved by an underlined purpose which is called the goal. That is why any abrupt, sharp, rectilinear movement directed towards a definite point manifests a masculine character as soon as it is represented or imitated.
>
> The feminine action does not proceed so much from a sudden impulse or from an activity of reaction as from a tendency: this tendency can be aroused but only inasmuch as the inner nature echoes this stimulation.[10]

Hence one can see that the human dynamics is essentially one of two 'beats' in the sense of two 'moments' in one single rhythm.

One of the major discoveries of this century, to which research in embryology, genetics, endocrinology, physiology and even depth-psychology has contributed, is that there exists a certain bisexuality in each human being.[11] We now know that the sexual differentiation in the human being is a process which is more and more obvious starting from the seventh week of the existence of the embryo up to the adult age, thanks to the genetic inheritance which clearly sets the

sex of the new human being at the moment of fecundation. However, all along the embryogenesis and, subsequently, with the maturation of the individual, elements of genetic, hormonal and psychological bisexuality remain – in various degrees and at various levels without, for all that, annulling the fundamental genetic sex of each as well as the usual phenotypical consequences which stem from these.[12]

We may also add that the sexual differentiation accommodates itself with an almost infinite variety of manifestations linked as much with the hereditary lot of the individual as with the extrinsic factors taken into account in the course of the intra- and extra-uterine history of each person.

Hence, since every human person possesses within himself or herself a certain sexual bipolarity, it is then obvious, as Daco affirms, that a 'pure male is as nonexistent as a pure female'.[13] Concretely, according to this author, each polarity plays its role in the following manner:

> The feminine pole (femininity) includes everything that in us is relaxed, at rest; in expectancy; passive; 'in a state of potentiality';[14] accumulates potential energy; prepares an exterior action of whatever kind. The masculine pole (masculinity) includes everything in us that is in movement; active; 'in act'; discharges accumulated energy; acts exteriorly in whatever manner.[15]

Elsewhere, the same author compares the attitude of 'femininity' and of 'masculinity' in relation to vital energy, with the example of the bow and arrow, the feminine being the progressive accumulation of energy like the bow becoming taut, and the masculine, being the liberation and the exteriorization of the energy.[16]

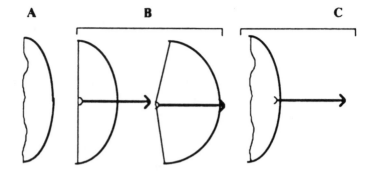

Daco takes up the same idea again in the following diagram which shows how, starting from an initial and not organized vital energy, the human act in every person, of whatever sex, goes through two 'phases': first the organization of this energy, proper to the pole of 'femininity', and then the dynamic release of this same energy through the exteriorization and the liberation mentioned in the example of the bow:

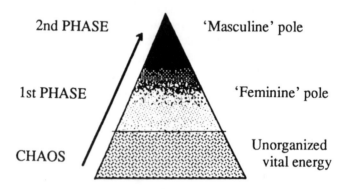

Such an effective bipolarity in the person (more or less well integrated according to one's degree of maturity) does not however exclude but rather implies and even demands, in order to achieve a true affective maturity, a predisposition to experiment reality first of all from one's dominant polarity according to one's genotypical and phenotypical sex. That is why, speaking of the woman, Daco says:

Because in a normal woman the behaviour patterns of femininity are more numerous than the behaviour patterns of masculinity, the woman is predisposed to certain attitudes in face of life, to certain ways of sensing and perceiving existence, to certain modes of thinking, of reasoning, of acting. In a word, she is predisposed to display the characteristics of femininity.[17]

This predisposition in the sexed human being, although it is rooted in the biological and the genital, is not for all that a determinism. On the contrary, it serves the development of the person in a positive exercise of his creative liberty. In other words, what in 'femininity' and 'masculinity' takes on rather the aspect of a determinism manifesting itself in a typical way in the genital activity (physical encounter of the sexes, and functions of generation and gestation in the mother), becomes a potentiality open to the manifold realizations of an undreamt-of richness at all the other levels of investment of the person: psychical, intellectual or others. This is all the more so when each person freely integrates in his or her personality the contribution of the complementary polarity always possessed by everyone to a certain degree.

These facts thus place us before a twofold perspective. The first is that fundamentally each person is either 'man' or 'woman' and the evolution of a normal psychology implies that the individual is enabled to assume adequately one's own genetic and phenotypical sex in a growth and openness to the other sex.[18] That supposes that each person has a more or less explicit predisposition to experiment reality and to commit oneself starting from its dominant sexual polarity. Consequently, every person of either sex is, precisely from one's personal sexual identity recognized socially, the natural subject of a symbolic reference to one's own dominant polarity and to the characteristic traits borne by this polarity.[19]

On the other hand – this is the second perspective before which these facts place us – because each person has potentialities which go much beyond the valencies of one's dominant sexual polarity and even include valencies of the

complementary sexual polarity, one cannot be confined to what is considered to be the feminine or the masculine according to a given culture.

Correlatively speaking, because sexuality is not the totality of their mystery, the fact that woman symbolizes 'femininity' and man 'masculinity', cannot constitute in any way a definition of what a person of this or that sex is.

In brief, we can determine in the idea of 'femininity' a notional content corresponding to a reality present in any human person, but with a more or less important predominance in the person of feminine sex. That is why the latter can symbolize, starting from herself, the values implied by this expression without being reduced for all that, as a person, to the feminine polarity.

c. Conclusion

We can see that these two approaches used to determine the precise content of the expression 'femininity', the first one proceeding from scriptural symbolics and the second, emanating from the humanities, do not contradict each other. Both confirm the extent to which the 'feminine' symbolization of the Church is based on this overall anthropological view offered to us by the Scriptures and which shows God creating *hâ' âdâm* as man and woman so that they might realize, by actualizing their reciprocal potentialities, this project of communion and fruitful collaboration with him and between themselves. This fact allows one to foresee why the 'feminine' personification of the Church can be a particularly efficacious means, among others, to bring out certain particularly rich overtones of the mystery of the covenant as a mystery of fruitful communion.

2. Synthesis of the major theological meanings of the 'feminine' quality of the chosen community

We can now take a further step by delving deeper again into the range of meaning that the previous chapters have opened, in order to sum up the most important theological meanings of the 'feminine' quality of the Church.

a. What the 'feminine' quality of the chosen community tells us about God's salvific project

The first important meaning is the one already identified at the beginning of this Chapter: it is the one recalling the relationship of reciprocity between God and his people implied in the covenant. The 'femininity' of the chosen people thus symbolizes eloquently God's benevolent plan to give himself, in the midst of humankind and for it, a covenant partner he wishes to introduce into a communion of a unique intensity and fruitfulness of which the union of spouses in marriage is the best image. At the same time, this symbolization emphasizes the historical character of the covenant and the perseverant fidelity of God whose salvific will is efficacious, despite the tergiversations of human beings wounded by sin.

b. What the 'feminine' quality of the Church tells us about the mystery of God who saves us

A second series of theological meanings evoked by the 'feminine' symbolization of the Church places us before God himself, and it is here that the capacity this symbolism has of 'moving us to greater things' finds its highest expression. This 'feminine' personification refers us to the Other, to this God who, in the final economy, is the divine bridegroom incarnate in Jesus Christ, the monogenic Son revealing the Father and communicating divine life to humanity through the power of the Spirit.

In order to assess adequately the implications of this symbolic level, let us recall this *sui generis* characteristic of the title of 'Father' given to God in the New Testament. The symbolic link between the incarnation of the Word in a human nature of the masculine sex and the sacramental manifestation of the Father, which Christ assures in the world, constitutes a fact which is an integral part of the economy of salvation in conformity with God's design. Whatever arguments are used to explain the reasons behind such a fact, whether it is the patriarchal framework of the Hebrew society, which would have made a 'feminine' incarnation of the one sent by Yahweh unthinkable, or this fact, brought out by Vergote and Tamayo, that the paternal figure (therefore masculine) has a greater capacity of representing God,[20] we are faced with a fact to be accepted as such because it bears meanings which can help us to penetrate the depths of the mystery.

And yet, what precedes must not cloud over another important element: God the Father who has revealed himself to humanity in his Son transcends the differentiation of the sexes. He is the totally Other and the Bible does not hesitate to speak of him through feminine images as well and, particularly, through maternal images.[21] The 'feminine' personification of the Church which, in a polar manner, refers us back to Christ and through him and by him to the Father, must not exclude the feminine symbolic valencies in the representation of the divine partner of the covenant.[22]

This reference to the Other borne by the Church Person (feminine) also reveals how the ecclesial bride receives herself in the depths of her being from her bridegroom, the 'saviour of her body' (cf Eph 5:23). She is therefore a bride only because her bridegroom, Christ, by giving himself up for her in a supreme act of love (Eph 5:25), makes her come into existence. In this sense, the ecclesial 'femininity' recalls in a particular way the salvific love of Christ, Word incarnate, who not only 'personalizes' his bride, but 'makes her exist'.

But here we must also offer some clarifications. The salvific commitment of Christ was itself translated through

the feminine and maternal image of the birth of the new humanity promised to Sion. It is therefore necessary to acknowledge that, also at this level, the feminine personification of the Church transcends itself, for in referring, in a polar manner, back to Christ, she focuses the attention on the saving act which itself bears feminine valencies.

The particular value of this 'feminine' symbolization of the Church and the necessity for her to surpass herself, emerge particularly when this symbolization refers back to the role of the Spirit in the salvific economy. Throughout our study, we have come across this operative presence of the Spirit of Jesus. It is the transforming gift of the Spirit as well as his permanent unifying presence in the ecclesial body of Christ that realizes these nuptials between God and humanity in spite of the infinite distance separating the two 'spouses'. This affirmation is true both with regard to the nuptials between God and human nature in the person of the Son and the sanctification of his humanity and to the nuptial covenant between Christ and his ecclesial body. The role proper to the Holy Spirit is to communicate the grace which raises the creature in view of its union with God without dispossessing this creature of its own personal identity.

This transforming action of the Spirit in the *Ecclesia Mater* also enables the latter, as a true bride, to collaborate in this salvific work which, however, depends only on God. The Spirit communicates to the Church both the power to bring about instrumentally the actualization of the acting presence of the risen Christ in the Memorial of his salvific offering, and the capacity to do so in a fully human manner through the profession of faith, that is, through this attitude of active acceptance and of commitment in communion. Hence, one can say that the 'femininity' of the Church also brings to mind this unifying, transforming and life giving presence of the Spirit in her, through whom and in whom Christ-bridegroom makes of this recreated humanity his collaborator in the fulfilment of salvation.

But the reference to the 'femininity' of the Church in relation to the mission of the Holy Spirit also includes a

transcendence of the human perspectives of the symbolic substratum. In order to understand this, one must recall that the Christ's gift of the Spirit to the ecclesial bride is the gift of the filial Spirit who introduces the believers into the great family of God, Father, Son and Spirit. The Church, in her intimate nature, even as bride and mother, is a people of adoptive sons and daughters of the Father in the incarnate Son, and in him, a people of brothers and sisters in a communion of love, of gift and of service to each other. Moreover, what the Spirit arouses in the Community, as a participation in the spiritual birth of humanity, is both the attitude of surrender of the Son to his Father and of openness to the paternal gift of divine grace which, by precisely uniting the persons to Christ, make them penetrate into his heart, and hence to the heart of divine intimacy. And that realizes itself always in an effective openness to communion with the brothers and sisters destined to share this same divine life. Thus it is that the 'feminine' qualification of the Church opens onto a reality beyond the 'dual' situation proper to spousality and to the commitment of the couple in parenthood, so as to make her penetrate into this filial and fraternal communion through the Spirit of Jesus who is the essential connective tissue of the new people saved by Christ.[23]

c. What the 'feminine' quality of the Church tells us about the elected humanity

Finally, the 'feminine' quality of the Church offers us in a special way certain essential theological meanings concerning the chosen community itself and each member of the people in whom the *Ecclesia, Sponsa et Mater*, is destined to actualize herself.

The fundamental significance stemming from this symbolism is the corporative identification of the Church Person as a community chosen by God to be his partner in the covenant. This community must bear, as the 'we' of the faithful, a share in the salvific activity of Christ in the world.

In this perspective also, this symbolic makes the individual person a bearer of his or her share of the life and mission of the whole community.

The second significance, particularly characteristic of the 'feminine' aspect, is the one that stems from the theme of the salvific motherhood of the people. We have already brought out how this feminine symbolic happily translates the first and fundamental aspect of the act of faith by setting the bride before God in an attitude of active receptivity. It is important to note the extent to which the image of the receptive-active commitment of the mother is apt to symbolize this fundamental fact, that is, the possibility of a human co-operation in salvation.[24] This image of responsible motherhood becomes one of the best suited means of expressing a characteristic affirmation of the Catholic ecclesiology: the 'sacramental' mission of the people of God implies a true responsibility borne by the Christians. And this responsibility realizes itself in and through the profession of faith of the ecclesial community in the all-inclusive sense of the expression, which is, first and foremost, actual acknowledgement and acceptance in thanksgiving and humility of this salvation that the Church has the power of actualizing and, from there, the effective commitment in love and in gift of oneself to make this salvation produce fruit in the community itself and in others.

However, let us recall that the *Mater Ecclesia* lives this responsibility in and through her members in whom she actualizes herself. The whole doctrine of the baptismal priesthood is implied here. This priesthood is lived by each baptized person – always, in communion with the whole – when each one adopts as his or her own the ecclesial faith in Christ and in the salvation he communicates. That supposes and calls for the spiritual offering of oneself by each person through love in the most concrete aspect of his or her life and, especially, in the service of neighbour, as his or her part in the spiritual birth of the new world.

In this trend of thought, one understands that the 'feminine' personification of the Church denotes the precedence, not only for the people of God as such but for each of her

members given to the service of holiness which is love and the gift of oneself, over every particular mode of exercising the mission determined by the gifts received. At the same time and in a similar perspective of love and gift, it implies the prime importance for the whole Church and for her diverse members to accept in a spirit of gratitude and communion the diverse vocations kindled by the Spirit among the members of the people of God. For it is in these and through these vocations that the service of holiness will incarnate itself according to the designs of the wisdom of God in order to complete the work of salvation.

In the light of these different levels of meanings, one final observation must be made which sums up this Chapter. The mystery of the 'femininity' of the Church crystallizes itself in a concrete person who is the type par excellence of this personification of the people of God. This figure is Mary, the humble daughter of Israel, the glorious mother of Jesus and our mother in the order of grace. If the special election of this woman has set her apart for an absolutely unique role in the history of salvation, it is in the way that she lived her maternal vocation that she appears to us as the figure and the model of the Church, bride and mother.[25] That is why Mary reveals to the people of God in a particularly eloquent way something of the depth of its mystery. At the same time, in her, every Christian, man and woman, can find a living illustration of what a believer in Christ is expected to live in the midst of and in his or her service to the ecclesial community. To contemplate Mary and to live in communion with her is, therefore, one of the most important ways to discover the most profound aspects of the mystery of the Church as the people of the new covenant.

NOTES

1. We are, therefore, far from the theme of the eternal feminine which was so dear to a good number of romantics of the nineteenth century, especially in Germany.
2. This liberty, this finality and this significance are what affect the biological facts in human beings and largely explain the wide variety in the behaviour

of men and women from one individual to another and from one cultural group to another.

3. Cf for instance in the study mentioned already, *Le deuxième sexe*.

4. Frederik Jacobus Johannes Buytendijk, *Woman: A contemporary view*, translated by Denis J. Barrette, Glen Rock, N.J., Newman Press, 1968, p. 362.

5. Abel Jeannière, *The anthropology of sex*, translated by Julie Kernan, New York, Harper and Row, 1967, p. 188. We must mention also the study by the French philosopher Yvonne Pellé-Douël, *Etre femme*, Paris, Seuil, 1967, p. 267. See also Edith Stein, 'Essays on Woman' in *The Collected Works of Edith Stein, Sister Teresa Benedicta of the Cross, Discalced Carmelite*, 1891-1942, vol. II, translated by Freda Mary Ohen, Washington, D.C., ICS Publications, 1987, p. 290.

6. We cannot summarize these theses here, still less appraise the content. Such an endeavour would go beyond the limits of this study.

7. In our study, we draw upon certain important works, in addition to those mentioned in the previous notes, and in particular on the following studies: Pierre Daco, *Comprendre les femmes et leur psychologie profonde*, Verviers, Marabout S.A., 1974, especially pp. 165-203; Karl Stern, *The flight from woman*, New York, Farrar, Straus and Giroux, 1965, p. 310; Louis Beirnaert, 'La sexualité escamotée?', in Etudes, 342 (1972), pp. 79-88. Our stand also ties in, in several aspects, with that of Suzanne Lilar, as much in her study, *Le malentendu du deuxième sexe*, Paris, Univ. of France Press, 1969, p. 303, as in her treatise, *Le couple*, Paris, Grasset, 1963, p. 305.

8. Cf Gilbert-Dreyfus, 'Le point de vue de l'endocrinologie', in the study by Lilar, *Le malentendu du Deuxième Sexe*, pp. 267-303.

9. F. J. J. Buytendijk, 'Femme; Approche phénoménologique', in *EU*, VI, pp. 976-981. The author shows clearly that these patterns express themselves in various ways depending on the cultural environment, a fact which makes their description difficult.

10. *Ibid.*, p. 980.

11. We base this development particularly on the synthesis made by Gilbert-Dreyfus, *op. cit.*, pp. 267-303.

12. What we have just said does not exclude the genetic anomalies nor the obstacles to the phenotypical and even functional development, obstacles which may be the result of various causes, of which the psychological and social ones are very often the most important.

13. Daco, *op. cit.*, p. 167.

14. For Daco, the vital energy is fundamental to the human being and prior to the polarities (a view quite similar to the Aristotelian-Thomistic notion of 'passions').

15. *Ibid.*, p. 174.

16. The following diagrams are from Daco, *op. cit.*, pp. 173 and 182.

17. *Ibid.*, p. 186. We can say the same for man and masculinity.

18. On the prime importance of this process by which the adolescent assumes his proper sexual identity and the capacity to develop an objective relationship, free and flourishing, with the other sex, see the book by Tony Anatrella, *Interminables adolescents, les 12-30 ans*, Paris, Cerf/Cujas, 1988, especially pp. 48-56, 118-123, 196-199.

19. A group of researchers under the direction of Antoine Vergote and Alvares Tamayo carried out a psychometric investigation on the representation of God starting from parental images (therefore, from symbols of which the one or the other sex is the natural subejct): *The parental figures and the representation of God: A psychological and cross cultural study*, New York – The Hague, Leuven Univ. Press, 1981 (sic 1980), p. 255. These researchers were able to establish lists of so-called 'paternal' and 'maternal' qualities of which the general content goes back to what we have brought out earlier when speaking of the traits proper to each pole. Note that they set up their lists starting from a vast range of psychological, sociological, philosophical and literary sources (cf pp. 234-237). The intercultural aspect of the research shows that this link between the respective polarities and each parental figure is rather universally perceived.

20. Cf Vergote and Tamayo, *op. cit.*, pp. 191-198 and 205-208. The results of the investigation show that even if the mother figure suggests a strong capacity to evoke a divinity from the enhanced value of several so-called 'maternal' traits, nevertheless, the father figure, as a rule, is considered to be a preferable representation of God. For the paternal figure integrates, in a better way, the parental dimensions of the two sexes, while possessing in its own way three traits particularly attributable to God: law, authority and knowledge. Certainly, one must understand the meaning of this affirmation, for the study has shown that 'God is represented as a complex unity holding the two parental dimensions in tension' (p. 207).

21. What we have just said, using the study by Vergote and Tasmayo as a source reference, confirms this necessary presence of the 'feminine' valencies and especially of the 'maternal' ones when parental images are used to create a symbolic representation of God.

22. On this question, see the observations made by John Paul II in *Mulieris Dignitatem*, no 8.

23. We could refer here with benefit to a study by Pierre Rémy, 'Le mariage, signe de l'union du Christ et de l'Eglise', in *RSPT*, 66 (1982), pp. 397-415. As he analyses the text of Ephesians 5:21-33, the author suggests that the presence of the Spirit in the Christian economy prevents the analogy of the nuptiality suggested by Paul from getting caught up in one of the snares that experimental psychology has detected in the individuals, that is, the survival of the specular process, of the mirror stage, which often intervenes in relationships of a dual type. In such a perspective, in which duality is surpassed, the mystery of the couple united in the Spirit is a witness to the reconciliation of the sexes and of generations and is a prophetic sign of the mystery of the Church as a communion of all in Christ.

24. By showing that woman as much as man is an active co-principle in the begetting of a new life, modern scientific knowledge clarifies in a special way the historical ambiguity of a so-called feminine 'passivity' which has prevailed because the procreative act was seen through the agrarian image of the seed cast into the earth, an image we find again in the Bible, for instance to show the fecundity of the word of God (cf Is 55:10-11). The expression 'active receptivity', according to the Catholic theology of grace, aptly interprets what the co-operation of the creature in the order of salvation consists in. It is co-operation which is an acceptance of the initial

act of God, but also a commitment of the freedom and responsibility of the person at the theological and ethical levels.

25. It is certain that the place of Mary in the economy of salvation is not limited to being a 'model' or an 'icon' since she is truly the mother of Christ and the 'spiritual mother' of the Christians. We only wish to stress here this 'typical' aspect of her vocation without for all that excluding the other aspect of her maternal role towards the Christians.

'Femininity' of the people of God and ecclesial renewal

However, at the end of the twentieth century, at the dawn of the third millennium of Christianity, is there any benefit for the Church to adopt the path of 'feminine' symbolisms in order to probe her mystery at greater depths? By doing so, are we not taking the risk of extolling a certain theological reduction to the 'feminine' dimension? That there are risks, I agree,[1] and the shades of meaning presented up to now precisely wanted to attenuate them. In spite of everything, however, the advantages appear yet greater to me; this explains the purpose of the present chapter in which I shall try to assess some of these advantages. A few preliminary remarks presented at the very beginning will help, I hope, to evaluate adequately within appropriate limits, the contribution made by the spousal and maternal symbolic images.

1. Limitations in the use of this symbolic form

A first comment goes back to the observation made in the introduction to this book. The presentation of the mystery of the Church in this study does not constitute a complete ecclesiology. Recourse to other analogies or symbolisms is necessary to determine clearly the essential aspect of this mystery. For instance, the community of believers makes up a *body*, the body of Christ of which he is the head. It is a people on a journey within the cosmos and in the history of man; its mission is to make its Lord sacramentally present by

the power of the Spirit. The Church can also be understood as a flock guided by one unique Shepherd, a *vine* of which each member is a branch because he or she is grafted on to the same stock, Christ. A truly exhaustive approach to the ecclesial mystery must thus follow several paths in order to preserve an equilibrium in the overtones suggested by each image.

But precisely, each image has its own proper overtones. So does the 'feminine' symbolization. The purpose of this initiative was precisely to help us grasp in greater depths and in more subtle shades of meaning the richness of this particular symbolic in order to make a better assessment of its contribution to our perception of the ecclesial mystery and to our commitment in the mission as members of this people.

A second consideration is also necessary. The application of a 'feminine' qualification of the Church to the concrete life of the people could be most ambiguous if we did not take into account a law proper to the symbolic language and worded as follows: no symbolic form can claim to define what is, on the natural plane, the subject from which these symbolizations are brought forth, in this case, the Israelite woman in the conjugal and maternal context.[3] For we must remember that the symbol does not define, it 'leads towards' something else; it opens out on a new horizon of transcendent meanings allowing one to apprehend something of the mystery in an overall, and in some way experimental, perspective.

2. Renewal from this approach to the mystery

The overtones proper to this symbolic mode are real, as we have seen. Let us, therefore, attempt to discover what contributions they can offer to the ecclesial renewal today.

a. A view that reinforces the corporate character of the people of God

The 'feminine' personification of the ecclesial community as bride and mother reveals the mystery of the people of

God under the traits of a person, one and unified, a 'living' person. I believe that this is a particularly fruitful approach helping us to go beyond an excessively legalistic and external view of the Church. Already, in 1964, in his preface to the French translation of Karl Delahaye's often quoted study, *Ecclesia Mater*, Congar mentioned the danger of having an excessively legalistic view of the Church:

> When the Church is no longer seen as composed of faithful men, but principally as a mediating institution, her mission and her motherhood are viewed as exercising themselves in valid external acts of the instituted ministry and little in the Christian quality of love and prayer according to which her members live.[4]

The 'feminine' symbolization of the Church, therefore, helps us to maintain to the fore the corporative commitment of the people of God realizing itself in all the activities by which this people lives its mystery and its mission of mediation.

> It is the liturgy taken as a whole that is the celebration of the Church in which Christ acts for our salvation. It is this life of fidelity and of thought of the Christians considered as a whole that gives the Church its nourishment in truth. In all things, the entire Church is at work, and it is so through its whole existence. In the pastoral action of the Church, beyond a particular definite and solitary act, beyond a particular moment, it is the whole ecclesial life that is both the means and the setting in which Christ operates.[5]

This approach can shed light on one question to which we are particularly sensitive today, that is, the link between this 'life' of the ecclesial 'we', one and unified, and its more institutional aspect as a society having its own precise structure, providing definite means of salvation (cf Eph 4:12). The 'feminine' personification of the chosen people particularly

226

helps us to understand more clearly how the Church (the *Ecclesia congregans*), structured, by the special service of the 'ordained' ministries, as successors of the apostles, in order to fulfil her mission of proclaiming salvation and of assembling human beings, is no other than this community of faith and of life assembled by Christ in one Body (the *Ecclesia congregata*). The mission is therefore immanent to the life, not in the sense that the efficacy of the means of salvation would depend on the faith of the ministers (or on the faith of the community), but in the sense that it is the living community which, through the action in it of the Holy Spirit and through its faith commitment, bears the efficacious gifts entrusted to it by Christ and through which he assembles those who are open to his action. This perspective is, therefore, the theological foundation of the responsibility of the Church as a whole, a responsibility shared by each individual member according to his personal call.

It seems to me that such an overall view could be of great help to us, as a Church, to progress in finding solutions to certain questions which have a more concrete impact on us today. I can mention, for instance, all the debates revolving around the relations between the responsibility of the baptized people as a whole and that of the ministries ordained as successors to the apostles. We know that these questions must always bring together two poles essential to the life of the Church, the 'corporative' pole entailing the profound responsibility of the believers, men and women, who constitute this ecclesial 'we', and the pole of the special service provided by the ordained ministers expected to keep alive in the community the fundamental reference of all the people to Christ Jesus, the unique pastor of his people and of whom they are the 're-presentatives'.[6] Let us also mention the questions related to setting up the multiform services that Christians, men and women, are called to perform in the midst of the life and mission of the Church, and the concrete articulation of these services in unity and communion.[7] I am also thinking about everything that touches upon the question of the place of the laity in the Church.[8]

b. An ecclesiology of communion

A second line of direction stems directly from what has come before. The life of this Church seen as the 'we' of Christians is a life of communion. And it is in communion and through communion that the people of God fulfils its mission. Here again, the reference to this 'femininity' of the Church, as a relational symbolic and reciprocal commitment, can certainly help to strengthen the awareness that has developed during these recent years about this essentially communional character of the people of God.[9]

It is especially under the aspect of a communion both received from God and lived in the very acceptance of the relationship with Christ in the Spirit, and through Christ with the Father, that this point of view appears to me as being particularly fruitful.[10] For the ecclesial communion is not, basically, the fruit of human endeavours; it is a gift of God, the very gift of salvation which is a participation in the divine communion. That is true in all the spheres of ecclesial activity: worship; the actualization, through every form of preaching of the Word of God; the pursuit of unity as much in the life of the Church and her services as outside her visible frameworks, in mission, etc. Whatever may be the activity in question, it is always based on the same principle: the Church and her members give to themselves neither the Word, nor the sacraments, nor the life of grace which unite them and place them in each other's service.[11] They *receive* this life in communion and express it humbly and actively in and through the living gift of themselves to God and to their brothers and sisters.

The ecclesial communion is also received through God's gift of each individual person to the whole Community, each one called to contribute to the life and mission of the people of God. In this sense, each person is given to his or her brothers and sisters through Christ and the Spirit, as much in his or her individual mystery as in his or her personal charisms (cf 1 Cor 12-13; Rom 12:3ff; Eph 4:7-12; 1 Pet 4:10). In other words, the awareness of a 'feminine' qualification of the

Church can help Christians, men and women, live in an attitude of 'communional' acceptance of each other and of other human beings outside the boundaries of the Church who are, also, gifts from God.

c. A renewed mentality in all forms of services in the life and mission of the Church

From the above, one can already detect a few consequences at the level of a transformation of mentalities in the the Church with respect to *service*. We realize more and more today the importance of the active commitment of all the faithful in the ecclesial mission. All are called to become involved together in service. The 'feminine' qualification of the Church, with the emphasis it places on the attitude of acceptance and on the prime importance of living and vivifying reciprocal relationships, allows us to see more clearly what the spirit of service, which must imbue the commitment of each baptized person, fundamentally consists in. If the service in the Church is intrinsically linked to this life of communion which, based on the charisms and the ministries received from the Spirit, 'organizes', in a profound sense, the being and the mission of the people of God, one then understands why concrete love is what comes first in all forms of service. Without this prime importance given to love, the ecclesial service would risk confining itself within a functional perspective, totally alien to what the mission of the Church, in depth, is all about.

This prime importance given to love as the living sap of all forms of service directly ties in with the call addressed to every Christian, to holiness.[12] For it is this reaching out towards holiness and hence towards the perfection of love that is the only true source of fruitfulness in the Church. This affirmation goes back to what the Fathers of the second general synod of bishops in 1985 affirmed in their final report:

Insofar as she is a mystery in Christ, the Church must be considered as a sign and instrument of holiness. For this reason, the Council has taught the vocation to holiness of all the faithful.[13] This vocation to holiness is an invitation to an intimate conversion of the heart and to a communion of life with God one and three: an accomplishment which surpasses all the wishes of man. Especially in our times when so many people feel a void in themselves and are going through a spiritual crisis, the Church must preserve and promote energetically the sense of penance, prayer, adoration, sacrifice, gift of oneself, charity, justice.

Throughout the whole history of the Church, the saints, men and women, have always been a source and origin of renewal in the most difficult of circumstances. Today, we have a great need of saints whom we must tirelessly ask God to give us.[14]

d. The 'qualified' contribution of women to the life and mission of the Church

We have just mentioned our awareness today of the urgency that everyone should be able to take their place and bring their multiform contributions to the life of the Church. A better grasp of the ecclesial mystery stemming from the 'feminine' aspect confirms the special importance of the active commitment of women, precisely because they are women, and therefore bearers of riches of a special quality.

But in order that the commitment of women may truly bring the anticipated enrichment to the ecclesial life, I would like to make two suggestions. According to me, one must be careful to define as little as possible the forms of commitment that women could be asked to exercise within the Church and her mission. It is important to let these women find out, starting from what they are as persons and as women, the various ways of giving form to their ecclesial vocation.[15] Secondly, it seems indispensable to me that when they assume

these many forms of commitment, women should not be afraid of being what they are, individual persons with their own personal gifts, of course, but also women bearers of sensitivities linked to the fact that they are women and, of which, they have no reason to feel ashamed. These sensivities can often bring about 'something new' either in the approach to reality in all its forms or in the means to contribute to the progress of the people of God.

e. Revitalization of the mystical understanding of the ecclesial mystery

These few paths, to which we could add many others, take us back, however, to what appears to me to be both the major contribution of this approach to the ecclesial mystery and the perspective that constitutes, as it were, the source of all the other paths. The rediscoveries,[16] within Christian thinking, of this 'feminine' personification of a Church both *bride* and *mother* can help us all, men and women, to renew our understanding of the ecclesial community by placing us before its most profound reality, its mystical and mysteric[17] reality. This profound reality is her mystery as a covenant Partner, born of the salvific love of her bridegroom, a love which, in the Holy Spirit, makes her bear fruit in the history of humankind, while immersing her in the Trinitarian communion even here below.

In the end, that is the ultimate richness of this 'feminine' qualification of the Church. It speaks to us of the Other, of God, Father, incarnate Son and Spirit. It speaks of the design of love of this God who wants to make a true partner of humankind. And in that, it speaks of life, the only one that can, by infiltrating itself in all the sinews of our human existence with all that this implies, make us truly happy.

This perspective is of the greatest importance in our Western culture which has placed much emphasis on the intramundane finalities of human existence and on the contribution of technology to earthly happiness. This has given

rise to a new mentality predominantly materialistic and 'technocratic'. Nevertheless, we see more and more that our world has an urgent need of 'breathing' the essential, of rediscovering its transcendent spiritual dimension without being forced to give up the human finalities which are proper to it. The Church must help human beings accede to this essential. In order to do so, however, she must herself live at that level, without evading the concrete human demands made on her in her journey with human beings in the midst of the realities here below.

It seems to me that the main stakes of any pastoral work today are these: to be able, in the world and in union with all human beings – especially the poor – in '(their) joys and (their) hopes, (their) griefs and (their) anxieties'[18] to live and witness to this essential, to the gratuitous eruption of the life of God in our existence with the whole dimension of hope and love which is thus communicated to us. I am convinced that the ecclesial vision emerging from these 'feminine' symbolics of the people of God can help our efforts in this direction, a fact that Congar's reflection seems to confirm once again:

> We proceed too much (in pastoral work) as if we believed it was all about filling up positions, about making a thing work, 'the Church'. In truth, it is mainly a matter of getting to the point of producing, or of making others produce spiritual acts, of making others meet God, of leading them to convert themselves to the Gospel. It is therefore not a matter of guaranteeing the articles of the programme, but of obtaining a prayer that is a prayer, a repentance or a movement of 'penance' or of conversion that is a repentance and a movement of conversion, a communion that is a communion, a faith that is truly faith! Often, we set about to do a pastoral of things, in which men fill in, come what may, the slots of a pre-established framework as if their only role amounted to maintaining a system and make it flourish if possible. We fulfil the articles of the programme 'religion' but there are hardly any spiritual acts, and we do not raise up Christians![19]

Many believers, men and women, throughout the history of the Church and in all states of life have experienced a call to live the profound dimension of the ecclesial mystery and thus to be, in a special way, keepers of a vigil for this constant eruption of the mystery of the gift of God in our existence and in our history. Let us think of contemplative mystics like Catherine of Siena, Edith Stein, Raïssa Maritain or Thomas Merton; of the mystics in action like Vincent de Paul, Marguerite d'Youville, and closer to us, Jean Vanier, Mother Teresa. These persons have often used, to express their grasp of the mystery and its repercussion in their lives, symbols linked to the image of the 'femininity' of the people before its God.[20] Perhaps then a wish would sum up many hopes put forward in this study and, particularly, in this last Chapter: may the people of God as a whole and everyone of us in it, become a little more mystical, a little more contemplative, a little more committed in a concrete surrender of ourselves in faith, love and service. I believe that in this way we shall better discover what this 'feminine' qualification of the Church carries as a revelation of the mystery and, by referring to it more easily but not exclusively, we shall help humankind

NOTES

1. Since the objective of this final Chapter is to identify concrete applications of what has preceded and since such an essay is necessarily to a large extent subjective, I shall express myself here in more personal terms.

2. Benoît Lacroix OP, in a brief article published in the periodical *Communauté chrétienne*, 166 (autumn 1989), p. 246 adds other less traditional images: 'a polar star guiding the wayfarers through the night; a tower rising in the midst of the waters; a spiritual homeland (Hans Küng); my spiritual hearth (Congar); an old olive tree which blooms every spring (Paul VI); the fountain in my village (John XXIII).'

3. And if that is true about the Israelite woman, all the more reason for every woman who could be considered as subject of such a symbolic reference.

4. Congar, 'Preface' to the book by Karl Delahaye, *Ecclesia Mater chez les Pères des trois premiers siècles*, p. 10. Congar goes on to show the consequences of such a legal reduction at the levels of doctrinal and liturgical activities.

5. *Ibid.*

6. In connection with this question, I would like to add an important corollary to this subject which is much discussed today: the exclusion of women from the ordained ministry. (If I present this in the form of a footnote, it is to be able to develop this point at a somewhat greater length without breaking the flow, more suggestive than explanatory, of the reflections in this Chapter.)

We know that the ecclesial tradition in the East and in the Catholic Church of the West has always judged that this representation of Christ Pastor by the apostolic ministry was to be reserved for men (*viri*) according to the very wish of Christ. In other words, the ecclesial magisterium teaches that the symbolic reference to Christ, proper to this ministry, is based on the masculinity of the human subject called to this service; this means that here we are also in the presence of a symbolic reference to the mystery based on the sex. For a subtle analysis of this question, see Jean-Guy Pagé, 'La femme et le ministère', in *Prêtre, un métier sans avenir?*, Montreal, Les Editions Paulines, 1989, pp. 341-368.

But then, is the allusion to the 'femininity' of the Church, such as it is viewed in this study, to be related to the 'masculine' symbolic reference recognized in the ordained ministry? In order to answer this question, the teaching of the magisterium on aspects requiring that the ordained ministry be of the masculine sex must be examined more closely. This teaching is presented as a consequence of the specifically Christological character of this ministry revealing itself in what has been termed since St Irenaeus as the 'cascade of missions': the Father sends his Son in a special human nature of the masculine sex to be his 'sacrament' in the world, and the incarnate Son sends his apostles to be 'those standing in his stead' (a symbolic of continuity or of identity with regard to the sex). I do not believe, however, from all we have seen up until now, that the symbolic vision in question in the identification of a certain 'feminine' quality of the Church refers to the same vision as the 'masculine' symbolization of the apostolic ministry, even if at times arguments bearing upon the appropriateness of this symbolism have alluded to the nuptial symbol to support the traditional understanding of the will of Christ setting this ministry aside for men alone (cf John Paul II, *Mulieris Dignitatem*, nos. 25-27).

The affirmation of the 'masculine' character of the ministry does not appear to me to be directly linked to the 'feminine' qualification of the Church as seen through the nuptial and maternal symbols; we are not saying, for all that, that the two perspectives are alien to each other, as we see in the reference made by Paul and by Christian authors in his wake, to the 'paternity' of the ministry (a paternity marked, let us not forget, with maternal 'valencies'). I believe that the aim of the 'feminine' symbolics is to express things at another level. They are set at the initial stage of the history of salvation seen as a whole and, therefore, at the level of the fundamental relationship in Christ, between God and humankind called to participate in the divine life, and corporatively becoming as Church, God's feminine collaborator for the total accomplishment of the salvific work. At that level, there is another cascade of missions, but it is set in a symbolic of discontinuity or of a bipolar reference at the level of sex: the Father sends the Son, and the incarnate Son sends the Church, his bride, destined to a

salvific motherhood. In a sense, this cascade is more comprehensive than the one already mentioned and includes the first, so that all forms of symbolization borne by a particular service in the Church, even the essential and structuring service of the ordained ministry with its proper symbolic, is always, as it were, immersed in this initial and fundamental symbolism of the relation between Christ bridegroom and the Church, bride and Mother.

To me, the consequences of this last affirmation appear to be very important. Thanks to this view of a structuring ministry immersed in the heart of the *Ecclesia Mater*, 'femininely' symbolized, one will be able to make a more adequate assessment of the following aspects. In the first place, we will have a better grasp of the importance of the figure of Mary for the life of the people of God. Mary is presented as the associate of her son and the model of the *Ecclesia Mater*. One will better assess also the urgency of finding means of giving to the ecclesial institution a face which corresponds better to her total human reality, actively integrating women as well as men in an authentic responsibility. And we know that progress is being made in this direction. Even if the ordained ministers refer to Christ through an identity of sex, one will be able to understand better how these ministers, in their activity and in their attitudes in the midst of a femininely symbolized community, must express the essential aspects of the mystery revealed by the feminine symbolic. Finally, the shades of meaning we have just put forward appear to me to offer avenues which could again address in another ministry as an ordained ministry. For if this ministry is 'apostolic', it constitutes, at the same time a sort of 'guidance' for the concrete response of the faithful to the gift of God – a response expressing itself in multiform services – which elicits the ecclesial bride's typical participation in the salvific birth of the new world.

7. On this question, see the interesting article by Jean-Marie-Roger Tillard, 'L'Eglise catholique et la pluriformité des ministères', in *EC*, 15 (1982), pp. 139-144. The apostolic exhortation *Evangelii Nuntiandi* by Pope Paul VI (1975), especially nos. 59-73, remains a reference of prime importance for this question of the articulation of the diverse services assumed by the faithful in the mission of the Church.

8. See the many publications about this subject on the occasion of the Synod of Bishops in 1988 and especially the post-synodal apostolic letter of John Paul II, *Christifideles Laici* (1989).

9. In his apostolic letter, *Christifideles Laici*, Pope John Paul II treats this question of the ecclesial communion in a special way. He then applies it to the co-responsible commitment of the different categories of baptized persons serving the mission of the Church.

10. This point of view was developed in some excellent studies published in recent years, in particular the article by A. Denaux, 'L'Eglise comme communion. Réflexions à propos du Rapport final du Synode extraordinaire de 1985', in *NRT*, 110 (1988), pp. 16-37 and 161-180, as well as the one by Walter Kasper, 'L'Eglise comme communion. Un fil conducteur dans l'ecclésiologie de Vatican II', in *Communio*, 12 (1987), pp. 15-31.

11. One of the essential functions that the ordained ministry assures by its activity as 'representative' of Christ is precisely that of keeping alive

within the ecclesial community this awareness of the absolute gratuity of the gift of God and of the impossibility, for the faithful of every category (ministers included), of claiming to be able to lay hands on the means of salvation and on grace. On this subject, see Bernard Sesboüé, 'Ministères et structure de l'Eglise: Réflexion théologique à partir du Nouveau Testament', in *Le ministère et les ministres selon le Nouveau Testament, op. cit.*, pp. 406-407.

12. It is worthwhile to recall here the remarks already made on this subject in Chapter 9, especially about the conditions to be met so that the Christian commitment may truly edify the Church in unity (cf. *supra*, pp 238-243).

13. Cf *Lumen Gentium*, Chapter 5.

14. 'Synthèse des travaux de l'assemblée synodale; le rapport final voté par les Pères', in *DC*, 1909 (1986), p. 38. The Fathers go on by addressing this call to holiness to various categories of the faithful.

15. Let us recall here what Pope Paul VI was saying in 1976 at the Congress of the Italian Feminine Centre: '...it becomes evident that woman has her place in the living and active structure of Christianity, and in such an important way that we have not yet been able to bring out all the potentiality therein!', in *DC*, 1711 (1977), p.8.

16. I say precisely 'rediscoveries' for the themes of the Church viewed as bride and as mother had great importance in the Christian thought of the early Middle Ages, as Yves Congar shows in his study: *L'ecclésiologie du haut Moyen-Age*, Paris, Cerf, 1968, pp. 77-81. The same author, in a work already mentioned (*L'Eglise de St Augustin à l'époque moderne*), shows how this theme has taken less and less space in Western ecclesiology especially since the twelfth century, and that very often, when a reference was made to a feminine personification of the Church, it almost always pointed to the Mother Church of Rome (cf pp. 111, 126, 216). The author points out a few exceptions like St Bernard, Isaac of the Star, even Bossuet, and closer to our times, Scheeben.

17. The expression 'mysteric' refers to the mystery experienced by the community when it participates, through the liturgical celebration, in the 'mysteries', that is, in the sacramental actualization of the mystery of Christ dead and risen.

18. *Gaudium et Spes*, No 1.

19. Congar, 'Préface', *Ecclesia Mater*, pp. 17-18.

20. In the study, *L'Eglise de St Augustin à l'époque moderne*, Congar shows that the mystics and the spiritual people are the ones who, more often than not, have used the language of the nuptial and maternal symbolism to speak of the Church.

Conclusion

One Church, bride and mother: first, Israel; then definitely the people of the new covenant; and, at another level,[1] first and foremost, the One who is its icon par excellence, Mary, but also, in part, every person in whom the Church is actualized. In all of these cases, the bride and the mother is this humanity chosen by the Father of our Lord Jesus, the Christ, in order to be holy and immaculate in the presence of God, in love communicated by the Spirit, like a people of adoptive daughters and sons of the Father in Jesus (cf Eph 1:3-4). That is what this 'femininity' of the people of God essentially consists in insofar as it has revealed itself to us in this long theological reflection.

But to the concrete realization of this mystery, there is a condition that the history of Israel has brought to light: this task of transforming humankind and, especially, the individual persons by the living acceptance of the gift of God, realizes itself only insofar as we allow God to create in us a humble heart, a heart that opens out to Christ in his *kenosis* of love. It is in this perspective that I would like to conclude this research by evoking the following memory.

It was in the summer of 1969. With the help of the sisters, I was attending to the final preparations of a painful move: we were definitely leaving behind an American Indian reserve in north-eastern Alberta where my congregation had been working for twelve years and where I had worked for four years.

It was on the eve of our departure. I had to go on an errand to the neighbouring village, so I asked a certain woman if she would like to come with me. The trip would

give us both an opportunity to share a few brief moments before our final goodbye.

Mildred, a modest mother of three children, abandoned by her husband, was a great believer, a faithful and humble collaborator in the life of the parish community. Although illiterate, she was a 'wise woman' who spoke little but whom people willingly consulted. How many times had she shown me in a few words, and without believing too much in the worth of her ideas, what later would prove to be an enlightened line of action in the touchy problems concerning life on the reserve.

Nevertheless, one source of grief was undermining Mildred: a man of the area, who did not share her religious beliefs, was pressing upon her to come and live with him. She did not wish to respond to his demands, but did not dare prevent him from coming to her home because, according to these kinds of fears we sometimes still find in these milieux, she was afraid he would 'cast a spell' on her.

Towards the end of this last outing together, just as I was turning on to the path leading to her little log cabin perched on the hill overlooking the lake, we stopped a moment to admire the large white clouds floating along in a deep blue sky. In the typical manner of these Indian people, that is, gently and after a long moment of silence, she said to me: 'You know, Sister, when I see beautiful clouds like those in the sky, I tell God how smart I think he is.' Silence fell over us again, then she went on: 'You know X (the man who was pursuing her), I just told him not to come to my house anymore. It was because I was hungry for communion!' This remark, so simple, went straight to my heart. Had I spent these last four years in this place only to hear these words, it would have been well worthwhile!

Some ten years later, while visiting the reserve, I inquired about Mildred from one of my friends. In a very moved voice, she answered: 'Well, imagine; we lost our "Mildred" this year. After wearing herself out for years

bringing up her children, taking in children from social welfare, busying herself as always about the church, and greeting everyone in her home, at a time when, at last, she herself could have taken a rest, she left us. The reserve is mourning a "mother".

Indeed, blessed are those who are invited to the wedding feast of the Lamb!

NOTE

1. In a sense, even in the case of Israel, at least in the perspective of God's unique design.